C000126913

**work
comes out of
work**

Steidl

Dirk Reinartz

Alexander von Berswordt (Hg./Ed.)

work comes out of work

**Fotografien zu Skulpturen von
Photographs of the Sculpture of**

Richard Serra

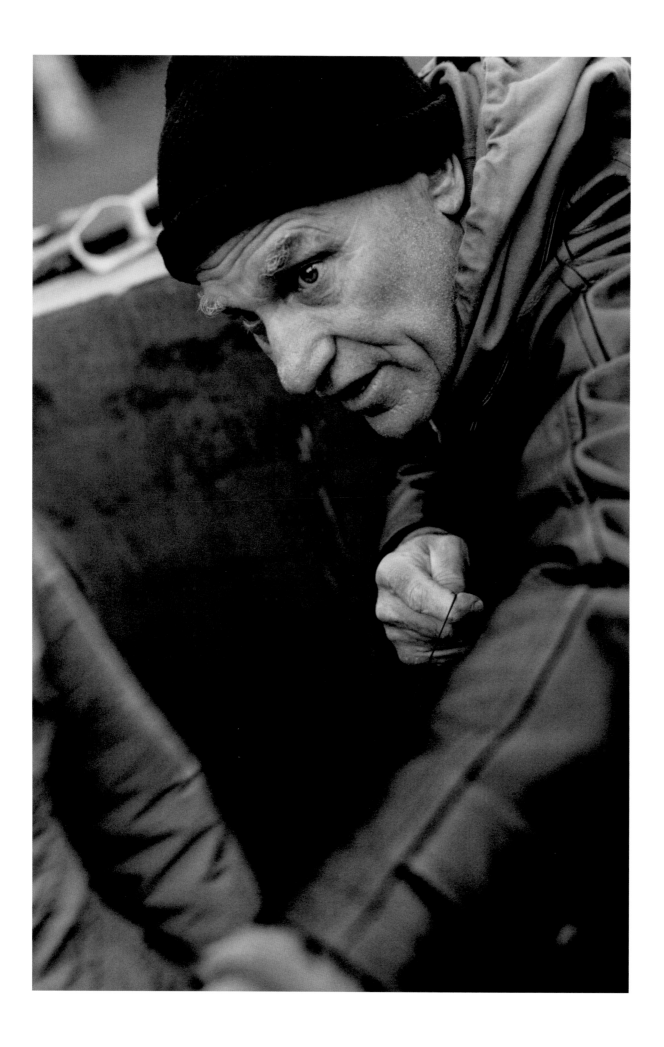

Inhalt
Contents

Bei der Arbeit, am Werk

**Fotografien von Dirk Reinartz zu
Skulpturen von Richard Serra**

Silke von Berswordt-Wallrabe

Anfänge

Der Fotograf Dirk Reinartz und der Bildhauer Richard Serra lernten sich in den frühen 1980er Jahren kennen und in ihren jeweiligen Arbeitsbereichen schätzen. Nachdem Reinartz immer wieder einzelne Skulpturen von Serra fotografiert hatte – zum Beispiel für Ausstellungskataloge oder im Rahmen seiner bildjournalistischen Tätigkeit für Magazine wie *Zeit-Magazin* und *Art* – entstand 1991 mit *Afangar* ein erstes gemeinsames Buchprojekt.[1]

Der Bildband *Afangar* dokumentiert eine ortsbezogene Skulptur, die Serra 1990 auf der isländischen Insel Videy bei Reykjavik aus neun Paaren von Basaltstelen installierte. Die Stelen sind auf zwei Höhenlinien so angeordnet, dass sie zum Umschreiten von Vesturey, der nordwestlichen Halbinsel von Videy, einladen. Wie bei allen Skulpturen von Serra – und insbesondere bei seinen landschaftsbezogenen Werken – gibt es auch hier keinen hervorgehobenen oder gar idealen Standpunkt. Wer die Skulptur erfahren will, muss sich auf den Weg machen und sie in ihrem landschaftlichen Kontext Schritt für Schritt selbst wahrnehmen. Dirk Reinartz lässt uns mit seinen Fotografien exemplarisch an einem solchen Rundgang teilhaben. Der Untertitel der Skulptur *Afangar* scheint zu beschreiben, was wir auf den eindrücklichen, beinahe elegischen Schwarzweißfotografien nachvollziehen können: „Stationen, Haltepunkte, Zwischenziele. Stehenbleiben und Schauen: zurück und nach vorn. Den Blick aufs Ganze richten."

Auch wenn eine Fotografie die persönliche, leibhaftige Erfahrung einer Skulptur – gerade im Fall der psychophysisch herausfordernden und oft ortsbezogenen Werke von Richard Serra – nicht ersetzen kann, vermag sie doch eine Vielzahl von Eindrücken, Informationen und möglichen Sichtweisen zu vermitteln. Eine so kenntnisreiche und bedachtsame Betrachtung, wie Dirk Reinartz sie den Skulpturen von Richard Serra widmete, erlaubt zweifellos besonders weitgehende Einsichten.

1 Richard Serra, Dirk Reinartz, *Afangar*, Göttingen 1991.

Dabei sind Reinartz' Fotografien stets mehr als rein protokollierende Bestandsaufnahmen. Durch die gestalterische Sorgfalt, mit der jeder einzelne Blickpunkt und jeder Ausschnitt gewählt sind, wird jede Fotografie zu einem eigenständigen, technisch höchst präzisen Bild. Allerdings konkurrieren Reinartz' Fotografien nie hinsichtlich eines vermeintlichen Kunstanspruchs mit den fotografierten Werken, wie es etwa durch spektakuläre Blickwinkel oder sonstige gesuchte Effekte möglich wäre; vielmehr bleiben sie in ihrer Aussage wirkungsvoll durch souveräne Zurückhaltung.

Prozesse

Bei einigen Skulpturenprojekten ergab sich eine besonders intensive Zusammenarbeit dadurch, dass Reinartz den gesamten Herstellungsprozess von der Stahlproduktion über die Formung der Skulpturenelemente bis zu ihrer Installation am endgültigen Standort begleiten konnte. Dies gilt beispielsweise für Serras Skulptur *Lemgo Vectors*, deren drei Blöcke 1998 in der Schmiede der Henrichshütte in Hattingen gefertigt wurden. Der trotz des Einsatzes von enorm leistungsfähiger Maschinentechnik auch heute noch archaisch anmutende Prozess des Schmiedens hat Serra seit jeher fasziniert und ihn im Zuge der ebenfalls in Hattingen erfolgten Fertigung seiner Skulptur *Berlin Block (for Charlie Chaplin)* zu dem 1979 gemeinsam mit Clara Weyergraf in der Henrichshütte gedrehten Film *Steelmill/Stahlwerk* angeregt. Der Film umfasst in seinem ersten Teil eine politisch motivierte, durch Schriftfelder und Stimmen aus dem Off anonymisierte Befragung der Arbeiter zu ihrer Tätigkeit. Im zweiten Teil folgt eine durch abrupte Schnitte extrem fragmentierte Sequenz von Aufnahmen einzelner Arbeitssituationen, die einen systematischen Einblick in den Ablauf des Herstellungsprozesses konsequent verweigern. Die Projektion des Films soll Serras Anweisungen zufolge bei größtmöglicher Lautstärke erfolgen, so dass die visuelle Verunsicherung durch die akustische Zumutung verstärkt wird. *Steelmill/Stahlwerk* ist somit zum einen ein politisches Statement, zum anderen eine konfrontative Montage, in der die überwältigende Atmosphäre des Stahlwerks mit avanciert ausgereizten filmischen Mitteln verdichtet zum Ausdruck kommt.

Dirk Reinartz hingegen bewegt sich mit einer gänzlich anderen Aufgabenstellung und einem anderen Selbstverständnis im Stahlwerk. Im Sinne einer klassischen Dokumentation geht es ihm zunächst darum, die einzelnen Fertigungsschritte festzuhalten, aufschlussreiche Details einzufangen und Abläufe nachvollziehbar zu machen. Betrachtet man beispielsweise die Fotografien, die er anlässlich der Schmiedung für die Stahlblöcke von *Lemgo Vectors* aufgenommen hat, so zeigt sich, dass auch im Rahmen einer so klaren Aufgabenstellung enorme Gestaltungsspielräume liegen. Dies wird allein schon durch die verschiedenen Bildtypen deutlich, die innerhalb eines Arbeitstages und erst recht innerhalb eines in aller Regel mehrwöchigen Herstellungsprozesses entstehen.

Im Mittelpunkt vieler Fotografien steht zwangsläufig das jeweils zu bearbeitende Werkstück: im Fall des Projektes *Lemgo Vectors* der etwa 80 Tonnen schwere Rohblock, der bei einer Temperatur von 1.200°C glühend aus dem Ofen kommt, in wuchtigen Ketten von Kränen gehalten durch die Luft schwebt, so zur Schmiedepresse gebracht und dort in vielen Schritten durch enormen Druck verformt wird. Auch die imposanten Maschinen und seltsam überdimensioniert anmutenden Werkzeuge setzt Reinartz detailreich differenziert ins Bild. So baut sich die 8.000-Tonnen-Schmiedepresse formatfüllend wie ein monumentales Bauwerk auf

(S. 43), greift eine riesige Kranzange nach dem Schmiedestück (S. 41) oder schiebt sich der Manipulator mit seiner gewaltigen Zangen-Armstange machtvoll ins Bild (S. 45). Neben Nahaufnahmen hält Reinartz immer wieder den weiteren Kontext der Arbeitssituation mit einigem Abstand in Totalen fest oder zeigt Arbeiter, die – neben den Maschinen oft irritierend klein – mit großer Konzentration ihrer Tätigkeit nachgehen. Sei es beim Gießen des Stahls, beim Walzen oder Entzundern der Grobbleche in der Dillinger Hütte, sei es beim Ausrichten, Vermessen und stückweisen Verformen an der Biegepresse bei Pickhan Umformtechnik oder schließlich beim ersten Probeaufbau einer neuen Skulptur – nie entsteht der Eindruck, dass die Arbeiter posieren oder den Fotografen überhaupt wahrnehmen. Dies hängt zum einen damit zusammen, dass die anspruchsvolle und oft auch gefährliche Arbeit ihre volle Aufmerksamkeit erfordert. Zum anderen besaß Reinartz die Fähigkeit, sich beim Fotografieren so behutsam und zurückhaltend zu bewegen, dass seine Anwesenheit fast unbemerkt blieb. Schließlich erlaubte er sich neben den informativ prozessbezogenen Fotografien immer wieder auch formal strenge, beinahe abstrakte Ansichten, bei denen die bildhafte Qualität überwiegt, so etwa mit einer Detailansicht der Flamme, die sich präzise durch einen erkalteten Stahlquader frisst und diesen in drei Blöcke trennt (S. 51). Wie auch bei anderen Serien erläutern die verschiedenartigen Bilder einander zwar wechselseitig, sie liefern aber keine lückenlose oder gar narrative Abfolge im Sinne einer Reportage. Zum einen sind die Vorgänge so fremd, dass Nichtfachleute das jeweilige Geschehen kaum einordnen können, zum anderen liegt ein großes Gewicht auf dem einzelnen Bild, auf der Erfassung des jeweiligen Moments, in dem die Aktion im Bild zum Stillstand kommt.

Stille

Die Fotografien von der Skulpturenherstellung erlauben einen Einblick in die wenigen noch verbliebenen schwerindustriellen Produktionsstätten, die den meisten von uns unzugänglich sind. Wer aber jemals ein Stahlwerk besucht hat, bleibt wahrscheinlich von der Reizüberflutung durch Dunkelheit, Hitze, Qualm, Dreck und Lärm nachhaltig beeindruckt. Ähnlich unbeirrt, wie die Arbeiter in dieser Atmosphäre ihrer Tätigkeit nachgehen, ordnet Reinartz mit seiner Kamera das für Außenstehende nur schwer zu durchdringende Geschehen, indem er prägnante Momente fotografisch stillstellt. Aus der beinahe überwältigenden Dichte der Eindrücke schafft er Bilder von eindringlicher Ruhe und Kraft.

Während in den Stahlwerken und in den Weiterverarbeitungsbetrieben eine Vielzahl komplex ineinandergreifender, teilweise auch simultan stattfindender und mehr oder weniger rasch bewegter Vorgänge festzuhalten sind, trifft Reinartz bei den fertig installierten Skulpturen auf in sich statische Strukturen, die ihrerseits zur Bewegung, zur Wahl immer wieder neuer Standpunkte und zur analytischen Reflexion des jeweils visuell und leiblich Erfahrenen anregen. Indem Reinartz bestimmte Standorte wählt, bestimmte Blickführungen hervorhebt und bestimmte Ansichten ins Bild setzt, hält er Momente des Verweilens fest, in denen das Wissen um die anderen Standpunkte mitschwingt. Als aktiver Beobachter bezieht er immer wieder Stellung gegenüber der jeweiligen Skulptur und ihrem Umfeld. Jede Fotografie zeugt von einer bestimmten Sichtweise, jede Fotografie ist eine ebenso entschiedene wie subtile Deutung des Gesehenen.

Im Vergleich zeigt sich, wie weitgehend Reinartz sich auf die jeweilige Skulptur und ihren jeweiligen Ort einlässt. So akzentuiert er die kompakte Dichte des geschmiedeten Zylinders *One* im weitläufigen Park des Kröller-Müller Museums, betont den

beinahe tänzerischen Dialog, mit dem die gebogenen Platten von *Berlin Junction* auf die extravagante Architektur der Berliner Philharmonie antworten, und unterstreicht lakonisch die spröde Sperrigkeit, mit der sich die Skulptur *Street Levels* anlässlich der documenta 1987 in der Kasseler Einkaufszone breit macht. Mit Fotografien der *Bramme für das Ruhrgebiet* erfasst er die mondlandschaftliche Leere einer ehemaligen Abraumhalde ebenso wie die emblematische Qualität der mächtigen Stahlbramme vor der Kulisse des Ruhrgebiets, während die Bilderfolge von *La Mormaire Elevations* zu einem bedächtigen Durchschreiten der weitläufigen, auf einer Lichtung am Waldrand platzierten Skulptureninstallation einzuladen scheinen. Die Fotografien der Skulptur *The Drowned and the Saved* zeugen schließlich von der existenziellen Situation, in der zwei geschmiedete Winkel, die allein zum Stürzen verurteilt wären, einander wechselseitig stützen.

Es kennzeichnet die Erfahrung von Serras Skulpturen, dass wir uns kein abschließendes, verbindlich feststehendes Bild von ihnen machen können. Vielmehr erfordern sie ein immer neues Hinsehen, eine immer neue Überprüfung des jeweils Wahrgenommenen und des eigenen, möglicherweise zu verändernden Standpunktes. In ihrem Medium erfordern auch die Fotografien von Dirk Reinartz ein außergewöhnlich geduldiges, aufmerksames Schauen, in dessen Verlauf sich erst eine Fülle an Details und an Nuancen eröffnet. So bedingt das kompakte, geradezu bescheidene Format, in dem Reinartz – unbeeindruckt von fotografischen Moden und Trends zum Großformat – seine Bilder üblicherweise aufs Papier bringt, eine sorgfältig abwägende Betrachtung aus der Nähe.[2] Gerade angesichts der oft beträchtlich raumgreifenden Dimensionen von Serras Skulpturen, aber auch angesichts der imposanten Szenarien in den Stahlwerken, erstaunt die Fülle an Informationen, die Reinartz auf kleiner Fläche mit souveräner Klarheit verdichtet. Vor allem sind es jedoch die unzähligen, bei allem Hang zum Dunklen sensibel ausdifferenzierten Grauschattierungen, die dem jeweiligen Bild einen vibrierenden Reiz und eine enorme Ambiguität verleihen. Es ist nicht übertrieben, Dirk Reinartz als einen Meister der Graustufenfotografie zu charakterisieren. Oder, in seinen eigenen Worten: „Das allerbeste Licht ist jedoch seine andere Seite – der Schatten."[3]

Schwere

Nach dem Tod von Dirk Reinartz im Jahr 2004 hat Serra weiterhin verschiedene Fotografen mit Aufnahmen seiner Skulpturen beauftragt, ohne dass es erneut zu einer vergleichbar intensiven Zusammenarbeit kam. Was Reinartz und Serra in ihrer Arbeit verbindet, ist möglicherweise eine tief verinnerlichte und auf je eigene Weise gelebte Ernsthaftigkeit, eine täglich neu versuchte Auseinandersetzung auch und gerade mit dem, was schwer ist und was schwerfällt. In einem grundlegenden Text schreibt Serra: „Konstruktive Entwicklung, tägliche Konzentration und Bemühungen sagen mir mehr zu als das spielerisch Überspannte, mehr als das Streben nach dem ätherisch Vergeistigten. Was immer man im Leben seiner Leichtigkeit wegen wählt, erweist sich bald als unerträglich schwer."[4]

Betrachtet man die Themen, die Reinartz neben den Auftragsarbeiten für seine selbst bestimmten Serien und Projekte wählte, so zeigt sich auch in seinem Werk eine deutliche Hinwendung zum Unbequemen, im Alltag oft Verdrängten, zum Schweren. Die deutsche Geschichte und der Umgang mit Erinnerung war Thema einer Werkgruppe zu Bismarck-Denkmälern.[5] Ein kritischer, zuweilen ironisch zugespitzter Blick auf die damals aktuelle gesellschaftliche Situation prägte Projekte wie *Kein schöner Land* oder *Besonderes Kennzeichen: Deutsch*.[6] Mit Fotografien

2 Reinartz fertigte seine Papierabzüge meist auf Standardpapier von 24 × 30,5 cm an, bei einem Bildmaß von ca. 16,5 × 25,5 cm.

3 Zitiert nach https://fcgundlach.de/de/biografie-dirk-reinartz, abgerufen am 28.11.2023. Die Stiftung F. C. Gundlach in Hamburg bewahrt gemeinsam mit der Deutschen Fotothek in Dresden das umfangreiche Archiv von Dirk Reinartz.

4 Richard Serra, Gewicht, in: ders., *Schriften, Interviews 1970–1989*, Bern 1990, S. 205–209, hier S. 208.

5 Vgl. Dirk Reinartz, *Bismarck. Vom Verrat der Denkmäler*, Göttingen 1991.

6 Dirk Reinartz und Wolfram Runkel, *Kein schöner Land*, Göttingen 1989; dies., *Besonderes Kennzeichen: Deutsch*, Göttingen 1997.

7 Dirk Reinartz und Wolfram Runkel, *Rheinhausen 1988*, Göttingen 2024 (im Erscheinen).

8 Eine Auswahl von 230 der dabei entstandenen Fotografien erschien in Buchform: Dirk Reinartz und Christian Graf von Krockow, *totenstill. Bilder aus den ehemaligen deutschen Konzentrationslagern*, Göttingen 1994. 1995 begann eine Ausstellungsreihe mit einem Konvolut von 136 ausgewählten Fotografien, die seither weltweit in zahlreichen Museen und Ausstellungsinstitutionen gezeigt wurden. Ein kompletter Satz dieses Ausstellungskonvoluts wird in Situation Kunst (für Max Imdahl) in Bochum bewahrt.

9 Reinartz formulierte in einem unveröffentlichten Manuskript einige der Fragen, die ihn bei der Arbeit am Projekt *totenstill* beschäftigten, so etwa: „Drückt sich die Menschenverachtung und Intoleranz in der Anlage und Architektur der Lager aus? Sind Bilder möglich, die den industriellen Charakter der Menschenvernichtung ahnen lassen? Sind Plätze und Steine Beweise?“

10 Eine kritisch reflektierte, skrupulöse Arbeitsweise vermittelte Reinartz auch seinen Studentinnen und Studenten an der Muthesius-Hochschule in Kiel; vgl. Christiane Gehner und Matthias Harder (Hrsg.), *Stille. Dirk Reinartz und Schüler*, Göttingen 2007.

11 Richard Serra, „The Yale Lecture, January 1990“, in: *Kunst & Museumsjournaal* (Amsterdam), Band 1, Nr. 6 (1990), S. 23–33, hier S. 23.

12 Serra zitiert hier die Theorie von Bertrand Russell; vgl. Richard Serra, Der Yale-Vortrag, in: *Kunsttheorie im 20. Jahrhundert. Künstlerschriften, Kunstkritik, Kunstphilosophie, Manifeste, Statements, Interviews*, Charles Harrison und Paul Wood (Hrsg.), Bd. 2: 1940-1991, S. 1395–1399, hier S. 1398.

aus Duisburg-Rheinhausen hielt Reinartz 1988 den Niedergang der dortigen Stahlindustrie mit seinen erschütternden Auswirkungen auf das Leben in einem ganzen Stadtteil und letztlich einer ganze Region fest.[7] Für sein bekanntestes und ihm persönlich besonders wichtiges Projekt, den Werkzyklus *totenstill*, fotografierte er von 1987 bis 1993 in den ehemaligen deutschen Konzentrationslagern.[8] In einer Zeit, als in Deutschland der Historikerstreit über die Einzigartigkeit des Holocaust geführt wurde und nicht wenige sich für eine Relativierung der nationalsozialistischen Verbrechen aussprachen, begab Reinartz sich auf eine höchst persönliche Spurensuche. Mit der Frage, ob Bilder möglich sind, die die industrielle Menschenvernichtung ahnen lassen, stellte er sich eine Aufgabe von existenzieller Schwere.[9]

Nicht nur in der Wahl seiner Themen, sondern wesentlich auch in der fotografischen Umsetzung stellte Reinartz höchste Ansprüche an sich selbst.[10] Nicht selten kam es vor, dass er mit einzelnen Fotografien unzufrieden war und noch einmal losfuhr, um das gleiche Motiv anders, besser zu fotografieren. Seine Papierabzüge fertigte er grundsätzlich selbst an, in minutiöser, geduldiger Handarbeit im eigenen Labor, so dass auch an einem langen Arbeitstag nur eine überschaubare Anzahl von Abzügen entstand.

Ein produktives Misstrauen gegenüber dem eigenen Tun und die Bereitschaft, das eigene Schaffen immer wieder in Frage zu stellen, verbinden Reinartz' Arbeitsweise mit derjenigen von Richard Serra. „Work comes out of work“[11] stellt Serra fest und beschreibt damit die Fähigkeit, aus der kritischen Reflexion der jeweiligen Tätigkeit immer wieder neue Aufgaben und Arbeitsweisen zu entwickeln. Für Serra heißt dies beispielsweise, dass er in der Auseinandersetzung mit industriellen Produktionsverfahren, wie sie in dieser Intensität nur im Stahlwerk möglich ist, Anregungen zu weiteren Werken erhält. In der Entwicklung solch neuer Werke kommt es wiederum häufig vor, dass Serra mit seinen Ideen und Ansprüchen an die Grenzen des technisch Machbaren geht und so wiederum Ingenieure und Arbeiter zur Weiterentwicklung ihrer routinierten Verfahren herausfordert.

Wenn aus Arbeit weitere Arbeit hervorgeht, so heißt das in diesem besonderen Fall aber auch, dass die Skulpturen von Richard Serra seinen Freund und Weggefährten Dirk Reinartz – der sich nie als Künstler bezeichnen wollte – zu Fotografien bewegen, die im Rahmen ihrer medialen Bedingungen ähnlich substanzielle Formulierungen sind. Serra schreibt über die Möglichkeit, Erfahrungen auszudrücken: „Jede Sprache hat eine Struktur, über die man in dieser Sprache selbst nichts aussagen kann. Stattdessen braucht man eine andere Sprache, die sich mit der Struktur der ersten beschäftigt und ihrerseits eine neue Struktur erzeugt, über die man nichts aussagen kann, es sei denn in einer dritten Sprache – und so fort.“[12]

Wenn ein Fotograf eine Sprache beherrscht, die gewichtige Aussagen nicht nur, aber wesentlich auch zu Serras Werk ermöglicht, dann ist das zweifellos Dirk Reinartz.

At Work

On Dirk Reinartz's Photographs
of Richard Serra's Sculptures

Silke von Berswordt-Wallrabe

Beginnings

The photographer Dirk Reinartz and the sculptor Richard Serra met in the early 1980s and by and by came to appreciate one another's work. After Reinartz had repeatedly photographed individual sculptures by Serra (for exhibition catalogues and as part of his photojournalistic work for magazines, such as *Zeit-Magazin* and *Art*), their first joint book project, *Afangar*, came about in 1991.[1]

The photographic catalogue *Afangar* documents a site-specific sculpture that Serra installed on the Icelandic Island of Videy near Reykjavik in 1990, consisting of nine pairs of basalt stelae. The stones are arranged on two contour lines in such a way that invites the viewer to walk around Vesturey, Videy's north-western peninsula. As is the case with all of Serra's sculptures, and, particularly with his landscape-related works, there is no single or even ideal vantage point for viewing. If you want to experience the sculpture, you have to set off and see it for yourself, step by step, very much in the context of its landscape. Dirk Reinartz's photographs are an example of such an excursion. The subtitle of the sculpture *Afangar* seems to encapsulate the understanding we gather from the impressive, almost elegiac black and white photographs: "Stations, Stops on the Road, to Stop and Look: Forward and Back, to Take It All In."

Even if a photograph cannot replace the personal, physical experience of beholding a sculpture, it can still convey a multitude of impressions, information, and possible viewpoints, especially in the case of Richard Serra's psychophysically-challenging and often site-specific works. Such a knowledgeable and considered examination as the one Dirk Reinartz has devoted to Richard Serra's sculptures undoubtedly allows for particularly far-reaching insights. Reinartz's photographs are invariably more than mere documentary, photographic logs. The creative care with which each individual angle and detail is chosen transforms each photograph into a—technically-speaking—independent, highly precise image. However, Reinartz's photographs never compete with the works photographed in terms of a putative artistic aspiration, as might obtain through the selection of spectacular angles or other devised effects one might seek out; rather, their overall statement is always masterfully restrained.

1 Richard Serra, Dirk Reinartz, *Afangar* (Göttingen: Steidl, 1991).

Processes

In some of the sculpture projects, Reinartz was in a position to accompany the entire fabrication process, from steel production to the shaping of the sculptural elements and their installation at the final location, which resulted in a particularly intensive collaboration between the two artists. This was the case, for example, in Serra's sculpture *Lemgo Vectors*, the three blocks of which were fabricated at the Henrichshütte in Hattingen in the Ruhr in 1998. The process of forging, which even today seems archaic despite the use of enormously powerful machine technology, has always fascinated Serra. In the course of the production of his sculpture *Berlin Block (for Charlie Chaplin),* which also took place in Hattingen, Serra was inspired to make the film *Steelmill/Stahlwerk*, which he shot together with Clara Weyergraf at the Henrichshütte in 1979. The first part of the film comprises a politically-motivated interview with the workers about their labor, which is rendered anonymous by means of text boxes and off-screen comments. The second part is followed by a sequence of shots—extremely fragmented by abrupt cuts—of individual situations featuring the work undertaken, which consistently deny a systematic insight into the manufacturing process. According to Serra's instructions, the film should be projected with the sound at the highest possible volume, so that visual uncertainty is intensified by the almost unbearable acoustic imposition of the soundtrack. On the one hand, *Steelmill/Stahlwerk* is thus a political statement, whereas on the other, it is a confrontational montage, in which the overwhelming atmosphere of the steel mill is expressed in concentrated form using advanced cinematic means teased-out to the maximum.

In contrast, Dirk Reinartz moves around the steel mill with a wholly different agenda and a personal concept of his role. In the sense of a classical documentary, he is initially concerned with recording the individual stages of production, capturing revealing details and rendering processes comprehensible for the viewer. When looking at the photographs he took during the forging of the steel blocks for *Lemgo Vectors*, for example, it emerges that—even within the framework of such a clearly formulated task—enormous creative freedom can obtain. This is exemplified by the different types of images that are made within one working day and, not to mention, within a production process that usually goes on for several weeks.

The focus of many of the photographs is inevitably the piece or work to be processed: in the case of the *Lemgo Vectors* project, the blank of cast steel weighing approximately 80 tonnes—which emerges red-hot from the furnace at a temperature of 1,200°C and floats through the air in massive chains held by cranes—is brought to the forging press and wrought there in many stages under enormous pressure. Reinartz also depicts the imposing machines and strangely oversized-looking tools with great attention to detail. The 8,000-tonne forging press, for example, fills the frame as a monumental structure (p. 43), a huge pair of tongs reaches out for the forged block (p. 41), the manipulator and its enormous pusher forces its way powerfully into the picture (p. 45). In addition to close-ups, Reinartz repeatedly captures the wider context of the work process from a distance in long shots or in depictions of workers—often perplexingly tiny next to the gigantic machines—going about their work with great concentration. Whether they are casting the steel, rolling or descaling the heavy plates at the Dillinger Foundry, aligning, measuring, and shaping at the bending press at Pickhan Umformtechnik, or, finally in the first trial assembly of a new sculpture, any impression that the workers are posing or even aware of the photographer simply never arises. One reason for this is that the demanding

13

and often dangerous work requires their full attention. On the other hand, Reinartz was able to move around so carefully, almost surreptitiously and with such restraint when taking photographs that his presence was barely noticed. Finally, in addition to the informative, process-related photographs, Reinartz repeatedly allowed himself to take formally stringent, almost abstract shots, in which the quality of the angle predominates: for example, a detailed aspect of the flame that precisely eats its way through a cooled steel slab and cuts it into three sections (p. 51). As in other series, the various images are mutually explanatory, but they do not provide a seamless or even a narrative sequence in the sense of reportage. On the one hand, the events are so unfamiliar that the uninitiated can scarcely assimilate them, whereas on the other, there is a bold emphasis on the individual image and on capturing the respective moment, in which the action in the photograph comes to a standstill.

Stillness

The photographs detailing the production of the sculptures provide an insight into the few remaining heavy industrial production sites that remain inaccessible to most of us to this day. However, anyone who has ever visited a steel mill is more than likely to be left with a lasting impression of the sensory overload obtaining there: a nexus of gloom, heat, smoke, dirt, and infernal noise. Just as the workers, who go about their work unperturbed in this inferno, Reinartz uses his camera to organize the events that are otherwise difficult for outsiders to assimilate. From the almost overwhelming density of impressions, he creates images of haunting quietude, energy, and power.

While in the steel mill and processing plants it is possible to capture a multitude of complex interlocking, sometimes simultaneous and mostly rapidly-moving processes, Reinartz encounters a degree of stasis in the installed sculptures, which, paradoxically, stimulate movement through the selection of ever new viewing angles and analytical reflection on what is to be experienced, both visually and physically. By choosing certain locations, emphasizing certain lines of sight and framing certain views, Reinartz captures moments of dwelling, in which knowledge of the other viewpoints also resonates. As an active observer, he repeatedly adopts a position regarding the respective sculpture and its given surroundings. Each photograph attests to a certain angle or viewpoint, each photograph is a decisive and subtle interpretation of what is beheld.

When compared to other works, it demonstrates the extent to which Reinartz engages with respective sculptures and their locations. For example, he accentuates the compact density of the forged cylinder *One* in the Kröller Müller Museum Park, he highlights the almost choreographed dialogue with which the curved plates of *Berlin Junction* respond to the extravagant architecture of the Berlin Philharmonic, and, in the case of the sculpture *Street Levels* in Kassel's shopping precinct at the 1987 *documenta,* he laconically underlines and expands its rigid bulk. Via his photographs of *Bramme für das Ruhrgebiet* (Bramme for the Ruhr District), he captures the barren lunar landscape of a former slag heap, as well as the emblematic quality of the mighty steel slab against the backdrop of the Ruhr region, while the sequence of images from *Elevations for l'Allée de La Mormaire* seem to invite the viewer to walk placidly through the extensive sculptural installation situated in a clearing on the edge of the forest. Finally, the photographs of the sculpture *The Drowned and the Saved* bear witness to an existential predicament in which two forged angles, which otherwise would have been doomed to collapse, mutually support one another.

The experience of Serra's sculptures is characterized by the fact that we cannot form a conclusive, binding, or fixed image of them. Rather, they require us to look at them again and again, to re-evaluate constantly what we are actually looking at, what we perceive and our own, potentially mutable, take on it. Indeed, the very medium of Dirk Reinartz's photographs also requires an extraordinarily patient, attentive way of looking, in the course of which a wealth of details and nuances come to the fore. Thus, the compact, almost modest format in which Reinartz—who is unimpressed by photographic fashions and trends towards the large format—usually prints his photographs, requires careful, considered, close-up scrutiny.[2] Particularly in view of the often considerably expansive dimensions of Serra's sculptures, but also with regard to the imposing scenarios in the steel mills, the wealth of information that Reinartz condenses into a small area with customary, masterful clarity, is nothing short of astonishing. To a certain extent, his photographs are persuasive due to their interior dimensions. However, it is primarily the innumerable shades of gray, sensitively differentiated despite their tendency towards tenebrity, that lend each image a vibrant charm and enormous ambiguity. It is by no means an exaggeration to call Dirk Reinartz a master of grayscale photography. Or, in his own words: "The very best light is but its obverse—shadow."[3]

Weight

Following Dirk Reinartz's death in 2004, Serra continued to commission various photographers to document his sculptures, but without an intensive collaboration comparable to the one he had enjoyed with Reinartz. What Reinartz and Serra have in common in their work is possibly a deeply internalized seriousness that they each live in their own way, a day-by-day attempt to come to terms with what is difficult and what one finds challenging. In a key text, Serra notes: "The constructive process, the daily concentration and effort appeal to me more than the light fantastic, more than the quest for the ethereal. Everything we choose in life for its lightness soon reveals its unbearable weight."[4]

If we examine the themes that Reinartz selected for his personally-chosen series and projects in conjunction with the commissioned works, his work also reveals a clear turn towards the uncomfortable, the things often repressed in everyday life, the weighty issues that require effort. For example, a group of works on the Bismarck memorials focused on the subject of German history and the approach to an engagement with remembrance and commemoration.[5] A critical, sometimes ironically-pointed view of the then current social situation shaped projects, such as *Kein schöner Land* or *Besonderes Kennzeichen: Deutsch*.[6] In 1988, Reinartz captured the decline of the steel industry in Duisburg-Rheinhausen and how its devastating effects afflicted an entire district and, ultimately, an entire region.[7] In the case of his best-known project, the cycle of works *totenstill*, which was particularly important to him personally, he photographed former German concentration camps from 1987 up until 1993.[8] At a time when historians in Germany were famously disputing the uniqueness of the Holocaust and a number of them were calling for Nazi crimes to be relativized, Reinartz embarked on a highly personal search for evidence. In an attempt to address the issue of whether it is possible to make photographs that can even impart an inkling of the scale and horror of the industrial extermination of human beings, he set himself a colossally weighty, existential task.[9]

Reinartz placed the highest demands on himself, not only in his choice of subject matter, but also in the way he went about his photography.[10] It was not uncommon

2 Reinartz mostly used standard 24 × 30.5 cm formats for his prints, whereby the photographs themselves measure 16.5 × 25.5 cm.

3 Quoted from https://fcgundlach. de/de/biografie-dirk-reinartz, last accessed 28 November 2023. The foundation F. C. Gundlach in Hamburg, in conjunction with the Deutsche Fotothek in Dresden, is responsible for Dirk Reinartz's extensive archive.

4 Richard Serra, "Weight," in Serra, *Writings. Interviews* (London and Chicago: The University of Chicago Press, 1994), pp. 183–185.

5 Cf. Dirk Reinartz, *Bismarck. Vom Verrat der Denkmäler* (Göttingen: Steidl, 1991).

6 Dirk Reinartz, Wolfram Runkel, *Kein schöner Land* (Göttingen: Steidl, 1989); Reinartz, Runkel, *Besonderes Kennzeichen: Deutsch* (Göttingen: Steidl, 1997).

7 Dirk Reinartz and Wolfram Runkel, *Rheinhausen 1988* (Göttingen: Steidl, 2024) [publication pending].

8 A selection of 230 of the resulting photographs was published in book form: Dirk Reinartz and Christian Graf von Krockow, *deathly still. Pictures of Concentration Camps* (Zurich: Scalo Publishers, 1995). In 1995, a series of exhibitions commenced with a collection of 136 selected photographs, which have since been shown in numerous museums and exhibition institutions worldwide. Situation Kunst (for Max Imdahl), Bochum, holds a complete set of this exhibition collection.

9 In an unpublished manuscript, Reinartz formulated some of the questions that motivated him to work on the project *totenstill*, such as: "Is the contempt for humanity and intolerance expressed in the layout and architecture of the camps? Is it possible for photographs to encapsulate an idea of the industrial character of the extermination of human beings? Are squares and stones evidence?"

10 In his capacity at the Muthesius University in Kiel, Reinartz also taught his students a critically-reflective, meticulous and methodological way of working; cf. Christiane Gehner and Matthias Harder, eds, *Stille. Dirk Reinartz und Schüler* (Göttingen: Steidl, 2007).

for him to be dissatisfied with individual photographs and to venture forth again to photograph the same motif differently and better. He always developed and printed his photographs himself, in painstaking, patient, and methodical manual work in his own dark room, so that even on a long working day, he only produced a manageable number of prints.

A certain mistrust of their own work and the willingness to question it at all times are common denominators in the methodologies of Reinartz and Richard Serra. "Work comes out of work,"[11] Serra states, describing the ability to develop constantly new tasks and ways of working from the insistent reflection on the given project or activity. For Serra, this means, for example, that he receives inspiration for further works by engaging with industrial production processes, which is only possible in this degree of intensity when actually on site at a steel mill. In the development of such new works, it often happens that Serra pushes the boundaries of what is technically feasible with his ideas and demands, thus challenging engineers and workers to continually readdress their otherwise routine procedures.

If further work emerges from ongoing work, then, in this particular case, it also means that Richard Serra's sculptures impelled his friend and companion, Dirk Reinartz—who never wanted to call himself an artist—to make photographs that were equally artistically valid within the framework and conditions of their medium. Serra pertinently quotes Bertrand Russell on the possibility of finding an expression for experience: "Every language has a structure about which one can say nothing in that language. There must be another language, dealing with the structure of the first and processing a new structure about which one cannot say anything except in a third language—and so forth."[12]

If there is one photographer who has mastered another language that renders it possible to make statements about Serra's work, not only in a profound way but also in essence, then it is without doubt Dirk Reinartz.

Translated from German by Timothy Connell

11 Richard Serra, "The Yale Lecture, January 1990," in *Kunst & Museumsjournaal* (Amsterdam), vol. 1, no. 6 (1990), pp. 23–33, here p. 23.

12 Serra is quoting Bertrand Russell's theory here; cf. Serra, "The Yale Lecture," p. 25.

Postindustrie und Alchemie

Richard Serras Produktion im Stahlwerk

Kathrin Rottmann

Seit den 1970er Jahren lässt Richard Serra wie viele andere Künstler:innen auch Fabriken für sich produzieren.[1] Seinen Skulpturen liegt seither eine industrielle arbeitsteilige Produktionsweise zugrunde, die untrennbar mit dem Werk und dessen Konzeption verbunden ist, weil die Skulpturen die Spuren ihrer Fertigung tragen und weil zahlreiche Fotografien und Filme sie in Ausstellungen und Ausstellungskatalogen sichtbar machen. Denn anstatt die Produktionsweise als künstlerisches Schaffen oder Kreation zu verklären, verfolgt Serra, so heißt es, mit der Dokumentation der Herstellung eine „Entmystifizierungsagenda"[2]. Sein gemeinsam mit Clara Weyergraf in Hattingen im Ruhrgebiet produzierter Film *Steelmill/Stahlwerk* (1979), mehrere Künstlerdokumentationen, die ihm in die Fabriken folgen, und Fotografien wie die von Dirk Reinartz zeigen, wo Serra seine Skulpturen fertigen lässt. Er beauftragt weder traditionelle Gießereien noch, wie einige Künstlerkolleg:innen, Unternehmen wie beispielsweise Lippincott, Inc., die sich seit den 1960er Jahren eigens auf die Herstellung von Skulpturen spezialisiert haben. Stattdessen favorisiert er Stahlwerke – die zu diesem Zeitpunkt bereits als alt geltende Industrie, die die Fertigkeiten, die Maschinen und die nötigen Ausmaße hat, um die Stahlteile seiner Skulpturen herzustellen.

Serras industrielle Produktionsweise hängt selbstverständlich von praktischen Belangen und technischen Möglichkeiten ab. Sie wurde aber, so die These, auch genutzt, um den Stellenwert der künstlerischen Produktion in der industriellen Gesellschaft auszuhandeln. Die industrielle Produktionsweise ist stets in gesellschaftlichen, politischen und ökonomischen Produktionsverhältnissen situiert, was in Kunstwerken reflektiert und zumindest in materialistischen Kunstgeschichten analysiert wird. Sie ist sozio- und geschlechterpolitisch kodiert und eröffnet der

Kunstkritik und Kunstgeschichte aufgrund ihrer historischen Verfasstheit Semantisierungsmöglichkeiten, die die Lesarten der Kunstwerke bestimmen.[3] Während die industrielle Produktion aufgrund ihrer entfremdeten, maschinellen und massenhaften Arbeit lange als Gegenstück der künstlerischen Produktion betrachtet wurde, stellte sie im 20. Jahrhundert in Aussicht, die tradierte bürgerliche Vorstellung von Kunst überwinden zu können, beispielsweise zu einer „klassenlosen Form", wie die Kunstkritikerin und Kunsttheoretikerin Lu Märten formulierte, die die Kunst Mitte der 1920er Jahre auf Arbeit zurückführte.[4]

Die avantgardistische Hoffnung einer solchen „Transformation von künstlerischer und gesellschaftlicher Produktion" durch Arbeit bestimmt auch Serras „Gang in die Produktion".[5] „Im wahrsten Sinne des Wortes wird hier Gemeinschaftsarbeit geleistet,"[6] hieß es 1952 in einem Lehrbuch für industrielle Schmiede über die arbeitsteilige Produktion, die auch Serra betont: „Meine frühe Entscheidung, ortsbezogene Arbeiten aus Stahl zu bauen, befreite mich aus dem traditionellen Künstleratelier. Letzteres wurde weitgehend ersetzt durch Urbanismus und Industrie. Stahlwerke, Werften und Fertigungsanlagen wurden zu meinen Ateliers. Meine Arbeit lässt sich nur in Zusammenarbeit mit Stadtplanern, Ingenieuren, Transportarbeitern, Schwerarbeitern und Monteuren realisieren."[7] Entsprechend werden seine Skulpturen charakterisiert als „materialistische Kritik"[8] an tradierten Künstler- und Werkvorstellungen des im Atelier schaffenden Genies und als „Widerstandsbekundung" gegenüber einer Kunst, die auch durch ihre ausgelagerte Fabrikation den kapitalistischen Produktionsbedingungen unterworfen worden sei.[9] „Die künstlerische Praxis wird in diesem Prozess auf den Stand der wirtschaftlichen Produktion gebracht und damit ihres elitären Status enthoben,"[10] heißt es – was zugleich an marxistische Fortschrittsvorstellungen erinnert, die die soziale und künstlerische Weiterentwicklung an die mitunter revolutionären Wirkungen der „materiellen Produktivkräfte der Gesellschaft" knüpfen.[11] Aber das Versprechen technischer Innovation und dadurch bewerkstelligter sozialer Utopien haftet Serras Skulpturen nicht an, obwohl seine industrielle Fertigung die technischen Möglichkeiten der Stahlwerke auf verschiedene Weise ausreizt. Vielmehr mutet seine industrielle Produktionsweise wie eine Ur-Industrie an, charakterisiert durch körperliche Arbeit, nicht durch Automatisierung, durch Arbeitshierarchien anstelle von Kollektivität, durch Maschinen und Maloche – und durch deren traditionell männliche Kodierung, die auch für Serras eigenes Arbeiten charakteristisch erscheint.[12] Dieser Eindruck entsteht vor allem wegen des Zeitpunkts. Denn Serra suchte die Industrie nicht im Boom auf, im Zuge dessen die Stahlproduktion für die Aufrüstung im Kalten Krieg vervielfacht worden war, sondern danach. Er ging während der Stahlkrise in die Produktion, als aufgrund des Strukturwandels und der Deindustrialisierung in den USA und den meisten westeuropäischen Ländern die Zahl der industriellen Arbeitsplätze zu schrumpfen begann, als die Stahlproduktion massiv reduziert wurde, Arbeiter:innen vehement streikten und um ihre Arbeitsplätze kämpften. Er beauftragte die Stahlwerke genau zu der Zeit, als im globalen Norden die ersten Hütten geschlossen und die Industrie in die sogenannte Industriekultur überführt wurden.[13] Serra kommentierte diesen Umstand nicht, aber er charakterisierte die schwerindustrielle Produktion als etwas Ungreifbares, das jenseits von Technologie, *research and development* angesiedelt ist – nicht in der Ökonomie, sondern in der Imagination. Er rief Vorstellungen der Industrialisierung des 19. Jahrhunderts auf, als Fabriken vielleicht wirklich noch Zukunftsversprechen waren, als Künstler wie Adolph Menzel heroische Schmiede malten und Maximilien Luce ermüdete Arbeiter, aber trotzdem von der Schönheit der Stahlschmelze hingerissen war. „Steel mills in and of

themselves are just marvelous phantasies. They are just bakeries that have gone into alchemy. They have magic and light and phantasy and history and weight and glow and a kind of industrial magic that is part of the industrial revolution that we'll probably never see again."[14] So schwärmte Serra 1995 in einem Interview über die Attraktion dieser vergangenen Prozesse.

Mittlerweile, knapp fünfzig Jahre nachdem Soziolog:innen das postindustrielle Zeitalter ausriefen, scheinen die Stahlwerke ferner denn je.[15] Die Henrichshütte in Hattingen, wo Serra Ende der 1970er Jahre seine Skulptur *Berlin Block (for Charlie Chaplin)* schmieden ließ, ist längst in ein Museum verwandelt; der Hochofen wurde ausgeblasen, die Schmiedepresse demontiert, verkauft und das Stahlwerk abgerissen. Deshalb verlegt Serra, der sich als „aktiver Produzent", nicht als Archäologe oder Historiker versteht, seine Produktion seither in die letzten verbliebenen Hütten, die seine Skulpturen noch herstellen können.[16] Als Produzent vermeidet er dort das Readymade und die Entfremdung der delegierten Fertigung, indem er aktiv in die Produktionsweise eingreift, indem er beispielsweise deren Spuren programmatisch auf seinen Skulpturen sichtbar machen lässt. Denn die Arbeiter, so erinnert sich die Belegschaft der Henrichshütte, durften den Stahl für Serras Skulpturen auf keinen Fall glatt schmieden. Sie sollten ihn gerade nicht nachbearbeiten, wie es sonst von ihnen verlangt wurde. Stattdessen mussten sie ihn, wenn seine Oberfläche zu glatt geworden war, nochmals mit der 8000-Tonnen-Schmiedepresse bearbeiten, so dass deren Abdrücke sich dem Material einprägen konnten.[17] Der Stahl war dadurch explizit nicht als Ware markiert, wie sie üblicherweise das Werk verlässt. Die Fertigung von Serras Stahlkubus lief jenseits der sonst in der Schmiede etablierten Stahlverarbeitung, auch wenn Serra seine Produktionsweise als unmittelbaren Teil der industriellen Produktion begreift.

„Der Marxist [Fritz] Sternberg, in dessen Wertschätzung Sie wohl mit mir übereinstimmen, führt aus, daß aus der (gewissenhaften) *Fotografie* einer Fordschen Fabrik keinerlei Ansicht über diese Fabrik gewonnen werden kann," notierte sich 1930 der Dramatiker Bertolt Brecht über die in der Regel im Auftrag der Unternehmen angefertigten Industriefotografien und erklärte in seiner Kritik einer kapitalistisch verfassten Kulturindustrie daran anknüpfend: „Die Lage wird dadurch so kompliziert, daß weniger denn je eine einfache ‚Wiedergabe der Realität' etwas über die Realität aussagt. Eine Photographie der Kruppwerke oder der AEG ergibt beinahe nichts über diese Institute. Die eigentliche Realität ist in die Funktionale gerutscht. Die Verdinglichung der menschlichen Beziehungen, also etwa die Fabrik, gibt die letzteren nicht mehr heraus. Es ist also tatsächlich ‚etwas aufzubauen', etwas ‚Künstliches', ‚Gestelltes'."[18] Anders als Hilla und Bernd Becher, die die verschwindende Industrie aufsuchten, folgte Dirk Reinartz Serra in die Fabriken. Seine Fotografien zeigen anstelle der Deindustrialisierung oder der Produktion der Stahlwerke Reinartz' spezifische Sicht auf Serras Produktion. Die Fotografien suggerieren mit Totalen und Nahaufnahmen nahezu sämtlicher Produktionsschritte einen Einblick und Überblick über die künstlerisch-industriellen Produktionsprozesse, aber sie konstruieren zugleich das, was Serra als Attraktion der Schwerindustrie schätzt. Sie verleihen seinem maschinellen Schmieden in der Post-Industrie die verloren gegangene „industrielle Magie" und „Alchemie".[19] Denn während der Stahl im 19. Jahrhundert häufig weiß gestrichen wurde, um ihn in Industriefotografien als glühend zu präsentieren, ist die für den Schmiedeprozess charakteristische sogenannte „weißglühend[e]" Farbe in Reinartz' Bildern fotografisch umgesetzt.[20] Die unzähligen Grauabstufungen auf den von Hand abgezogenen Fotografien visualisieren

die unzugänglichen molekularen Prozesse, die das Material während des Schmiedens transformieren. Zugleich muten die Bilder, in denen die Stahlblöcke die einzigen Lichtquellen sind, wie surrealistische Solarisationen an. Sie mystifizieren den technischen Prozess, die Materialtransformationen, das Pathos der Schwerarbeit und die schiere Monumentalität der Produktionsweise. Wer die Fotografien gesehen hat, kann dieses „industrielle Sublime" beim Betrachten der Skulpturen kaum mehr ausblenden.[21] Serras Skulpturen und Reinartz' Fotografien schaffen beides: Sie verweisen auf eine für das Ruhrgebiet spezifische Produktionsweise, die die Region bis heute maßgeblich prägt, und überführen diese längst vergangene Fertigung in manchmal kritisch, manchmal romantisierend anmutende Imaginationen der Schwerindustrie.

1 Vgl. Caroline A. Jones, *Machine in the Studio. Constructing the Postwar American Artist*, Chicago und London 1996; Glenn Adamson und Julia Bryan-Wilson, *Art in the Making. Artists and Their Materials from the Studio to Crowdsourcing*, London 2016, S. 157–174.

2 Stefan Germer, La Mormaire. Elevation, in: *Richard Serra and Dirk Reinartz. La Mormaire*, Hrsg. Alexander von Berswordt-Wallrabe, Düsseldorf 1997, S. 5–23, S. 16 (meine Übersetzung).

3 Die Analyse dieser Produktionsweisen ist Gegenstand meines DFG-geförderten Forschungsprojekts am Kunstgeschichtlichen Institut der Ruhr-Universität Bochum *Industrielle Produktionsweisen in der Kunst des globalen Nordens im 20. und 21. Jahrhundert. Studien in Kunst und Fabriken*, https://gepris.dfg.de/gepris/projekt/508930320.

4 Lu Märten, Kunst und Proletariat, in: *Die Aktion*, 15: 12, 1925, Sp. 663–668, Sp. 666.

5 Dietmar Rübel, Fabriken als Erkenntnisorte. Richard Serra und der Gang in die Produktion, in: *Topos Atelier. Werkstatt und Wissensform*, Hrsg. Michael Diers und Monika Wagner, Berlin 2010, S. 111–135, S. 114.

6 Adolf Schwartz, *Was der Mann aus der Schmiede von seiner Arbeit wissen muß!*, Düsseldorf 1952, S. 12.

7 Richard Serra, Erweiterte Notizen von Sight Point Road, in: *Richard Serra. Neuere Skulpturen in Europa 1977–1985*, Ausst.-Kat., Galerie m Bochum 1985, S. 5–10, S. 6.

8 Douglas Crimp, Serra's Public Sculpture. Redefining Site Specificity, in: Rosalind Krauss, *Richard Serra/Sculpture*, Ausst.-Kat., The Museum of Modern Art, New York, 1986, S. 41–56, S. 44 (meine Übersetzung).

9 Benjamin H. D. Buchloh, Richard Serra's Early Work. Sculpture between Labor and Spectacle, in: Kynaston McShine und Lynne Cooke, *Richard Serra. Sculpture: Forty Years*, Ausst.-Kat., The Museum of Modern Art, New York, 2007, S. 43–58, S. 47 (meine Übersetzung).

10 Germer 1997, S. 14 (meine Übersetzung).

11 Karl Marx, *Zur Kritik der Politischen Ökonomie* (1859), in: Karl Marx und Friedrich Engels, *Werke*, Bd. 13, 7. Auflage, Berlin 1971, S. 3–160, S. 9.

12 Vgl. Judy Wajcman, *Feminism Confronts Technology* (1991), Oxford 2000; Christopher Bedford, „Labor Fetishism" and Its Discontents in the Sculpture of Richard Serra and Robert Smithson, in: *Sculpture Journal*, 13: 1, 2005, S. 72–88.

13 Vgl. Lutz Raphael, *Beyond Coal and Steel. A Social History of Western Europe after the Boom. Frankfurt Adorno Lectures 2018*, transl. by Kate Tranter, Cambridge und Hoboken 2023.

14 Inge Classen, *Richard Serra: Bildhauer – Filme*, D: ZDF/3Sat 1995, 13 Min.

15 Vgl. Daniel Bell, *The Coming of Post-Industrial Society. A Venture in Social Forecasting*, New York 1973.

16 Serra (1985) 1994, S. 168 (meine Übersetzung).

17 Vgl. LWL-Museen für Industriekultur, Erinnerungsarchiv 3270.45/0138. Interview mit Günter W., 09.02.1998, Z. 468 ff.

18 Bertolt Brecht, [Durch Fotografie keine Einsicht] (um 1930), in: Ders., *Werke. Große kommentierte Berliner und Frankfurter Ausgabe*, Hrsg. Werner Hecht, Jan Knopf, Werner Mittenzwei und Klaus Detlef Müller, Bd. 21, Berlin, Weimar und Frankfurt 1992, S. 443–444, S. 443 f.; Ders., Der Dreigroschenprozess. Ein soziologisches Experiment (1930), in: Ebd., S. 448–514, S. 469. Vgl. Steffen Siegel, Keinerlei Ansicht? Industriefotografie und Kulturindustrie bei Bertold Brecht, in: *kritische berichte*, 46: 4, 2018, S. 5–14.

19 Serra 1995 (meine Übersetzung).

20 Vgl. Ulrich Wengenroth, Die Fotografie als Quelle der Arbeits- und Technikgeschichte, in: *Bilder von Krupp. Fotografie und Geschichte im Industriezeitalter*, Hrsg. Klaus Tenfelde, München 1994, S. 89–104, S. 96; Schwartz 1952, S. 87.

21 David E. Nye, *American Technological Sublime*, Cambridge und London 1994, S. 126 (meine Übersetzung).

Post-industry and Alchemy

Richard Serra's Production in the Steel Mill

Kathrin Rottmann

Since the 1970s, Richard Serra, in a similar way to many other artists, also commissioned factories to produce his artworks.[1] Since then, his sculptures have been based on an industrial mode of production—itself predicated upon the division of labor—and one that is inextricably linked to his works in steel and their conception, inasmuch as the sculptures themselves bear the traces of their production and because numerous photographs and films render these processes visible in exhibitions and exhibition catalogues. For instead of glorifying production methods as artistic creation, Serra is accredited with the pursuit of a "demystificatory agenda"[2] by documenting the production process. His film *Steelmill/Stahlwerk* (1979), produced in conjunction with Clara Weyergraf in the Ruhr town of Hattingen, as well as several artist documentaries that follow him into the factories, not to mention numerous photographs, for example, those made by Dirk Reinartz, all depict the sites to which Serra delegated the manufacture of his sculptures. He did not employ traditional foundries, nor did he, like some of his fellow artists, engage go-to companies, such as Lippincott, Inc., that had specialized in the production of sculptures since the 1960s. Instead, he favored steel mills—part of an industry that was already considered on its way out at the time, yet still had the workforce, the skills, the machinery, and the necessary capacity to produce the steel components for his sculptures.

Serra's industrial production method self-evidently depends on practical concerns and respective technical capability. However, it was also used to negotiate the status of artistic production in industrial society. The industrial mode of production is invariably situated in social, political, and economic relations of production, which, in turn, is reflected in artworks and—at least—analyzed in materialist art histories.

The eminently socio- and gender-politically coded character of the industrial mode, due to its historical provenance, opens up semantic scope for art criticism and art history that determines interpretation of the artworks.[3] Whereas industrial production—due to its alienated, mechanical essence predicated upon mass labor—had been perennially regarded as the antithesis of artistic production, it harbored the prospect in the twentieth century of being able to supersede the established, bourgeois idea of art; for example, to arrive at a "classless form," as the art critic and theorist Lu Märten put it, who, in the mid-1920s, traced art back to labor.[4]

The avant-garde aspiration of such a "transformation of artistic and social production" via manual and industrial labor also defines Serra's "Gang in die Produktion" (move into production).[5] "In the truest sense of the concept, collaborative work is conducted here,"[6] as a textbook for industrial blacksmiths from 1952 described joint production despite the division of labor, which Serra also considered important: "My decision, early on, to build site-specific works in steel took me out of the traditional studio. The studio has been replaced by urbanism and industry. Steel mills, shipyards, and fabrication plants have become my on the road extended studios. My work can only be built in cooperation with city planners, engineers, transporters, laborers, riggers."[7] Accordingly, his sculptures are characterized as a "materialist critique"[8] of traditional notions of the artist and the fabled 'genius' making art in the studio, as well as a "declaration of resistance" to forms of art that have also been seconded by capitalist conditions and modes of production via their outsourced manufacture.[9] Furthermore, "artistic practice is brought up to the standards of economic production in this process and thereby deprived of its elitist status,"[10] which is also reminiscent of Marxist ideas of progress that entwine social and artistic development with the betimes revolutionary effects of the "material productive forces of society".[11] However, the promise of technical innovation and the social utopias it generates is not inherent in Serra's sculptures, although his industrial production teases out the technical possibilities of the steel mill in various ways. Instead, his industrial mode of production seems like a primal industrial furnace, characterized by physical labor rather than automation, by hierarchies within the work force instead of the collective, by machines and hard slog not least by their traditional male coding, which also seems characteristic of Serra's own work.[12] This impression arises primarily because of the timing. Serra did not engage with the industry in its boom years, during which steel production was ramped up in the Cold War for rearmament purposes, but afterwards. He entered the world of production during the steel crisis, when the plethora of industrial jobs began to dwindle significantly due to structural change and deindustrialization—in the USA and most Western European countries; a time when steel production was massively reduced, when workers went on strike *en masse* and passionately fought for their jobs. He commissioned the steel mills at precisely the time when the first furnaces were closing in the global North and the industry was being transferred to so-called 'industrial culture'.[13] Serra did not comment on this fact, but he characterized heavy industrial production as something intangible that is located beyond technology, research and development—not in the economy, but in the imagination. He invoked notions of nineteenth-century industrialization, when factories were perhaps the actual, abiding promise of the future, a time when artists—such as Adolph Menzel, painted heroic furnaces, or Maximilien Luce depicted fatigued workers—were steadfastly enraptured by the perceived beauty of steel smelting. "Steel mills in and of themselves are just marvelous phantasies. They are just bakeries that have gone into alchemy. They have magic and light and phantasy and history and weight and glow

and a kind of industrial magic that is part of the industrial revolution that we'll probably never see again."[14] This is how Serra waxed lyrical about the attraction of these archaic processes in an interview in 1995.

Now, almost fifty years after sociologists proclaimed the arrival of the post-industrial age, steel mills seem even more remote than ever.[15] The Henrichshütte in Hattingen, where Serra commissioned the forging of his sculpture *Berlin Block (for Charlie Chaplin)* at the end of the 1970s, has long since been transformed into a museum; the blast furnace has been extinguished, the forging press dismantled and auctioned off, and the steel mill decommissioned. This is why Serra, who sees himself as an 'active producer' rather than an archaeologist or historian, has since moved his production to the last remaining furnaces that still have capacity to produce his sculptures.[16] As a producer, he eschews the readymade and the patent alienation of delegated production by actively entering into the mode of production, for example, by programmatically allowing its traces to remain visible on his sculptures. As the workers at the Henrichshütte recall, they were not permitted under any circumstances to forge a smooth steel block for Serra's sculpture. They were not supposed to temper and rework it, as they would otherwise have been required to do. Instead, if the surface had become too smooth, they had to process it again with the 8,000-tonne forging press, so that its profile could be imprinted on the steel.[17] This meant that the steel was explicitly not designated the kind of product that would normally meet the factory's standards. The production of Serra's steel cube went beyond the steel processing otherwise practiced at the furnace, even if Serra regards his production method as an integral part of industrial production.

"The Marxist [Fritz] Sternberg, for whom you surely share my admiration, explains that from the (carefully taken) photograph of a Ford factory no opinion about this factory can be deduced," noted the playwright Bertolt Brecht in 1930 about the industrial photographs that were usually taken on behalf of corporations, and, in his critique of a cultural industry constituted along capitalist lines, he elaborated: "The situation has become so complicated because the simple 'reproduction of reality' says less than ever about that reality. A photograph of the Krupp works or the AEG reveals almost nothing about these institutions. Reality as such has slipped into the domain of the functional. The reification of human relationships, the factory, for example, no longer discloses those relations. So there is indeed, 'something to construct,' something 'artificial,' 'invented'."[18] Unlike Hilla and Bernd Becher, whose seminal photographic taxonomy documented an industry in the throes of its disappearance, Dirk Reinartz followed Serra into the factories. Reinartz's photographs illustrate his specific view of Serra's mode of production rather than deindustrialization or production processes in the steel mills *per se*. Comprising a series of wide shots and close-ups of almost the entire stages of production, the photographs suggest an insight and overview of the artistic/industrial production processes, but at the same time, they construct and compile what Serra values as the allure of heavy industry. They lend his machine-based forging in the post-industrial world a sense of erstwhile "industrial magic" and "alchemy".[19] Whereas steel was often painted white in industrial photographs in the nineteenth century to accentuate its glowing appearance, Reinartz captures the so-called "incandescence" characteristic of the forging process photographically.[20] The countless shades of gray in the hand-printed photographs visualize the inaccessible molecular processes that transform the material during the forging process. At the same time, the images, in which the steel blocks are the sole source of light, resemble surreal solarizations.

They mystify the technical process, the material transformations, the pathos of the hard work, and the sheer monumentality of the production method. Scarcely anyone who has seen the photographs could ignore this moment of the "industrial sublime" when looking at the sculptures.[21] Serra's sculptures and Reinartz's photographs achieve both: they refer to a mode of production specific to the Ruhr, which continues to shape the region to this day, and translate this bygone mode of production into betimes critical, betimes seemingly romanticizing visualizations of heavy industry.

Translated from German by Timothy Connell

1 Cf. Caroline A. Jones, *Machine in the Studio. Constructing the Postwar American Artist* (Chicago and London: University of Chicago Press, 1996); Glenn Adamson and Julia Bryan-Wilson, *Art in the Making. Artists and Their Materials from the Studio to Crowdsourcing* (London: Thames & Hudson, 2016), pp. 157–174.

2 Stefan Germer, "La Mormaire. Elevation," Alexander von Berswordt-Wallrabe, ed., *Richard Serra and Dirk Reinartz. La Mormaire*, (Düsseldorf: Richter), 1997, pp. 5–23, p. 16.

3 The analysis of these production methods is the subject of my DFG-funded research project at the Institute of Art History, Ruhr-Universität Bochum: *Modes of Production in the Arts of the Global North in the 20th and 21st Centuries. Studies in Art and Factories.* https://gepris.dfg.de/gepris/projekt/508930320. Last accessed 7 December 2023.

4 Lu Märten, "Art and Proletariat" (1925), *October*, 178, 2021, pp. 20–26, 23 (trans. Timothy Grundy).

5 Dietmar Rübel, "Fabriken als Erkenntnisorte. Richard Serra und der Gang in die Produktion," Michael Diers and Monika Wagner, eds, *Topos Atelier. Werkstatt und Wissensform* (Berlin: Akademie Verlag, 2010), pp. 111–135, p. 114.

6 Adolf Schwartz, *Was der Mann aus der Schmiede von seiner Arbeit wissen muß!* (Düsseldorf: Stahleisen, 1952), p. 12.

7 Richard Serra, "Extended Notes from Sight Point Road" (1985), Serra, *Writings, Interviews* (Chicago: University of Chicago Press, 1994), pp. 167–173, p. 168.

8 Douglas Crimp, "Serra's Public Sculpture. Redefining Site Specificity," Rosalind Krauss, *Richard Serra/Sculpture*, exh. cat., The Museum of Modern Art (New York: MOMA, 1986), pp. 41–56, p. 44.

9 Benjamin H. D. Buchloh, "Richard Serra's Early Work. Sculpture between Labor and Spectacle," Kynaston McShine and Lynne Cooke (eds), *Richard Serra. Sculpture: Forty Years*, exh. cat., The Museum of Modern Art (New York: MOMA, 2007), pp. 43–58, p. 47.

10 Germer 1997, p. 14. See note 2.

11 Karl Marx, *A Contribution to the Critique of Political Economy* (Moscow, 1977), p. 21.

12 Cf. Judy Wajcman, *Feminism Confronts Technology* (Cambridge: Polity Press, 1991); Christopher Bedford, "'Labor Fetishism' and Its Discontents in the Sculpture of Richard Serra and Robert Smithson," *Sculpture Journal*, 13: 1 (2005), 72–88.

13 Cf. Lutz Raphael, *Beyond Coal and Steel. A Social History of Western Europe after the Boom. Frankfurt Adorno Lectures 2018,* trans. Kate Tranter (Cambridge and Hoboken, NJ: Polity Press, 2023).

14 Inge Classen, *Richard Serra: Bildhauer – Filme*, D: ZDF/3Sat (1995), 13 Min.

15 Cf. Daniel Bell, *The Coming of Post-Industrial Society. A Venture in Social Forecasting* (New York: Basic Books, 1973).

16 Serra (1985) 1994, p. 168. See note 7.

17 Cf. LWL-Museen für Industriekultur, Erinnerungsarchiv 3270.45/0138. Interview with Günter W., 9 February 1998, Z. 468 ff.

18 Bertholt Brecht, "No Insight through Photography" (1930), Marc Silberman, ed. and trans., *Brecht on Film and Radio* (London: Bloomsbury, 2000), p. 144; "Bertholt Brecht: The Threepenny Lawsuit" (1930), ibid., pp. 147–199, p. 164 f.

19 Serra, 1995. See note 7.

20 Cf. Ulrich Wengenroth, "Die Fotografie als Quelle der Arbeits- und Technikgeschichte," Klaus Tenfelde, ed., *Bilder von Krupp. Fotografie und Geschichte im Industriezeitalter* (Munich: C.H. Beck, 1994), pp. 89–104, p. 96; Schwartz 1952, p. 87. See note 6.

21 David E. Nye, *American Technological Sublime* (Cambridge, MA and London: MIT Press, 1994), p. 126.

Produktion der Skulptur
Lemgo Vectors

Production of Richard
Serra's sculpture
Lemgo Vectors

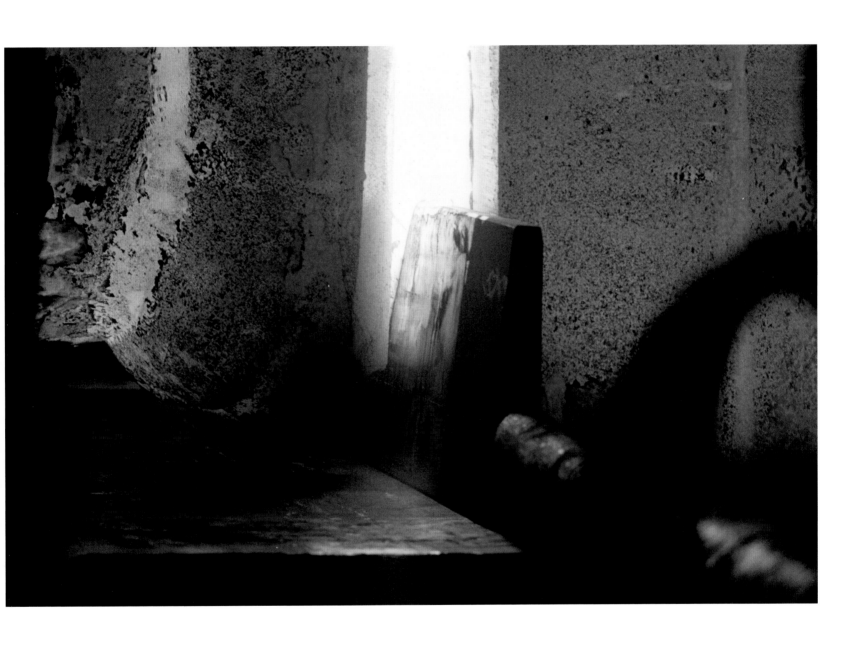

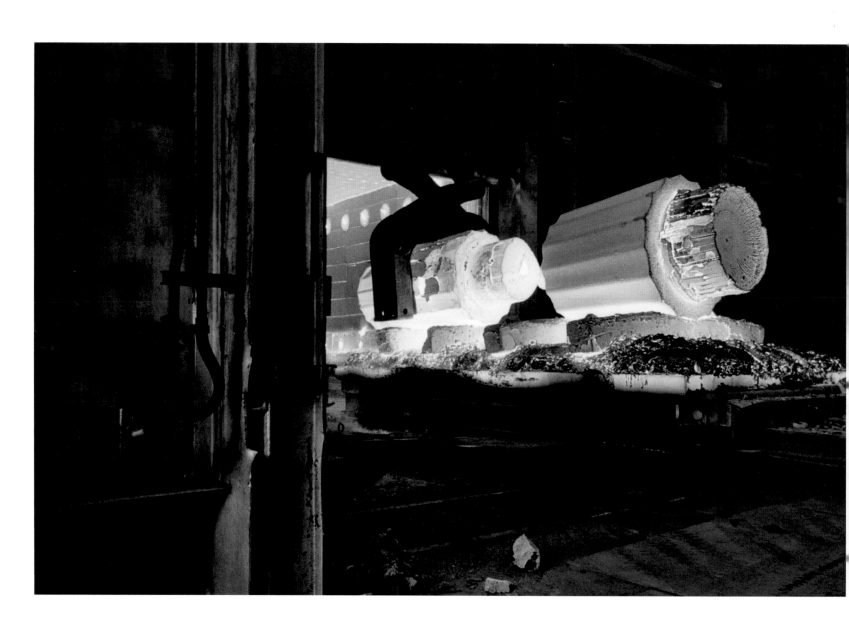

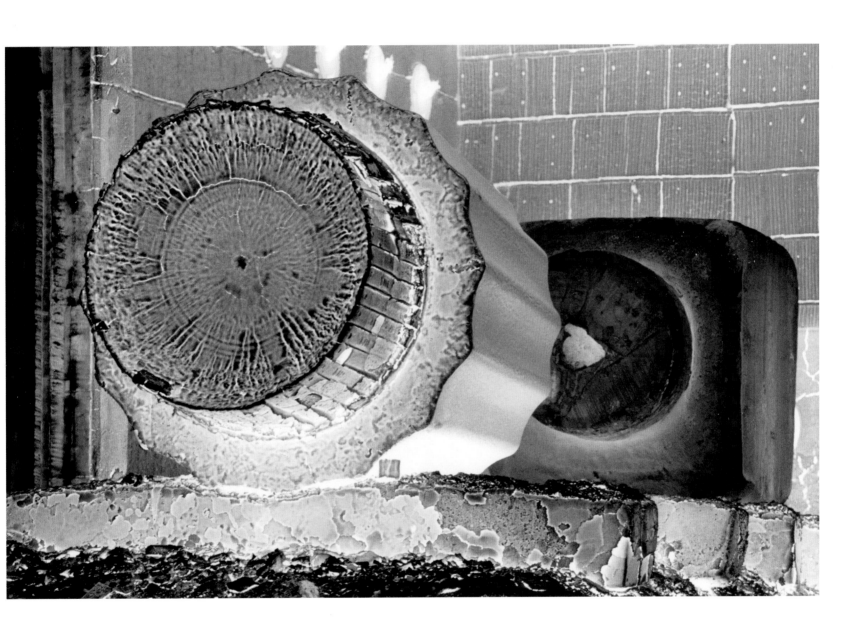

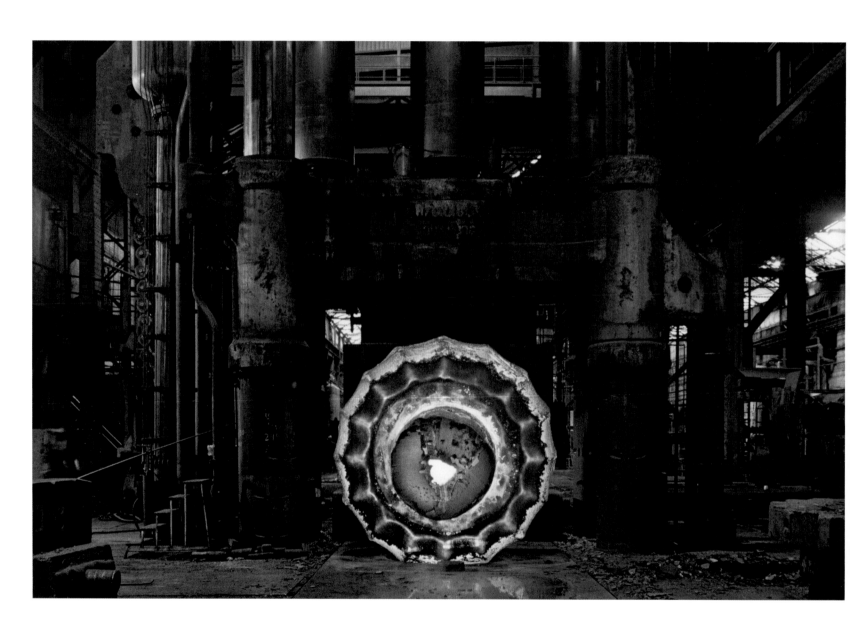

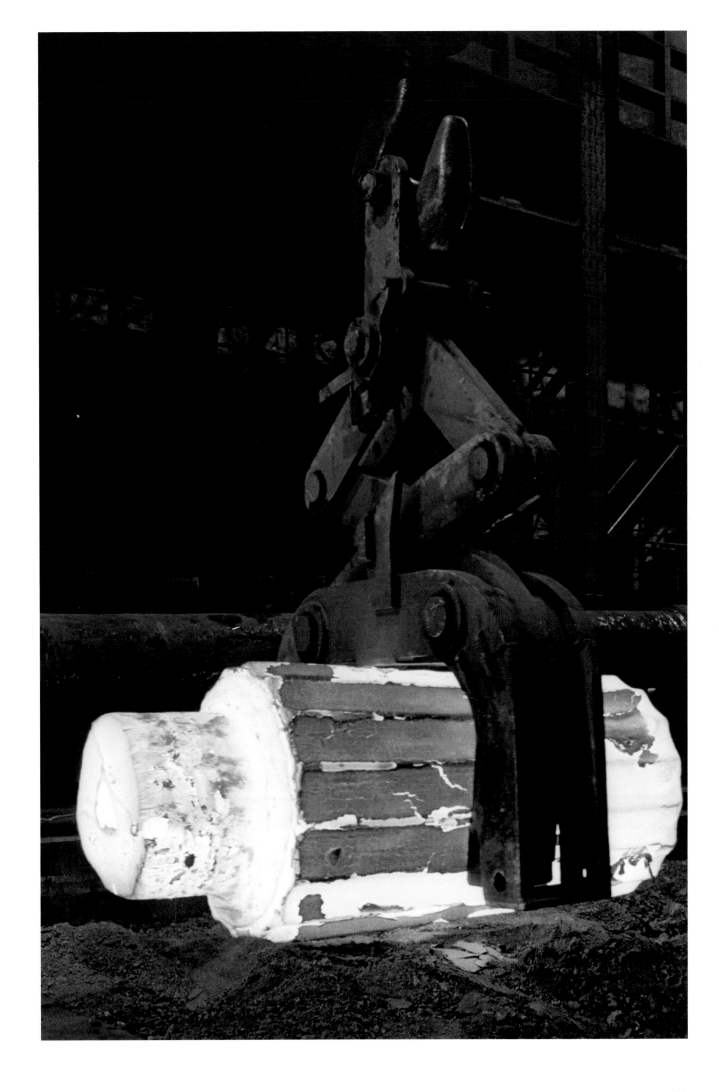

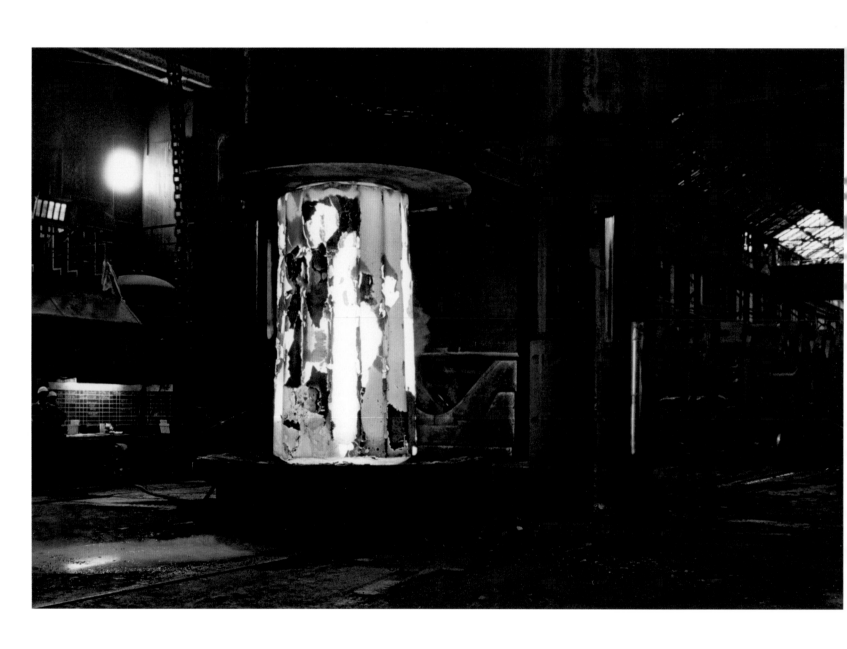

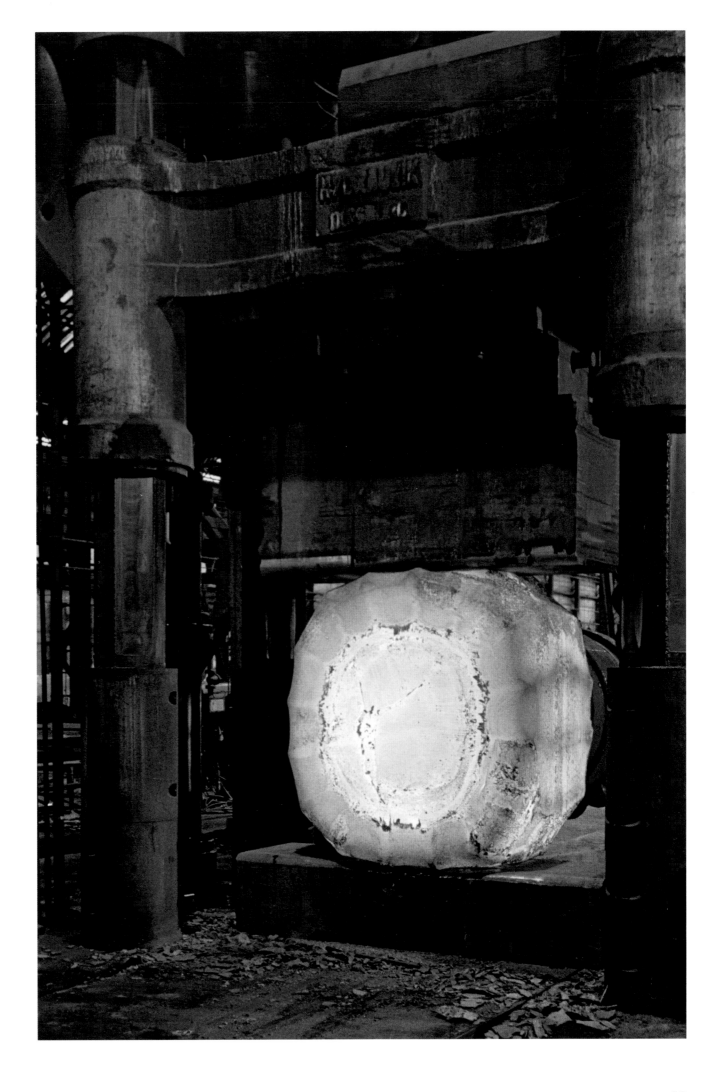

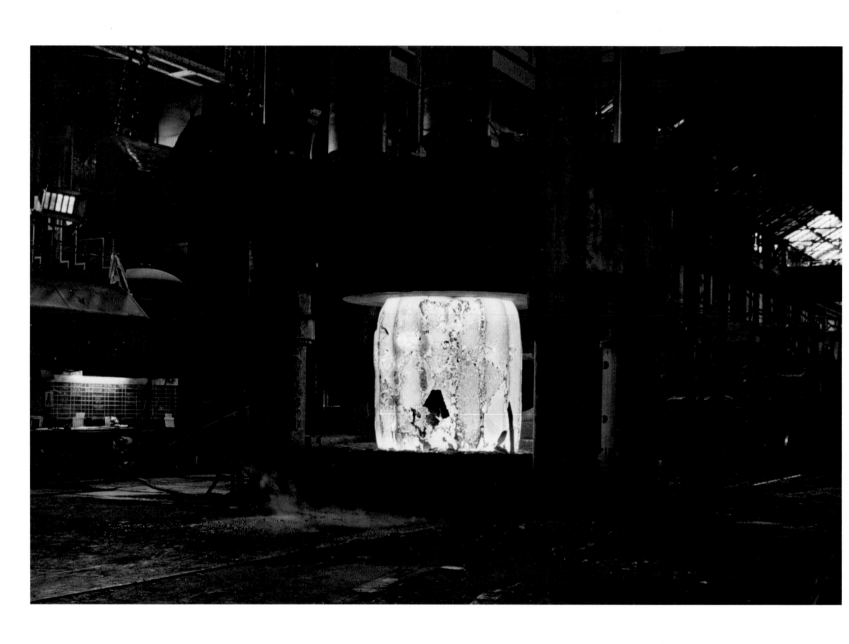

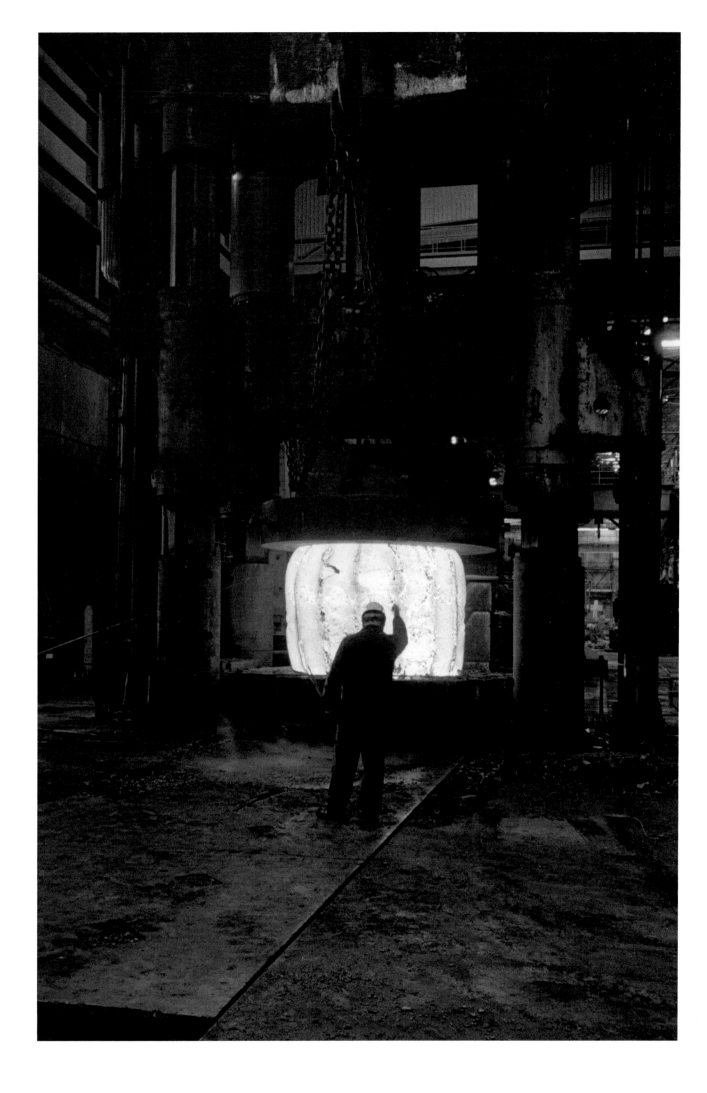

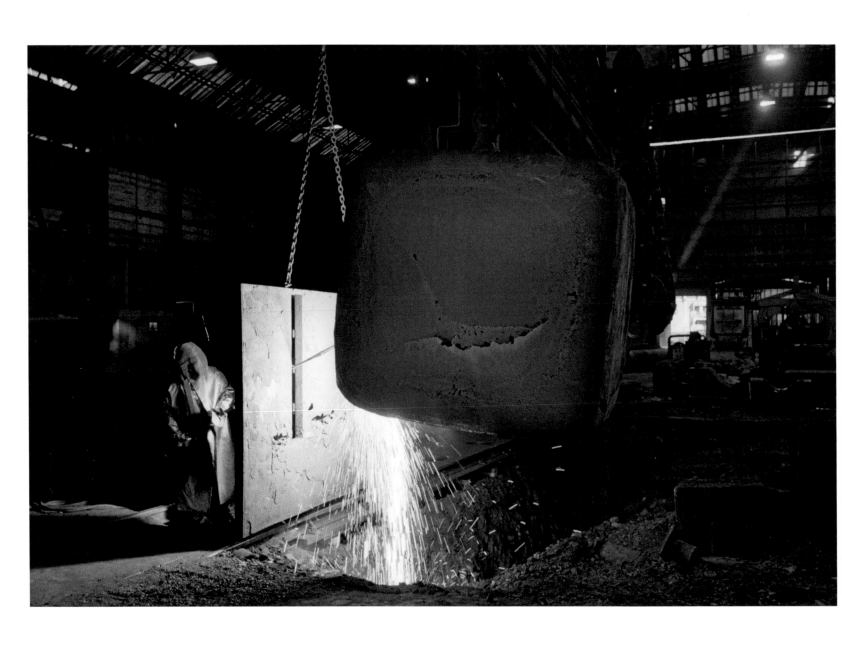

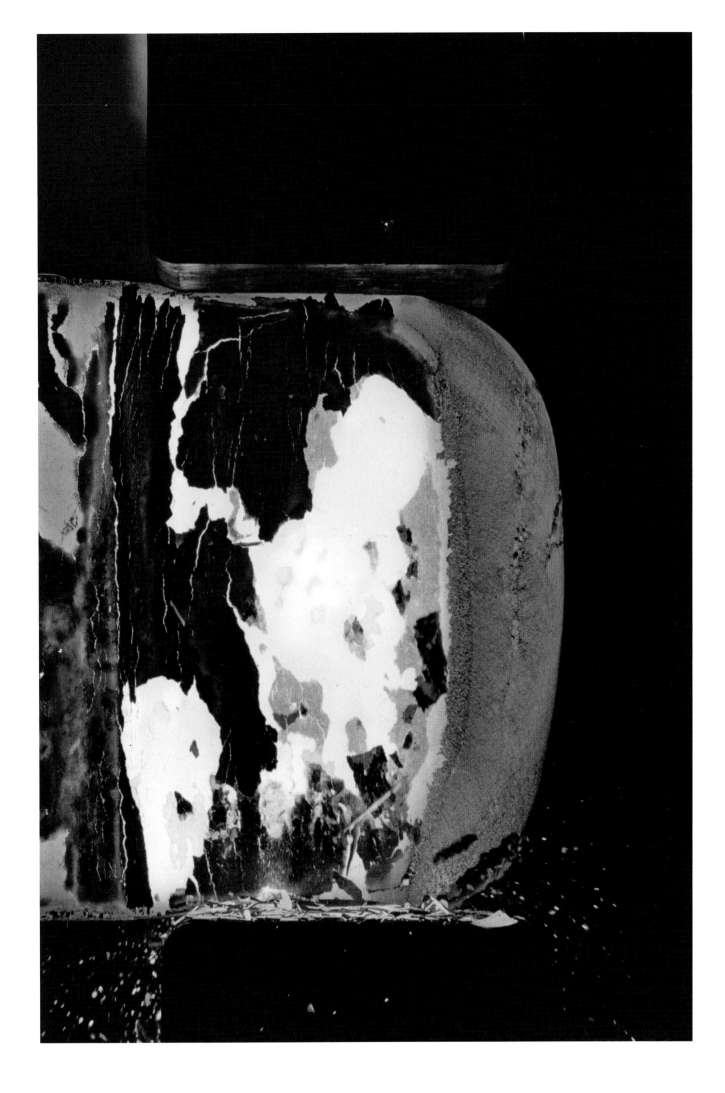

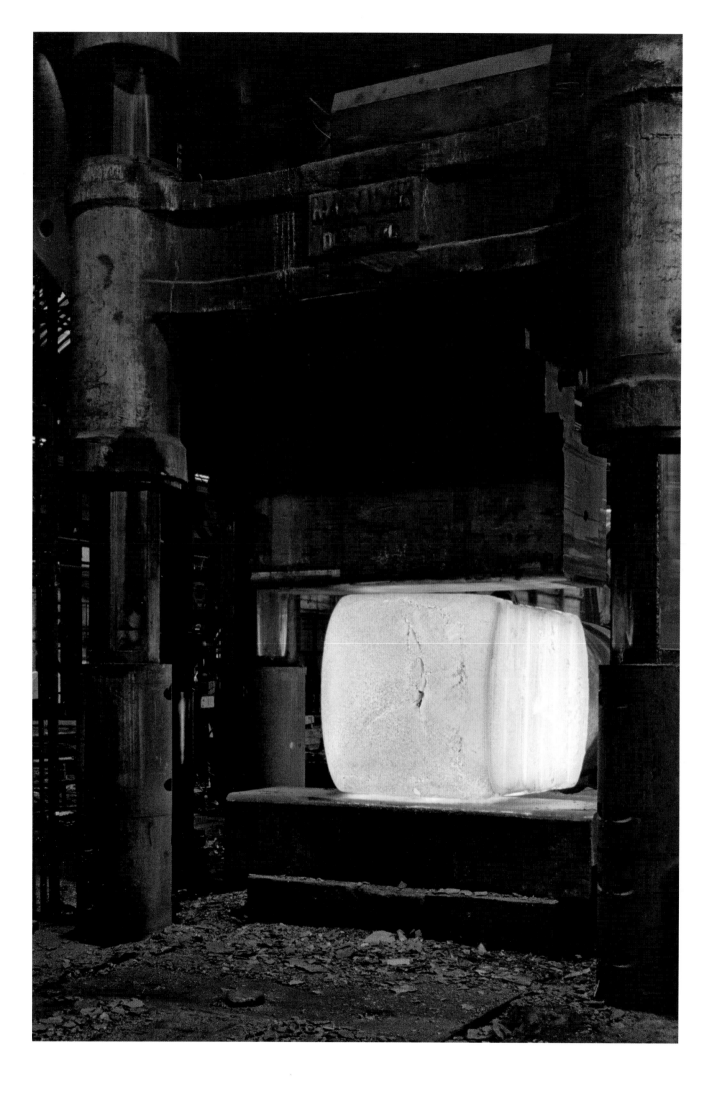

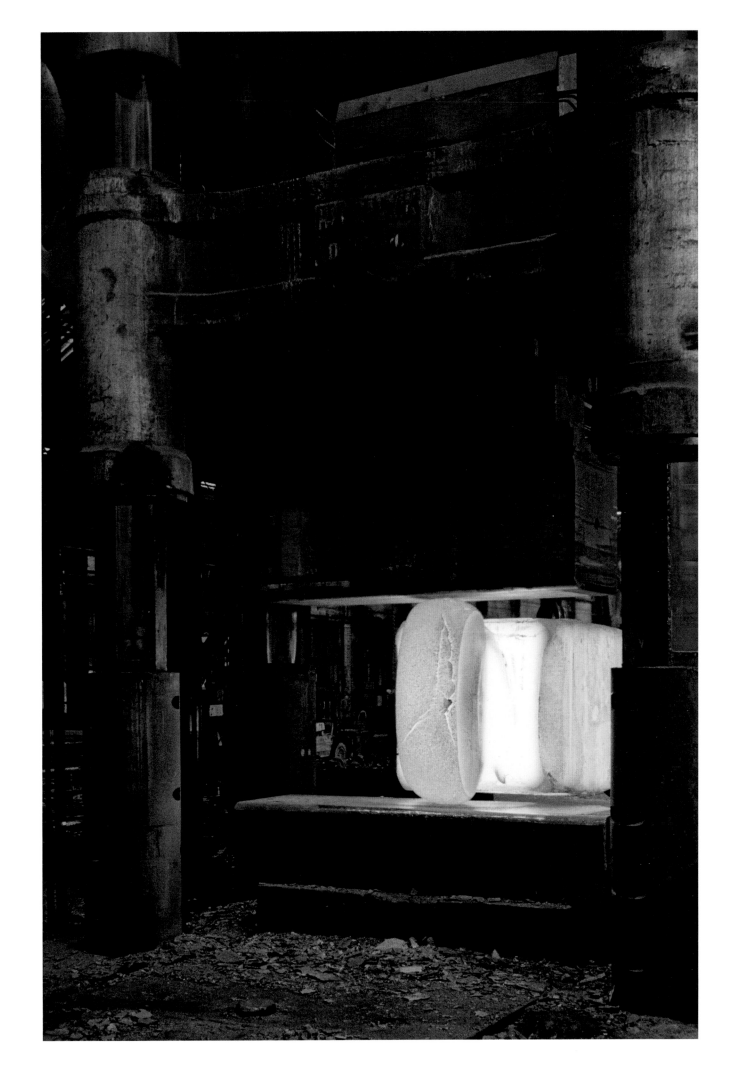

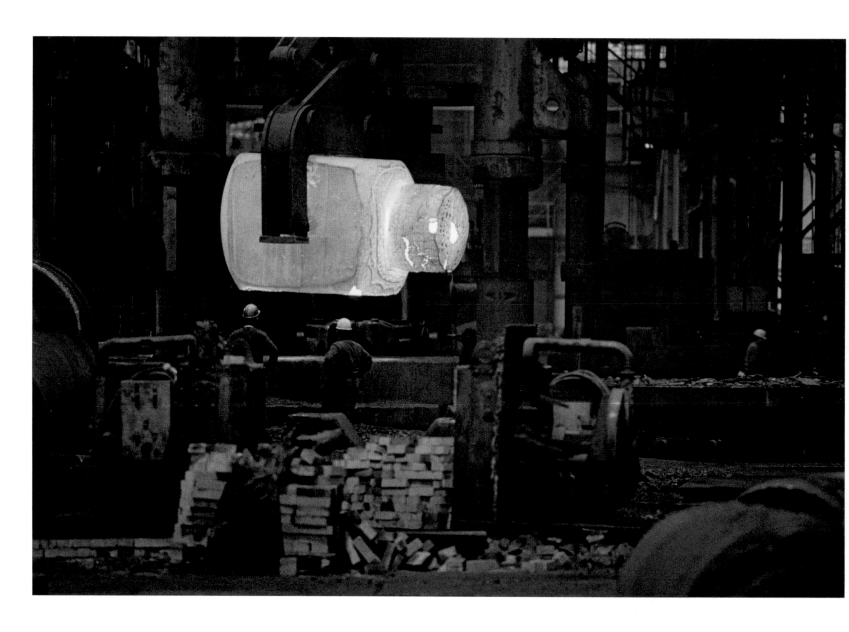

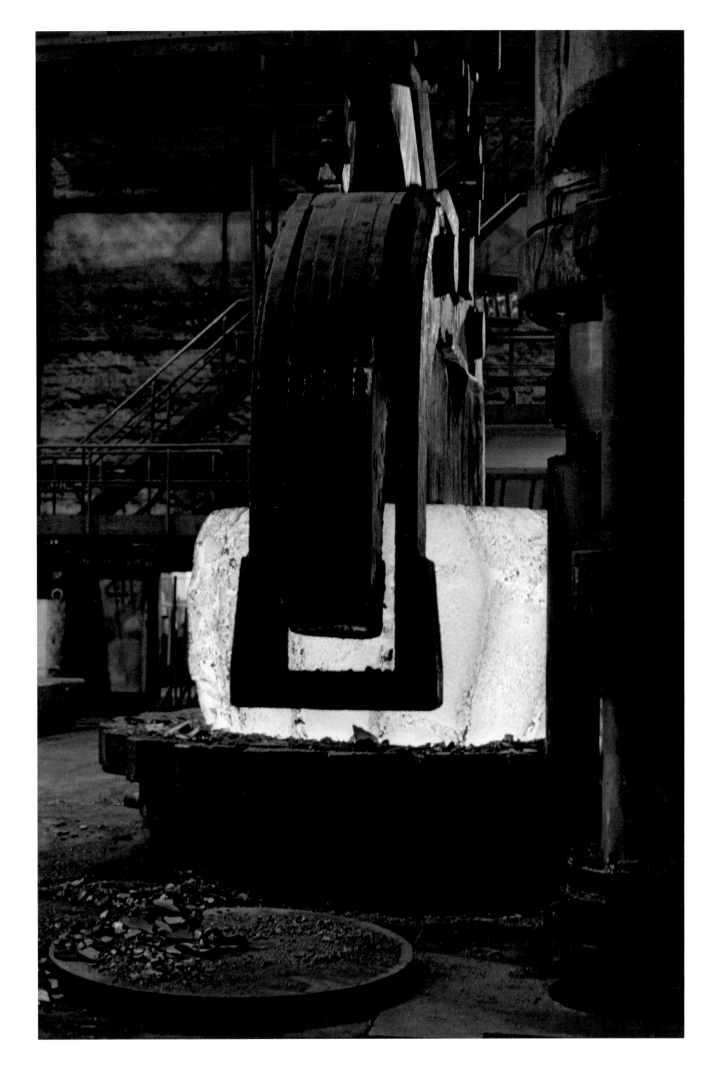

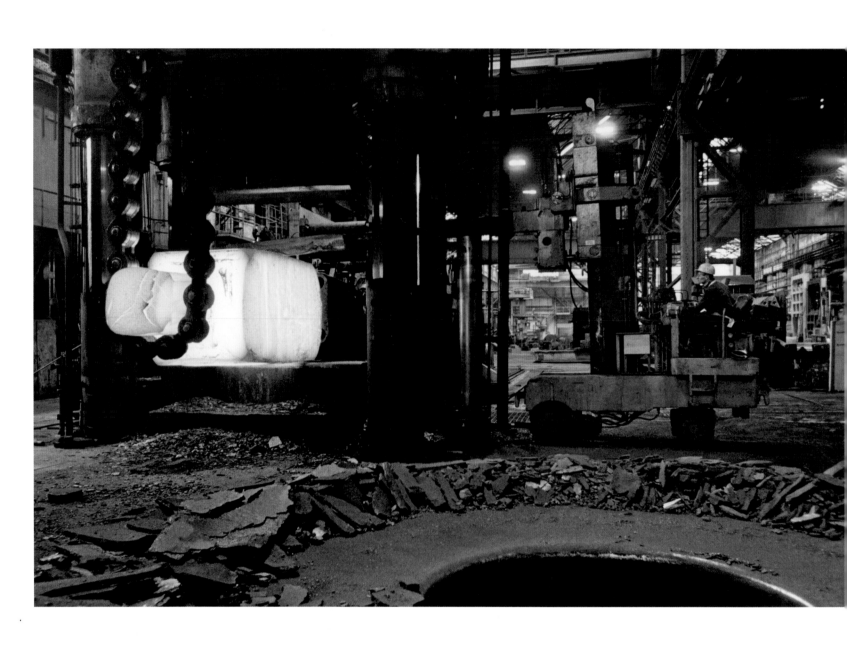

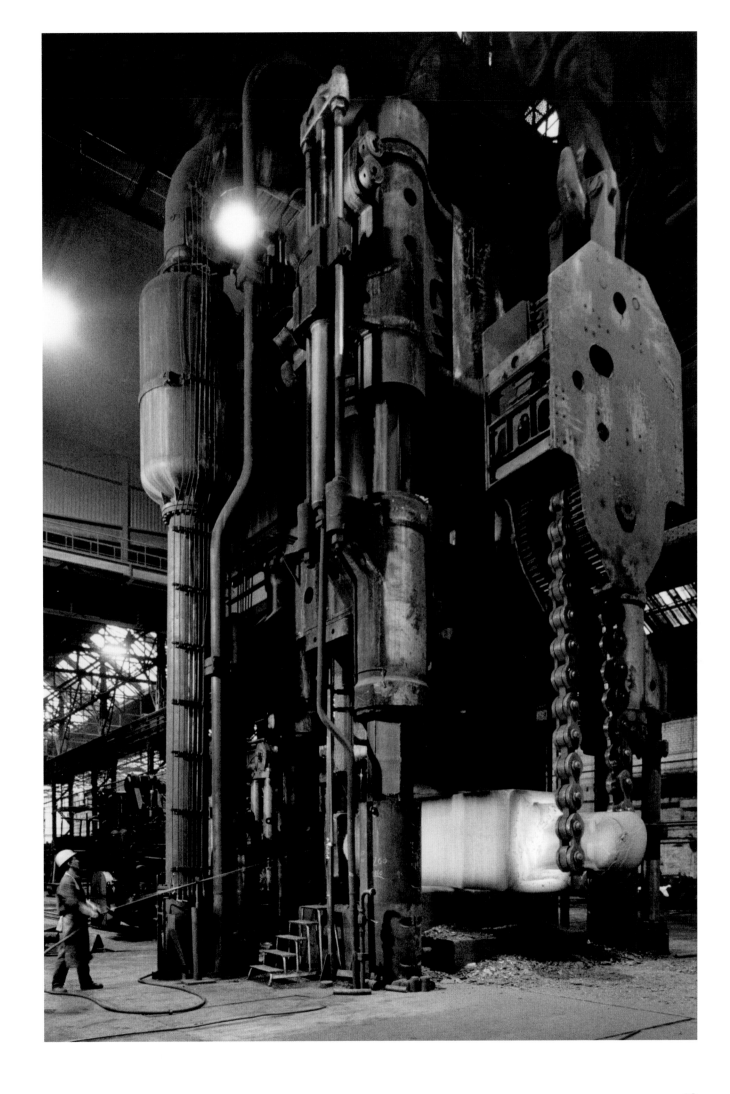

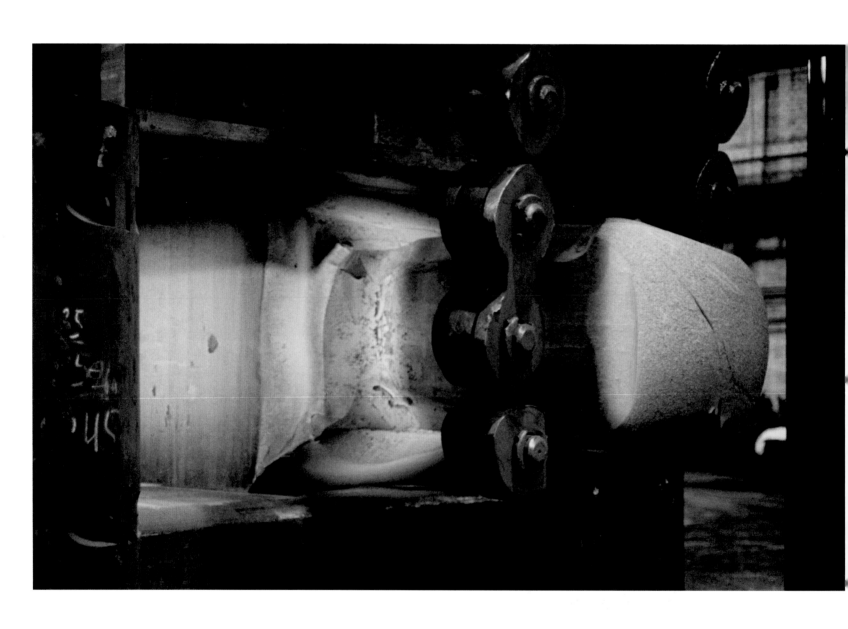

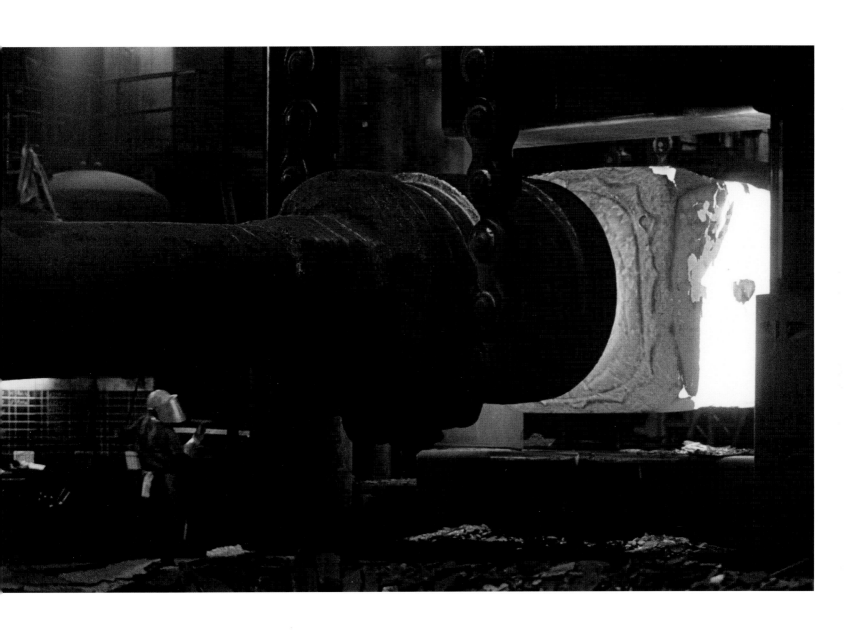

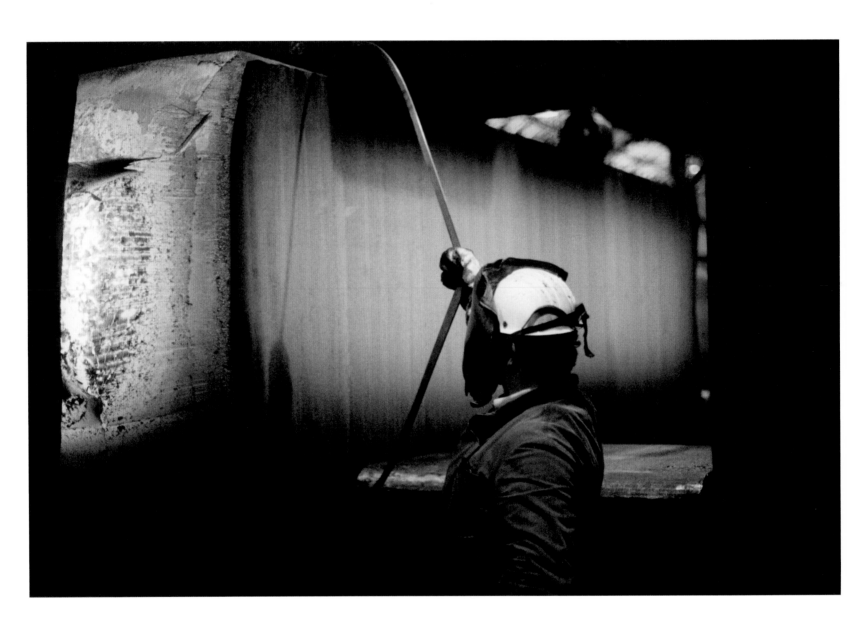

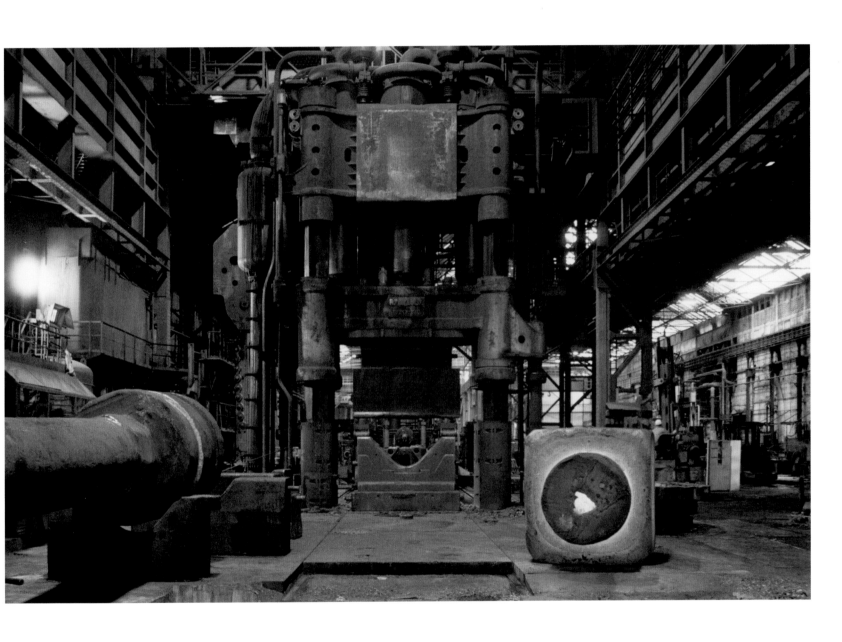

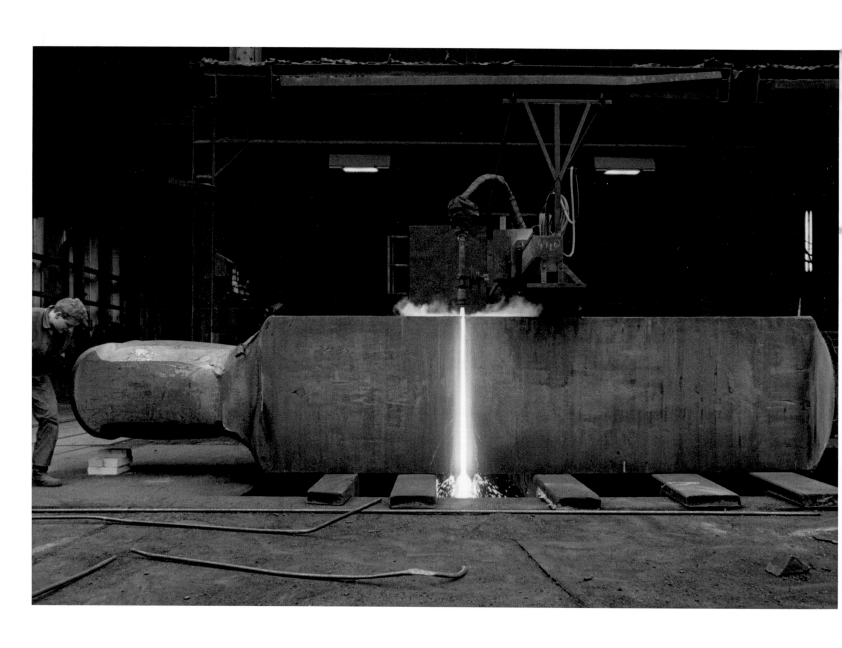

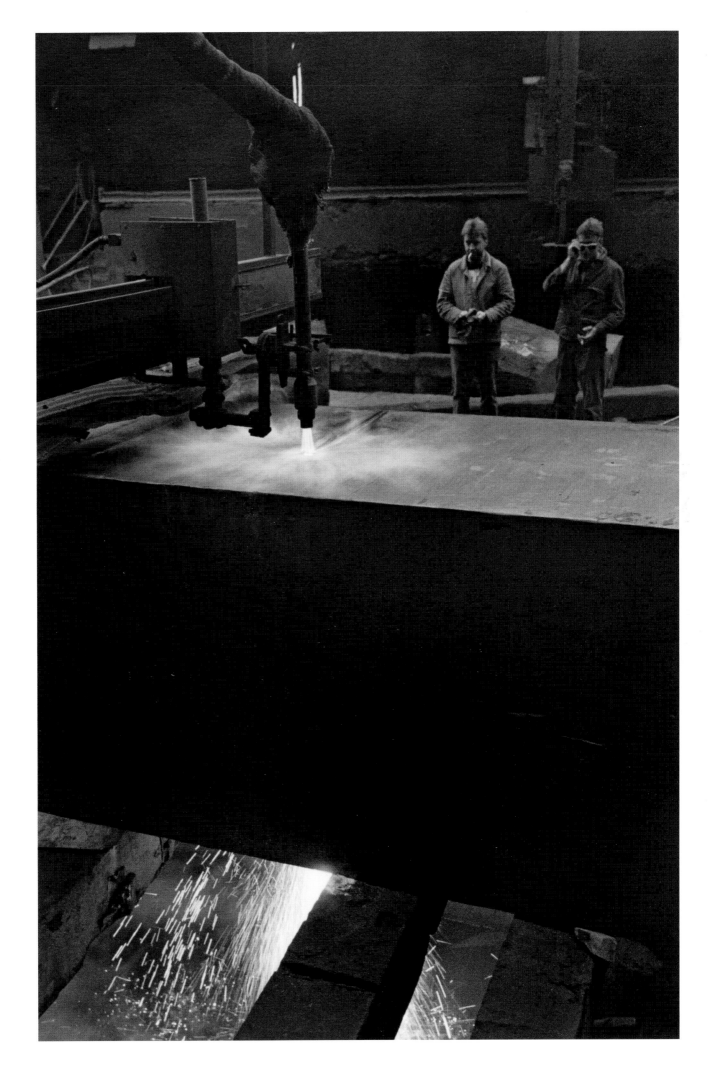

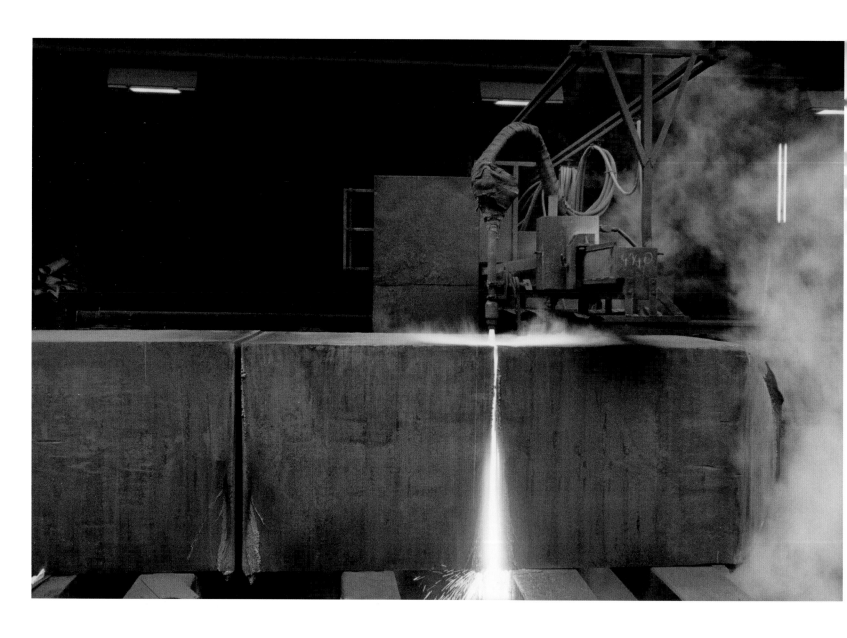

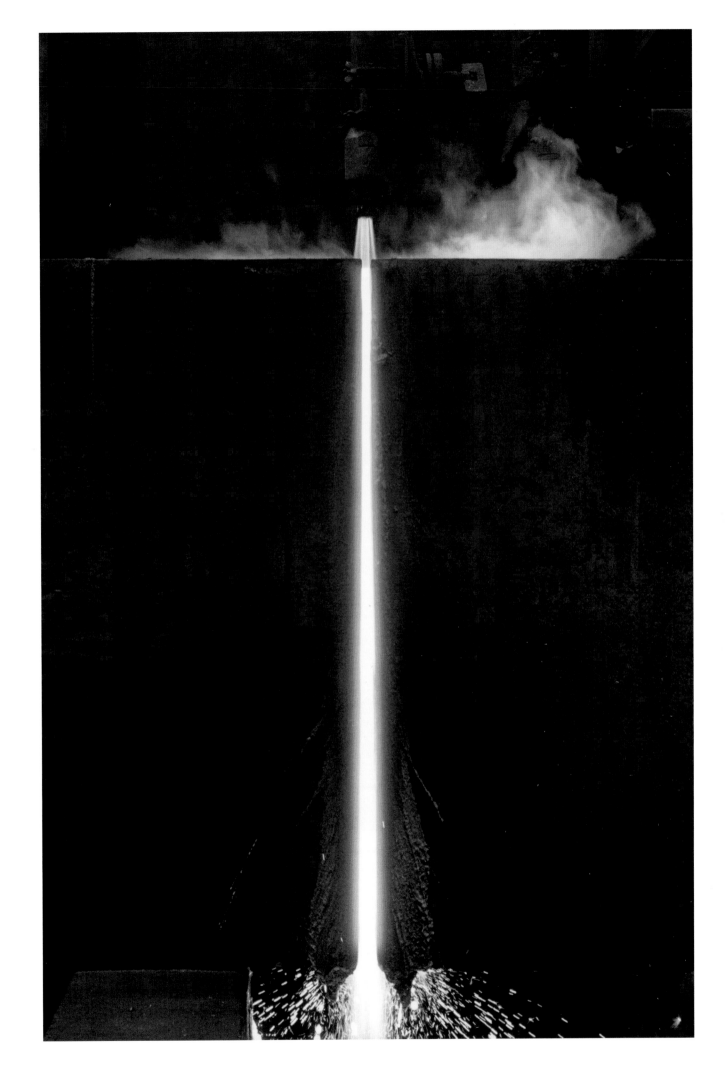

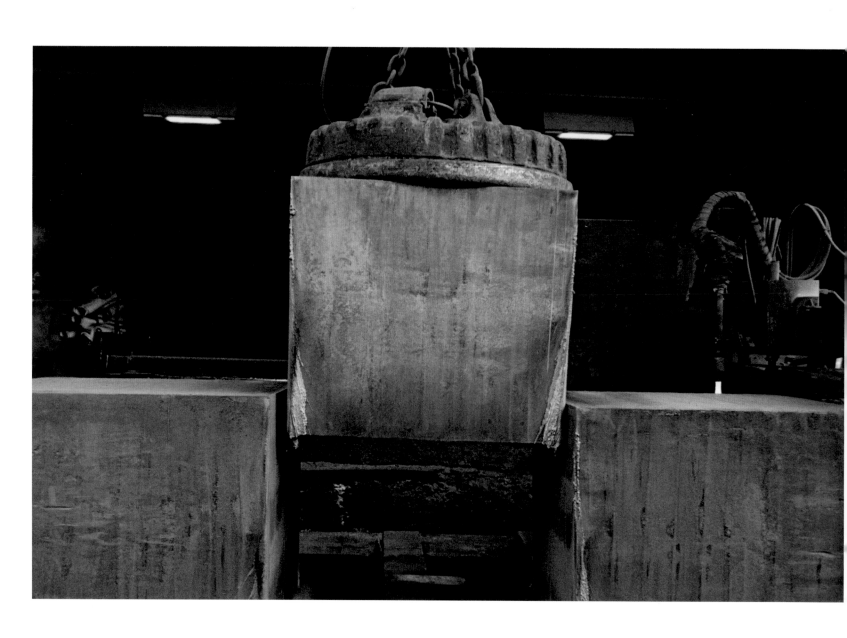

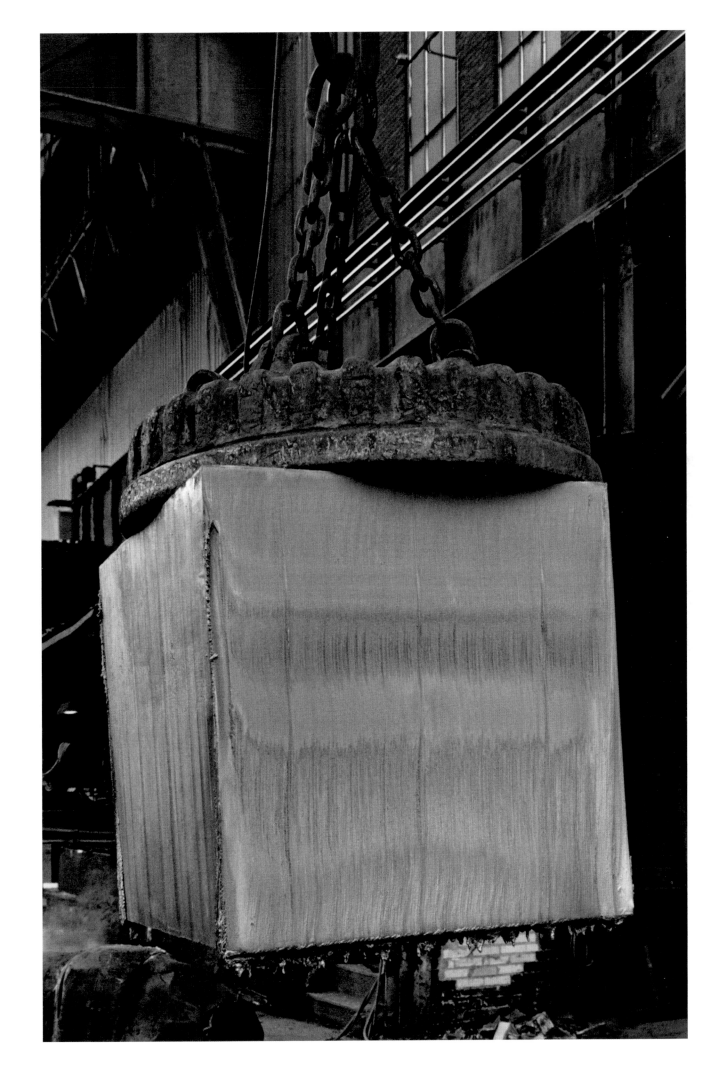

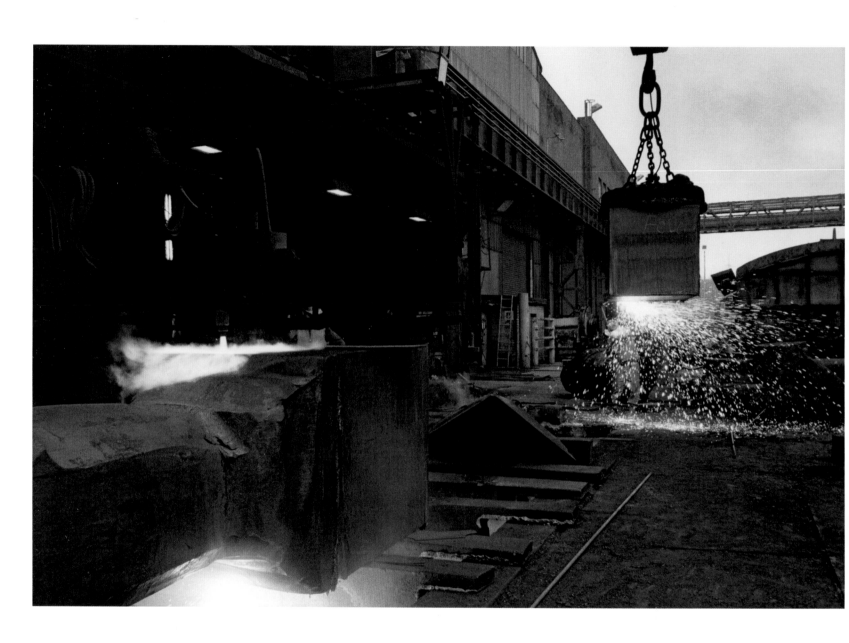

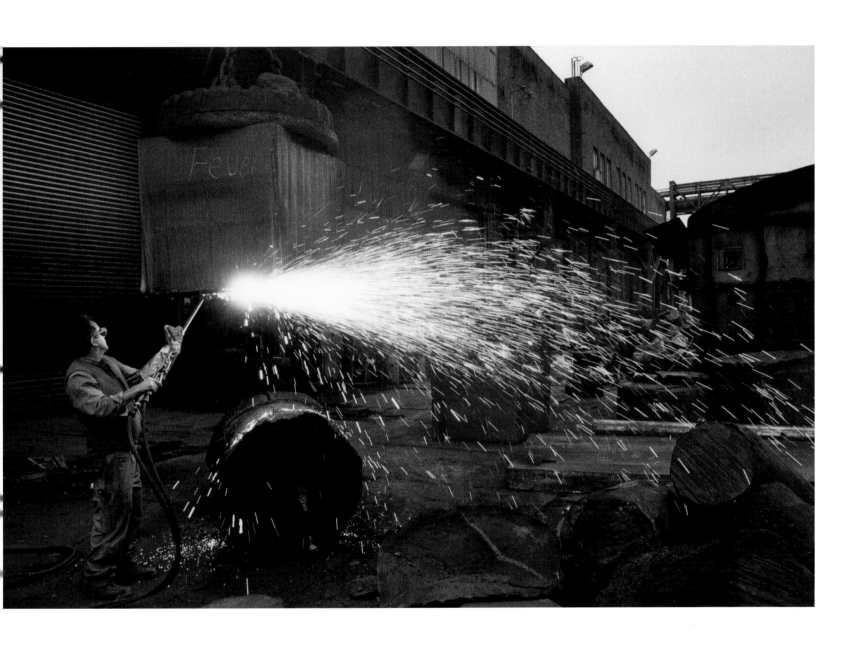

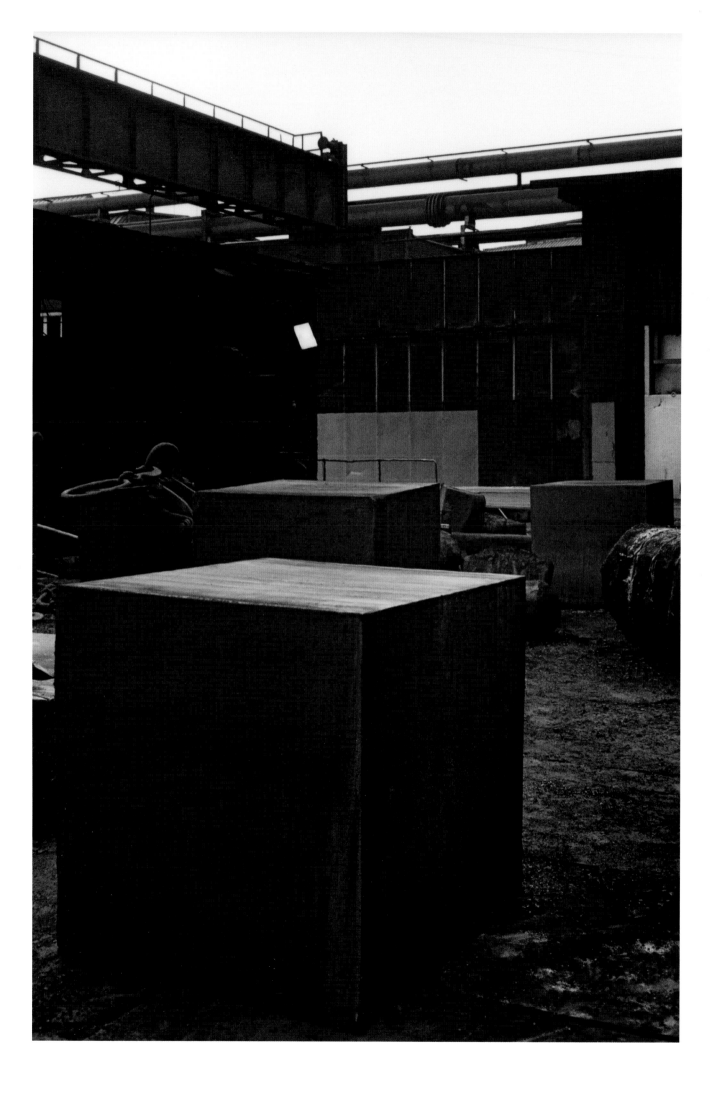

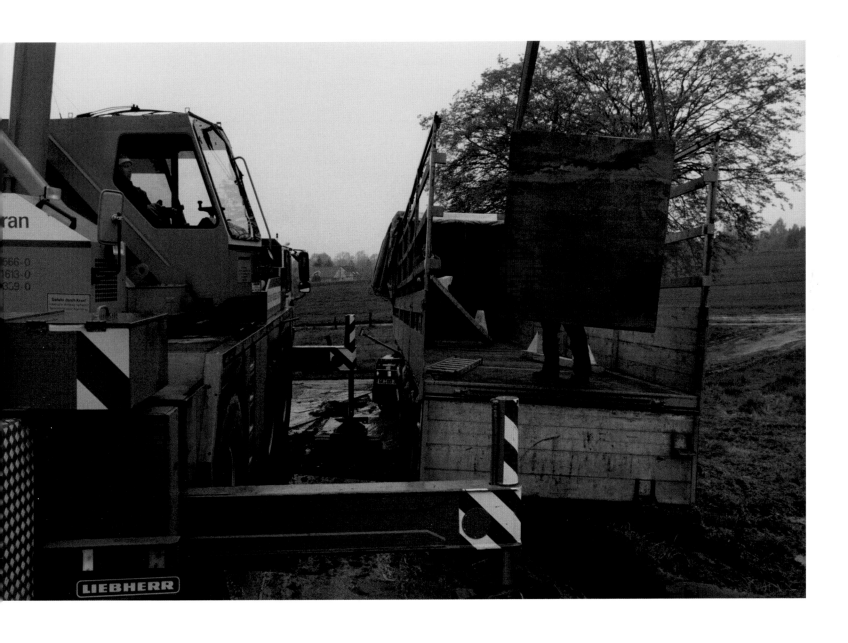

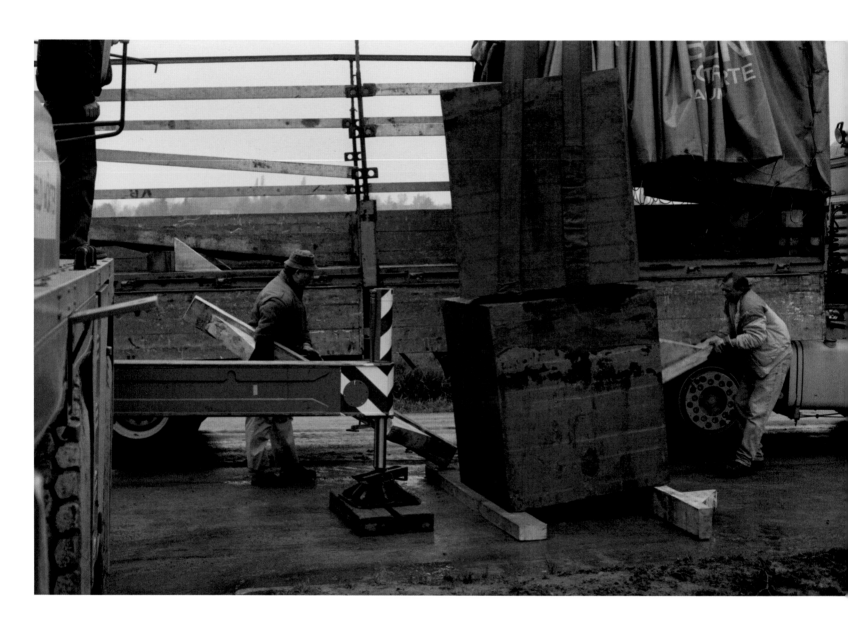

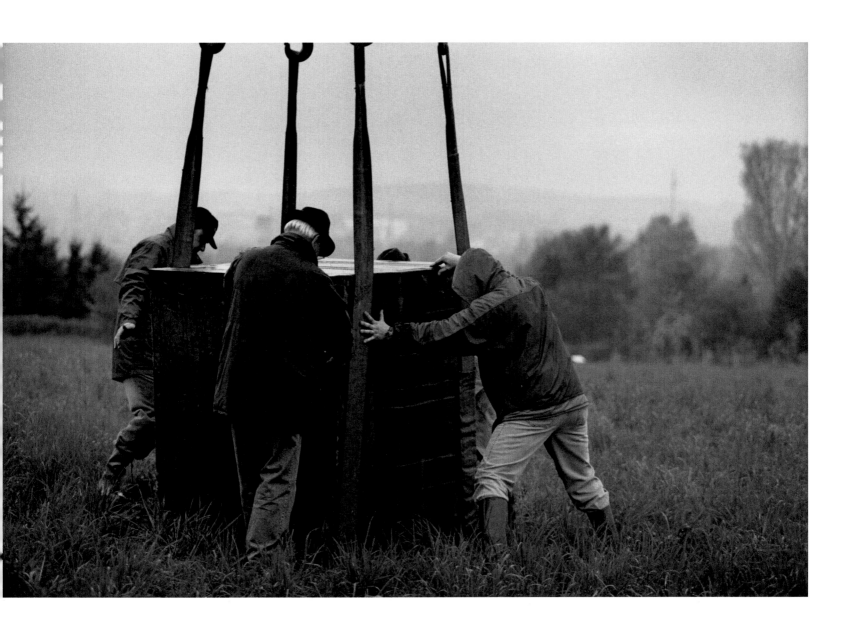

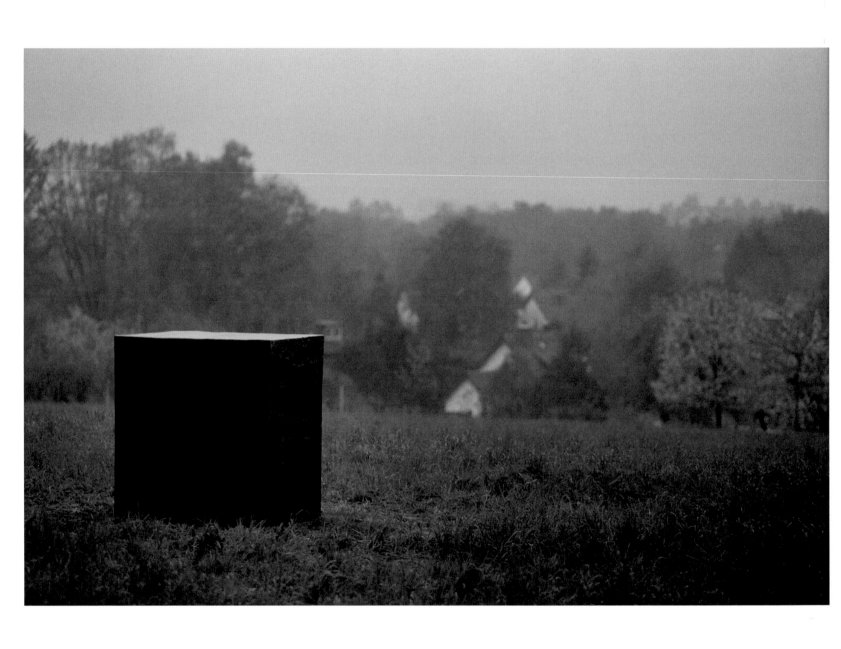

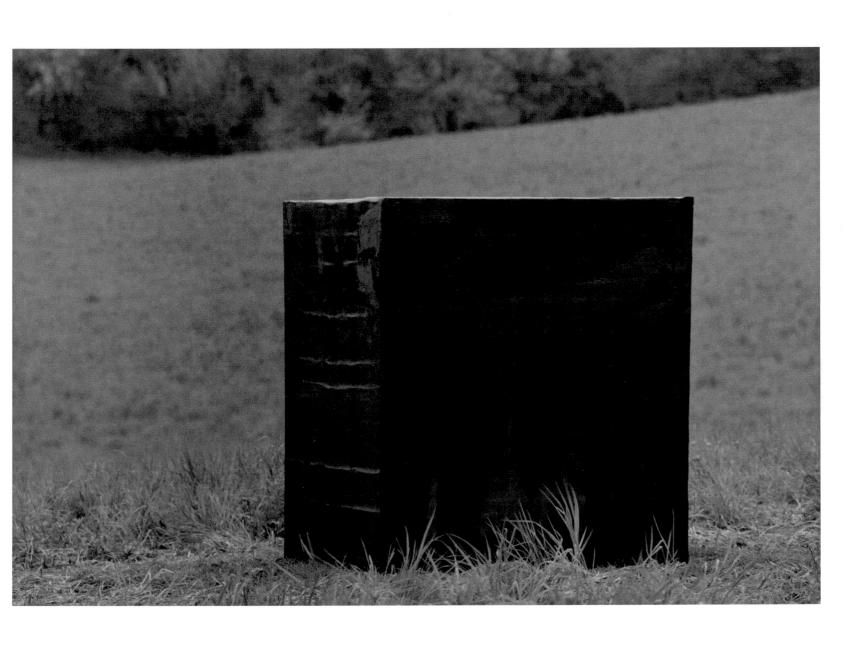

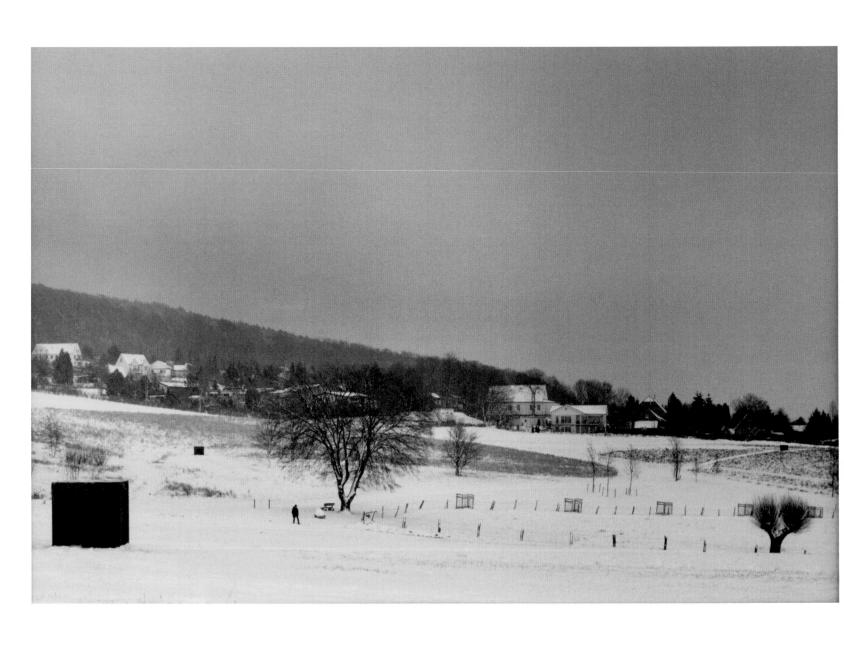

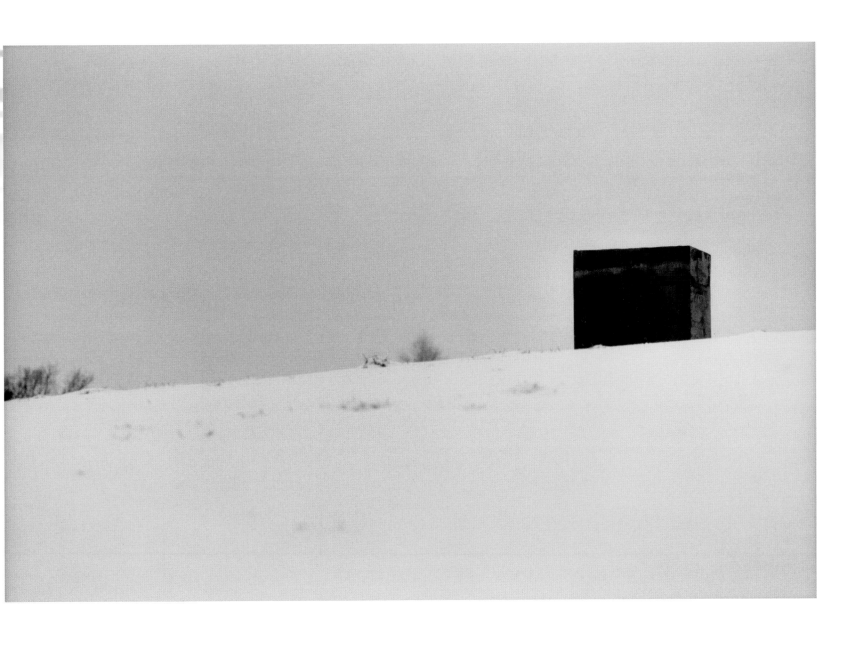

Produktion der Skulptur
Dirk's Pod

Production of Richard

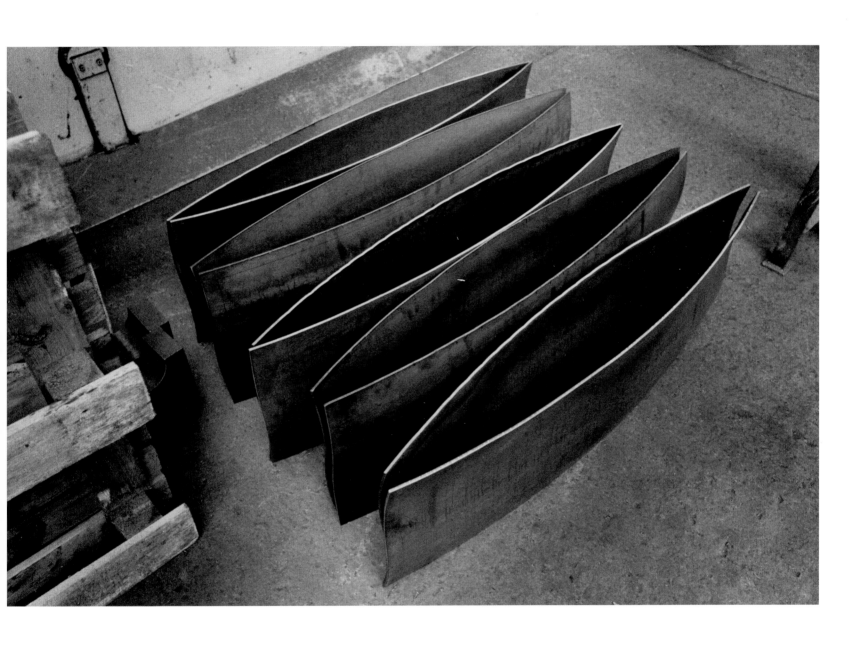

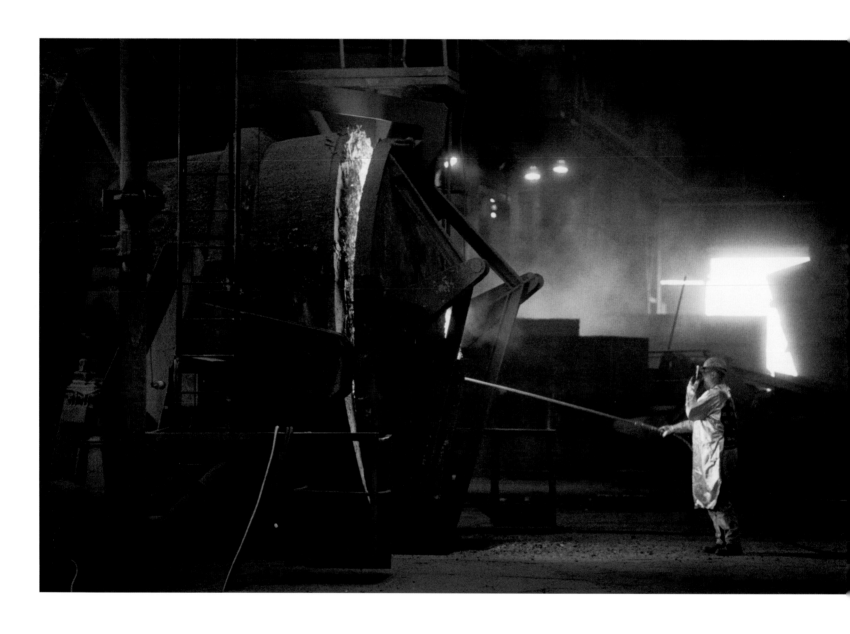

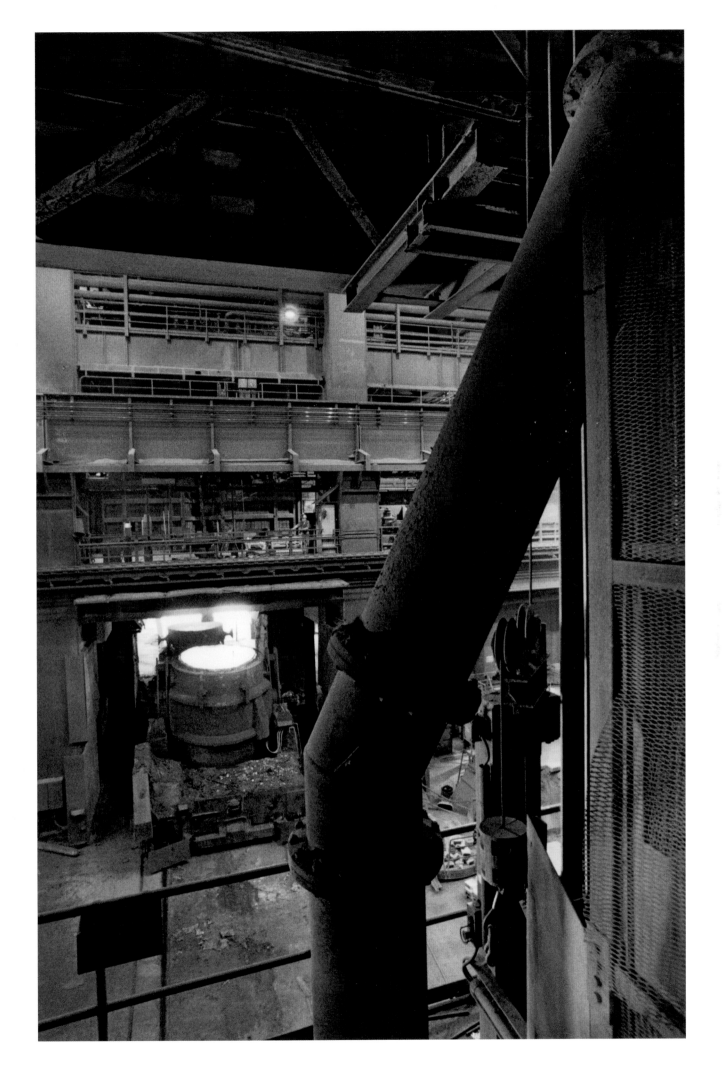

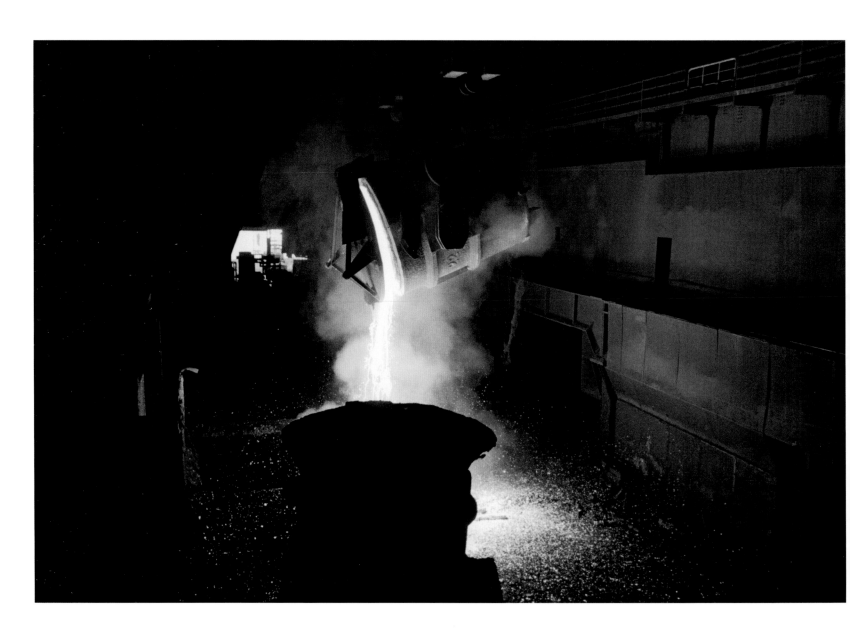

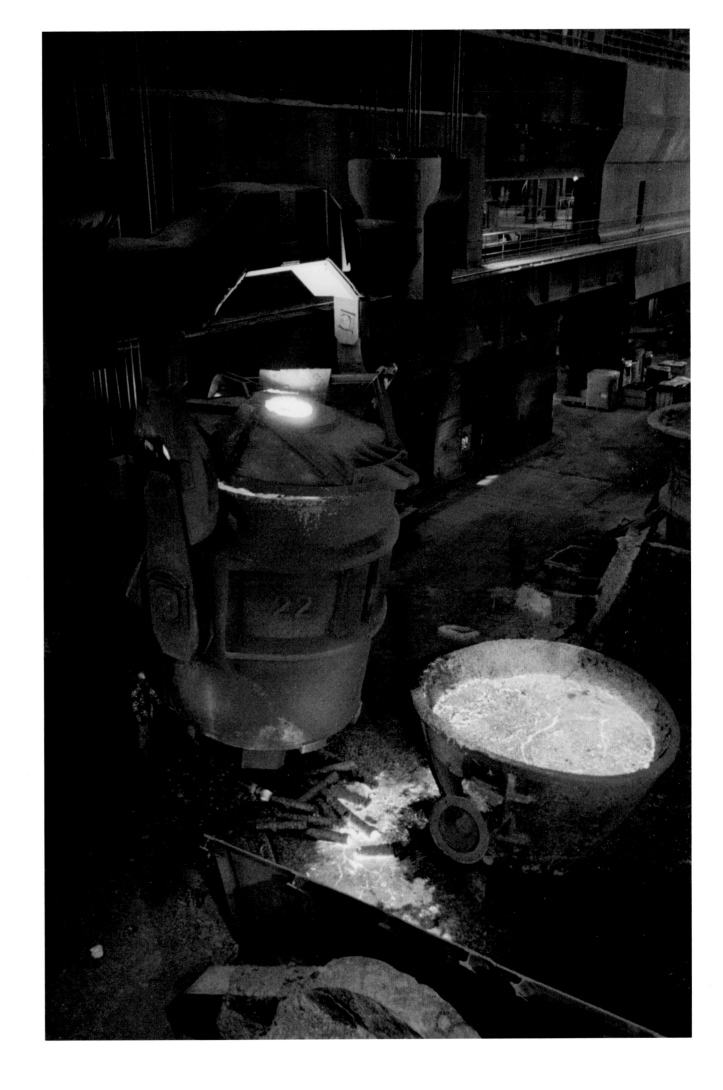

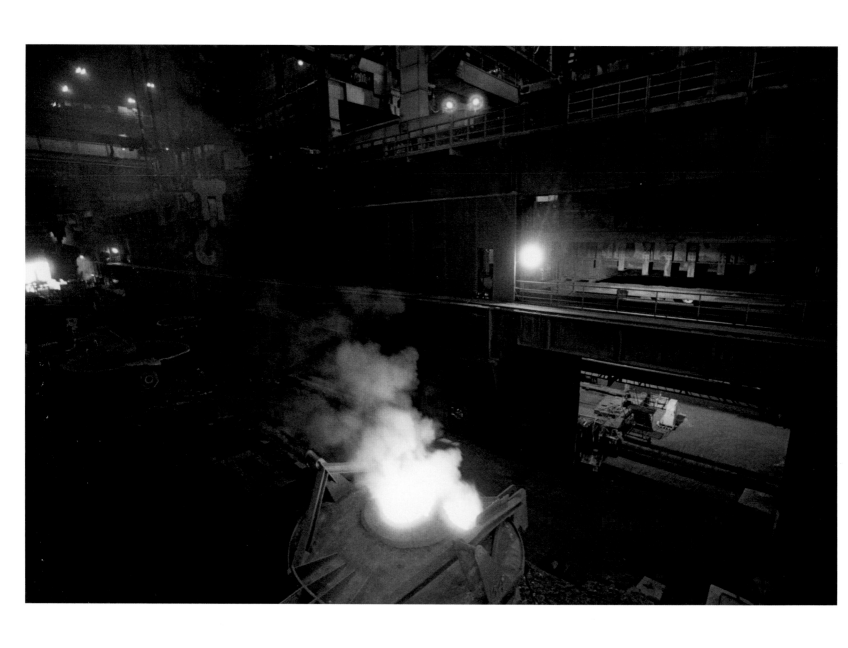

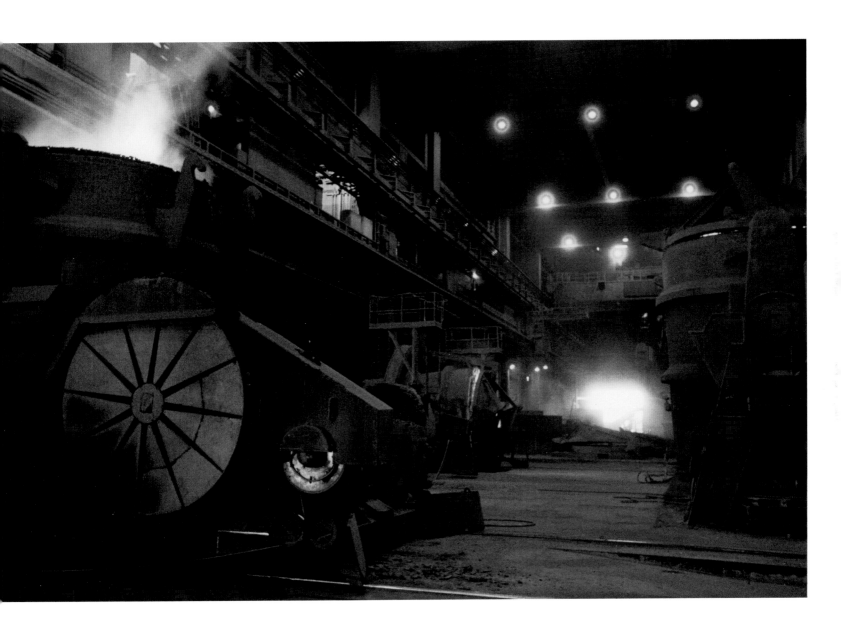

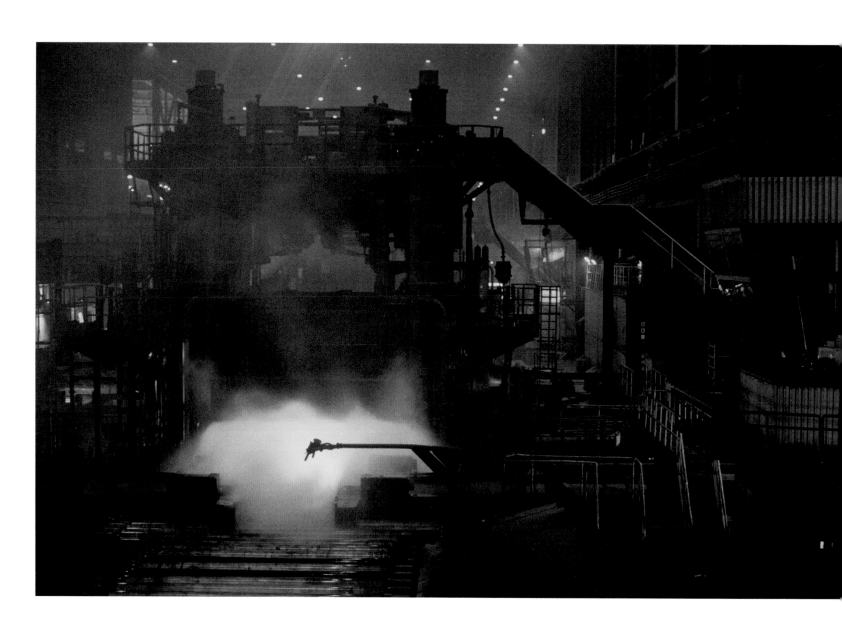

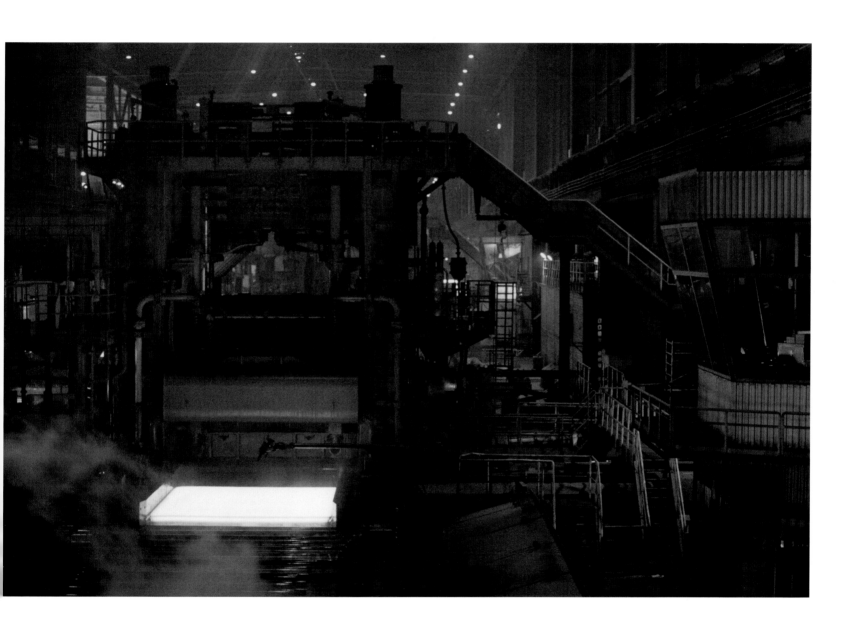

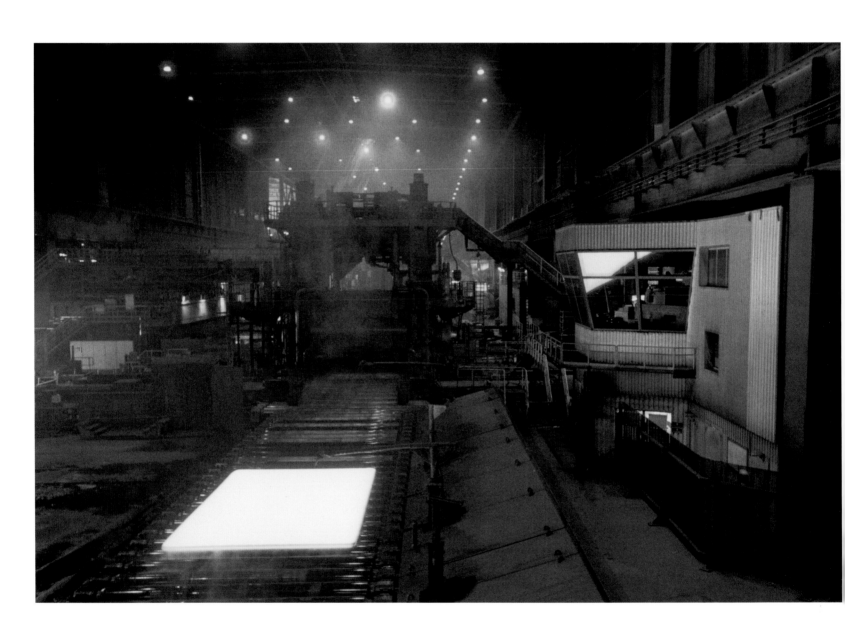

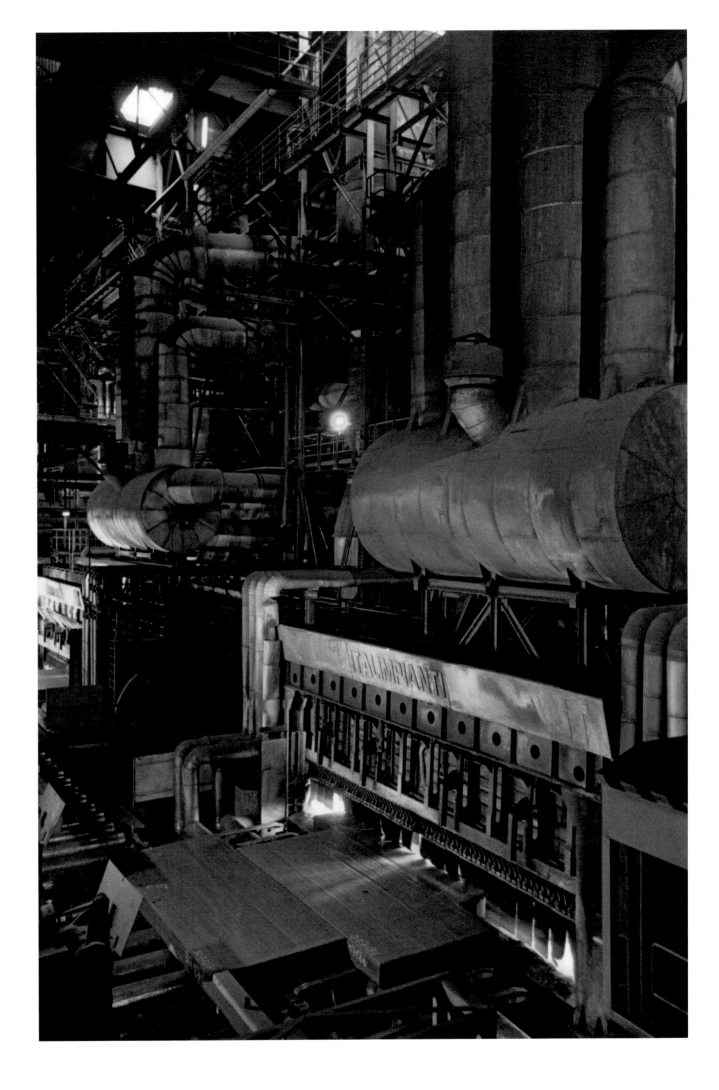

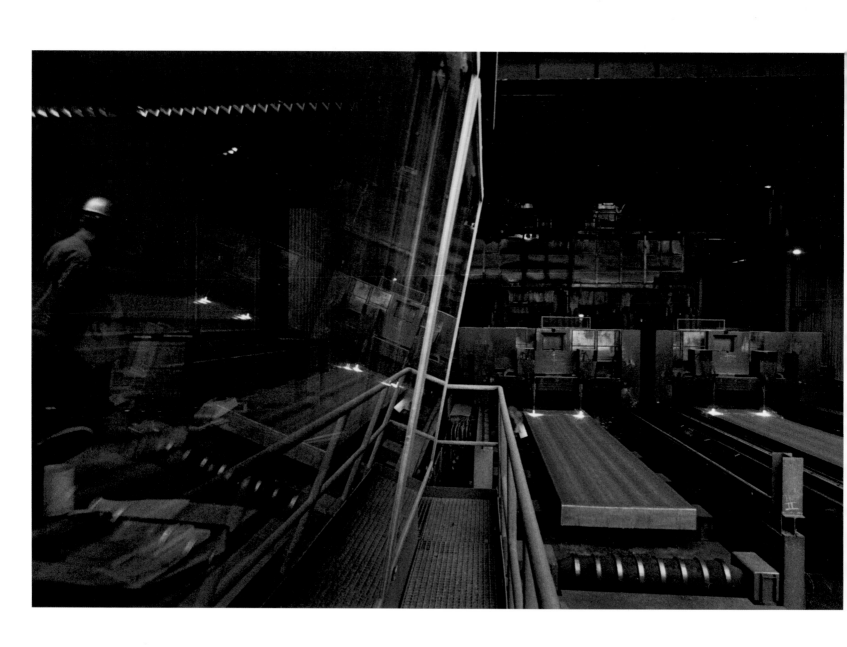

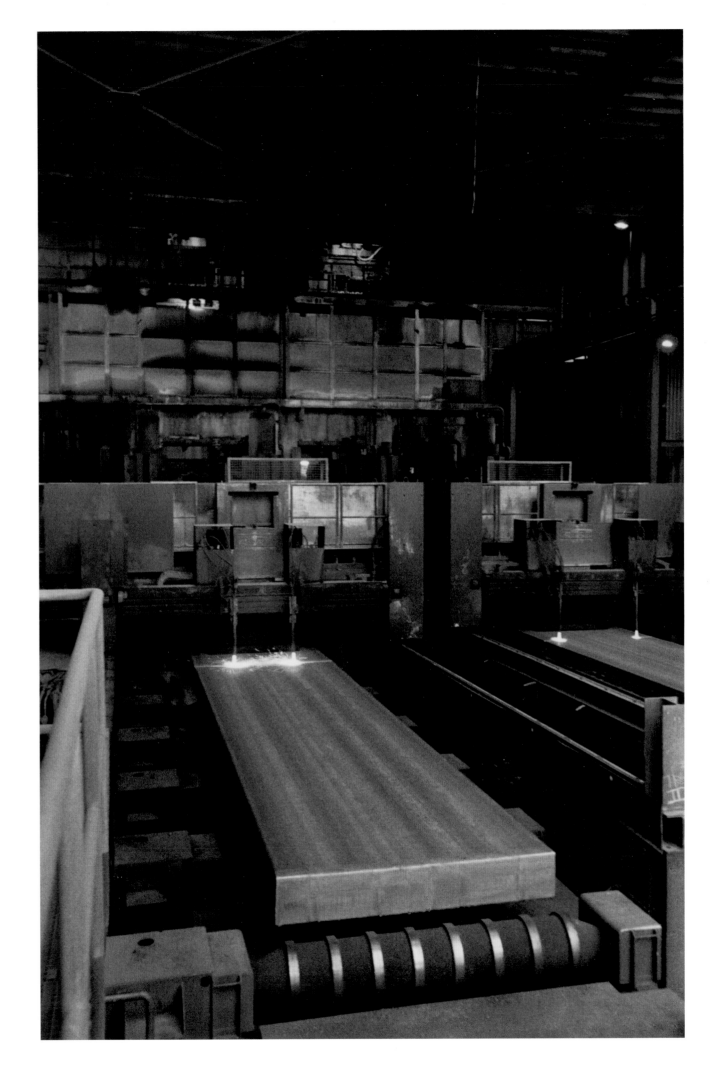

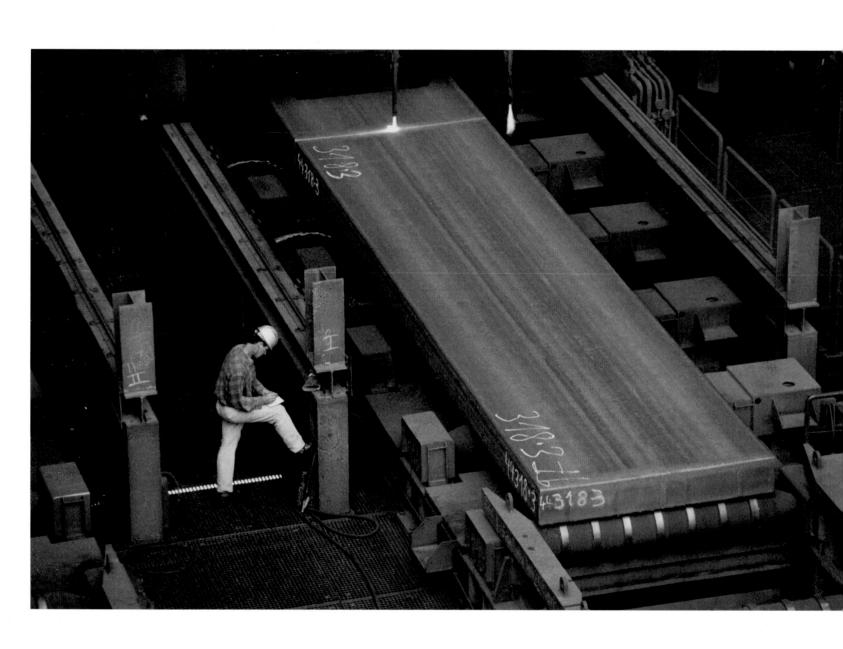

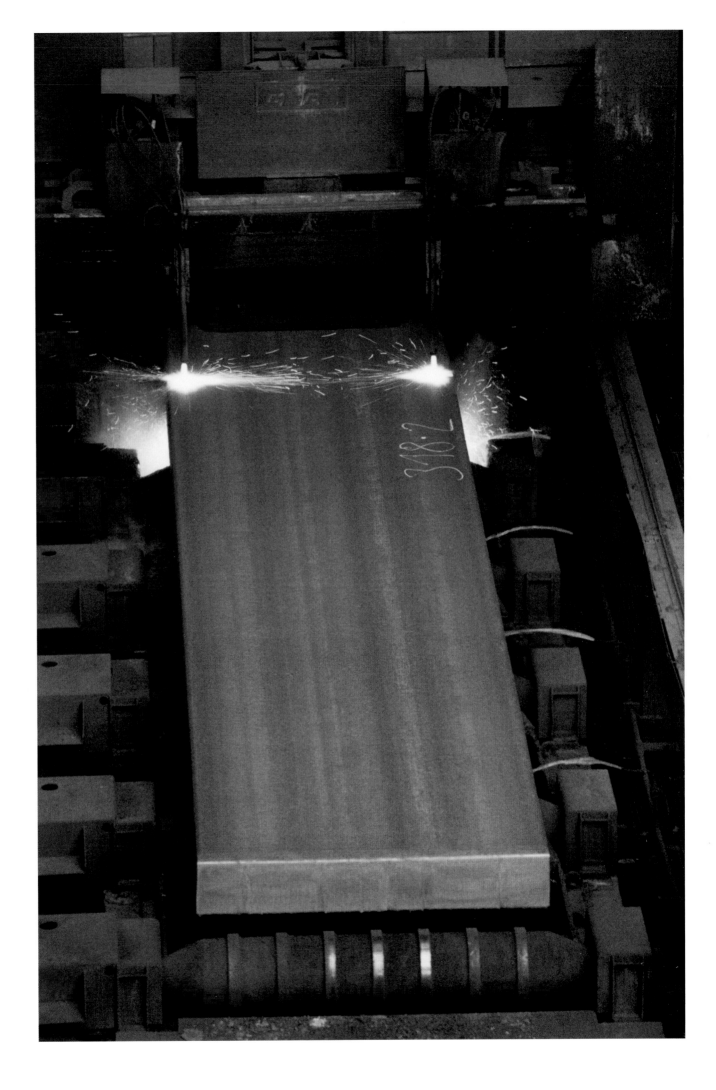

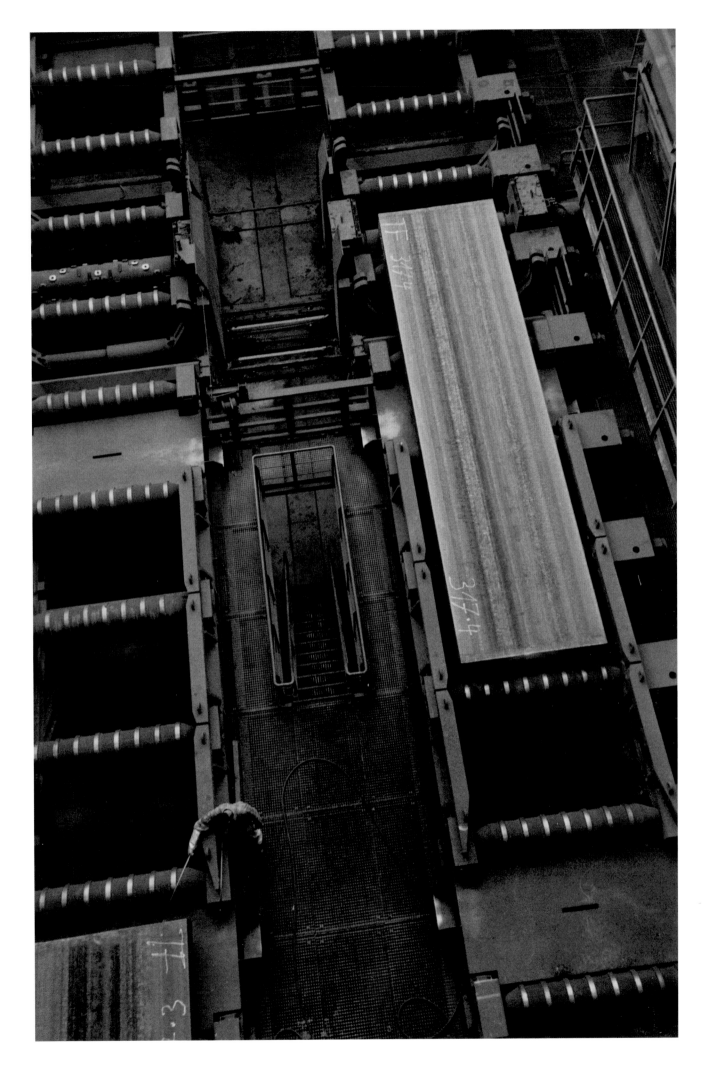

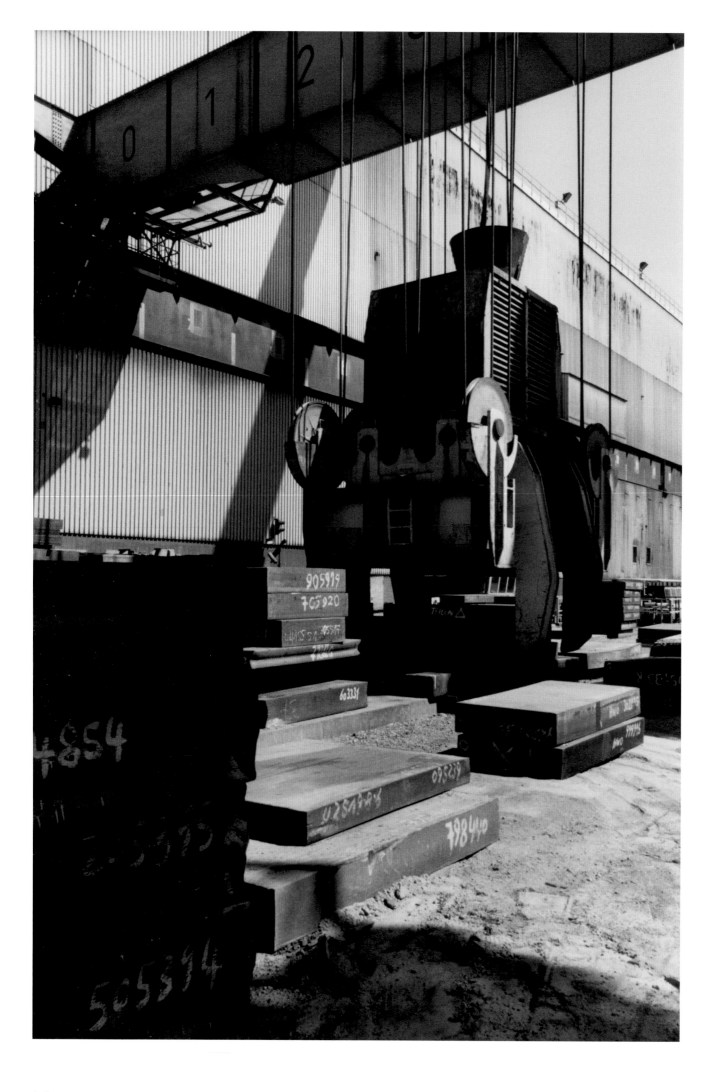

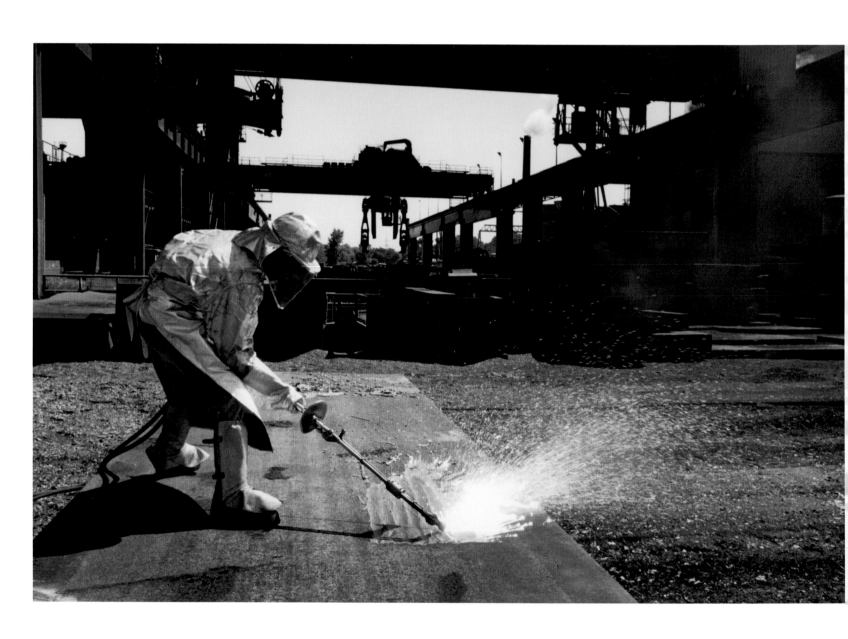

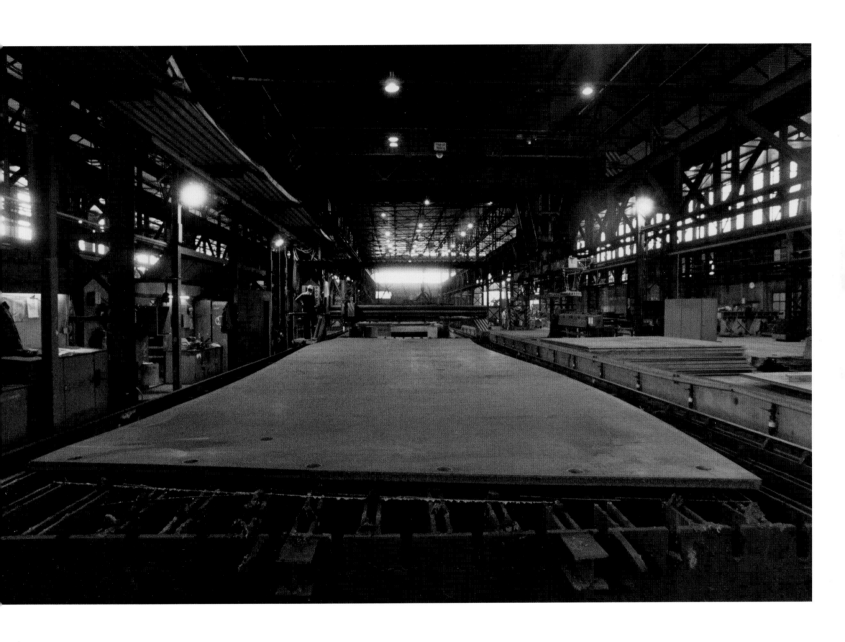

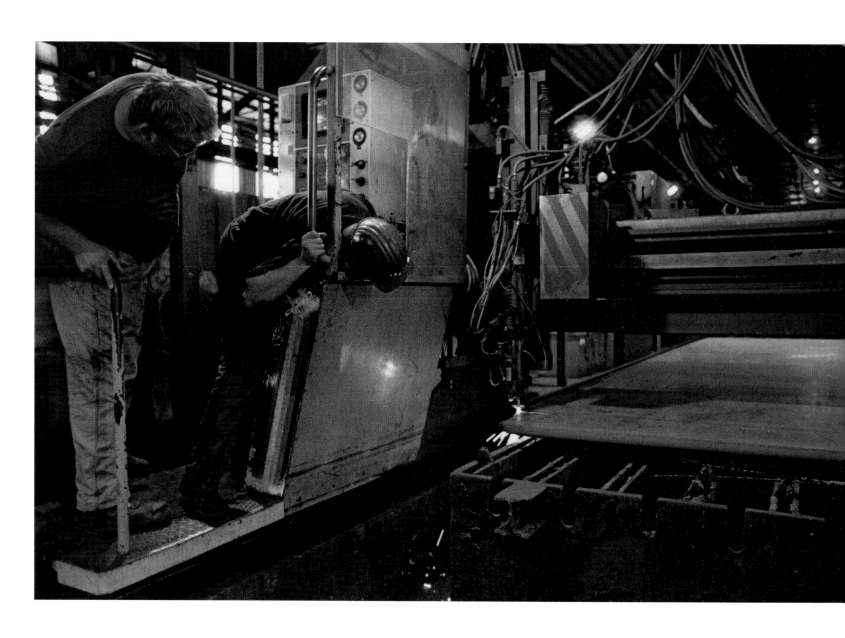

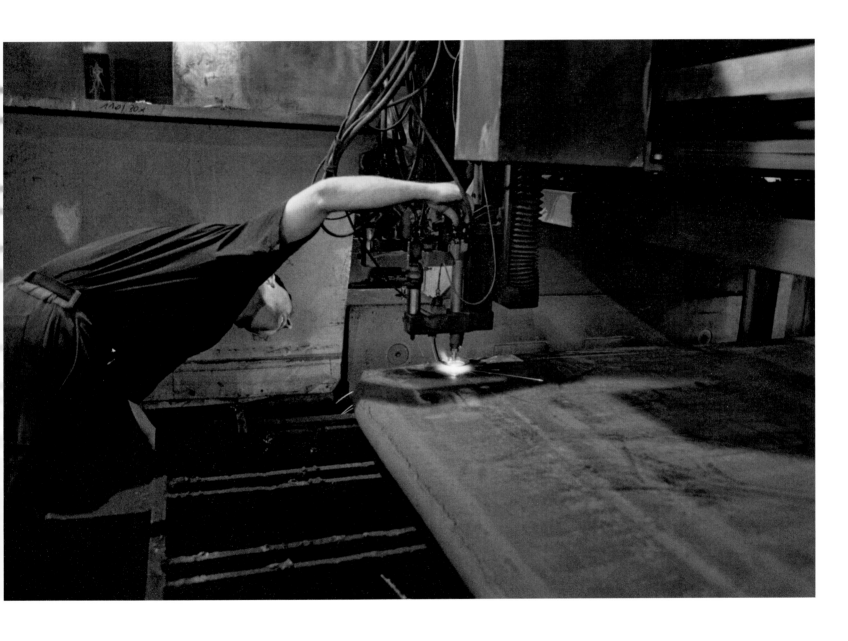

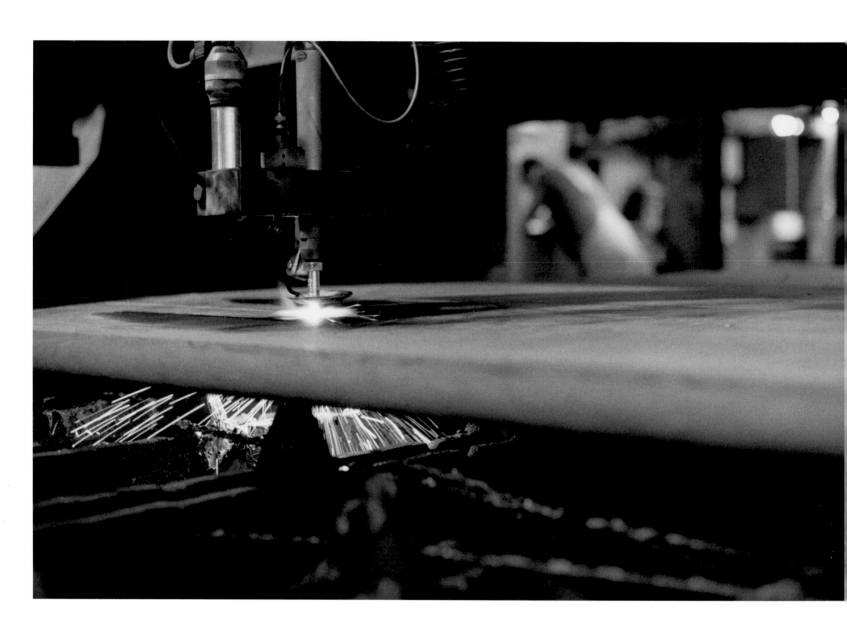

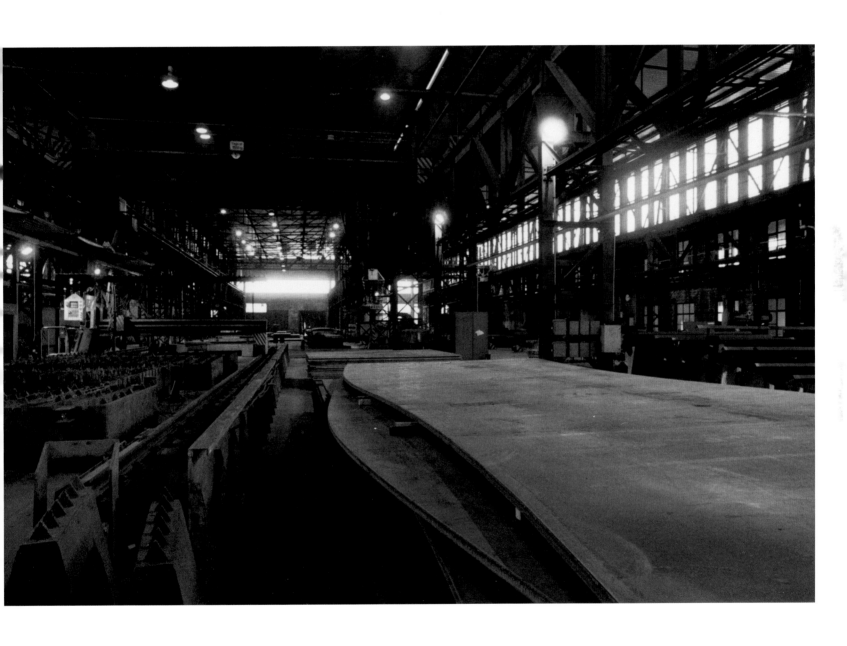

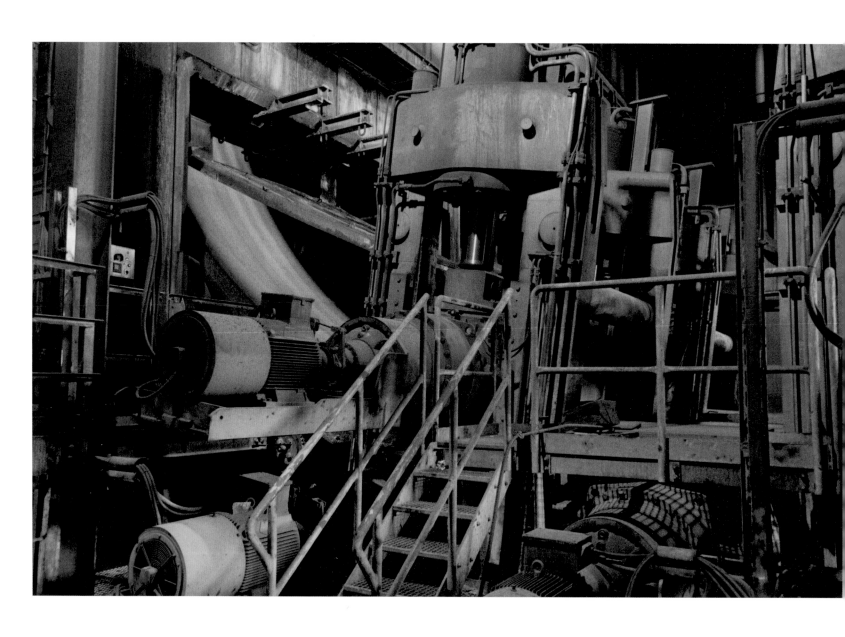

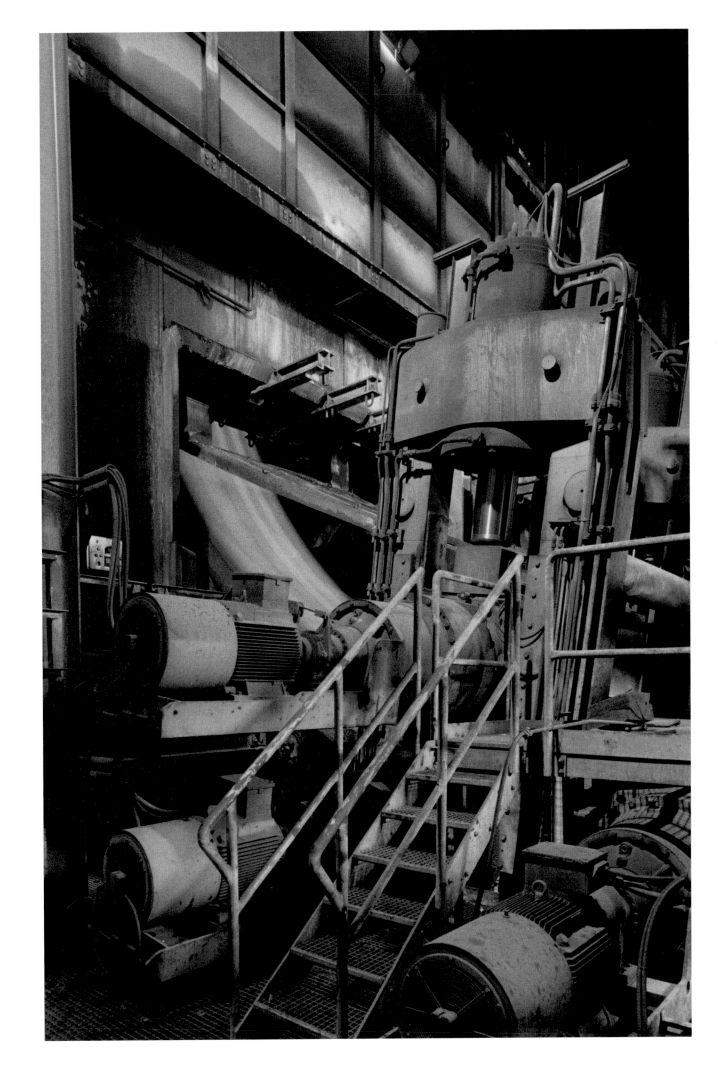

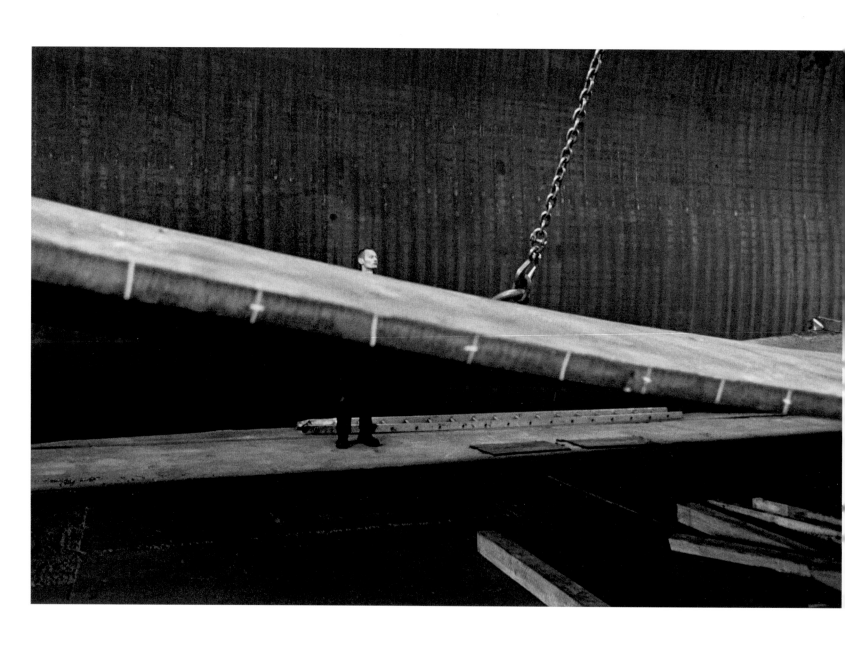

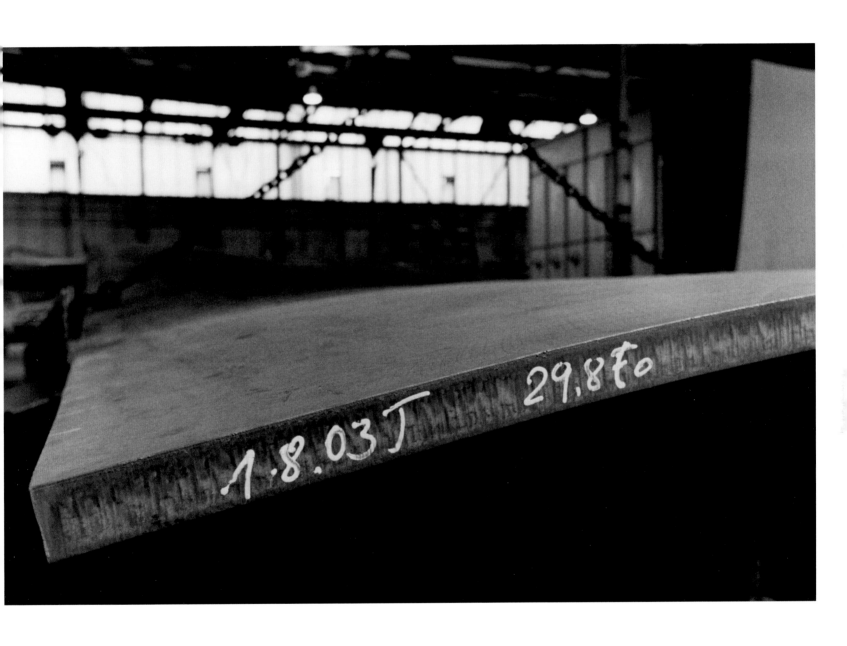

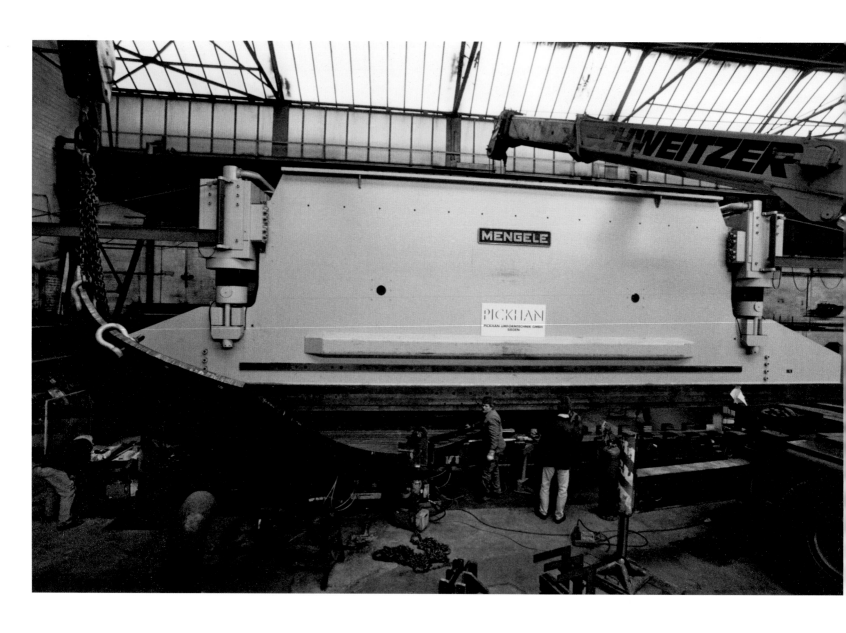

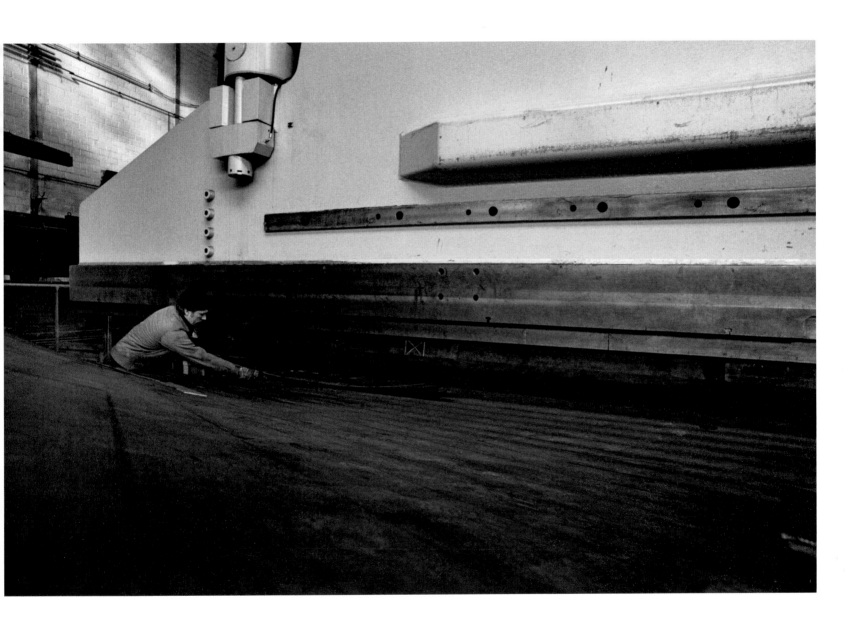

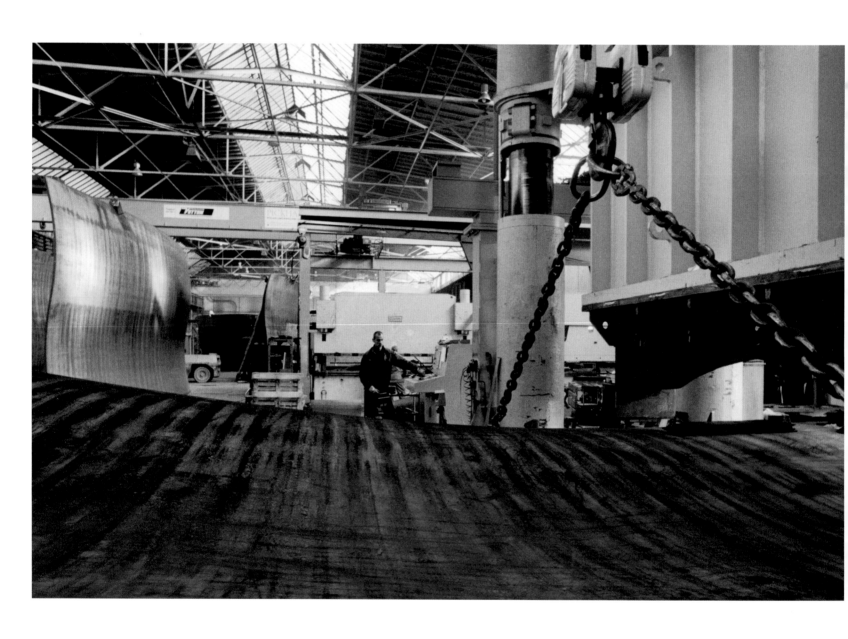

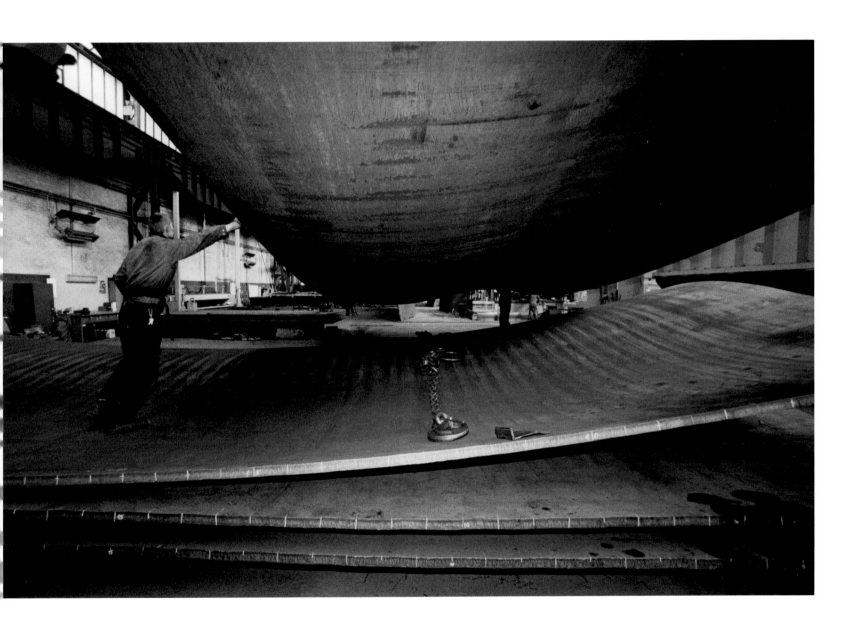

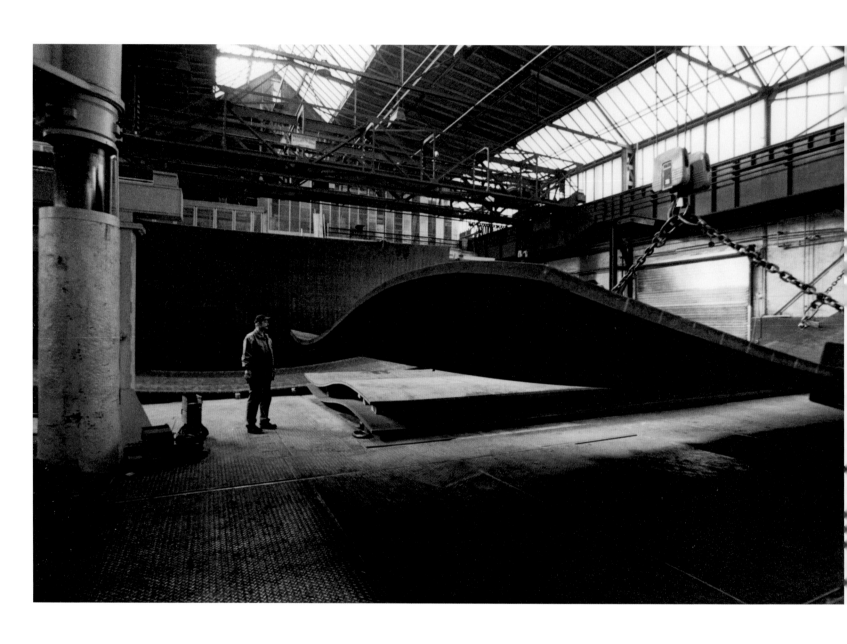

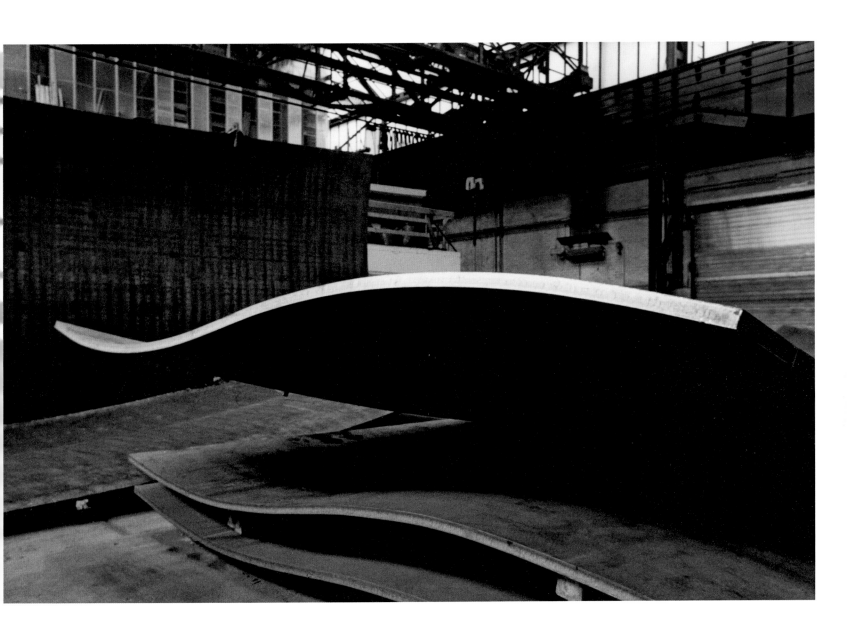

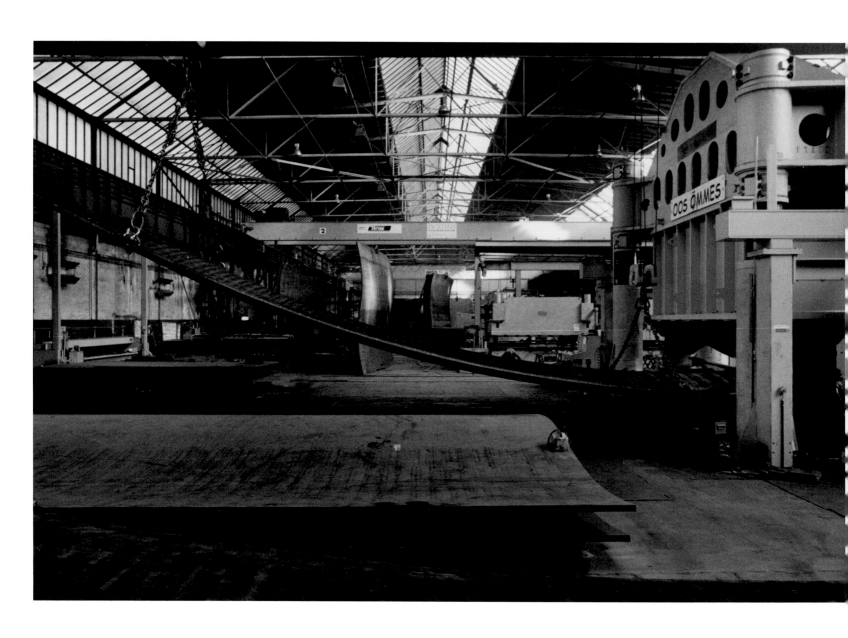

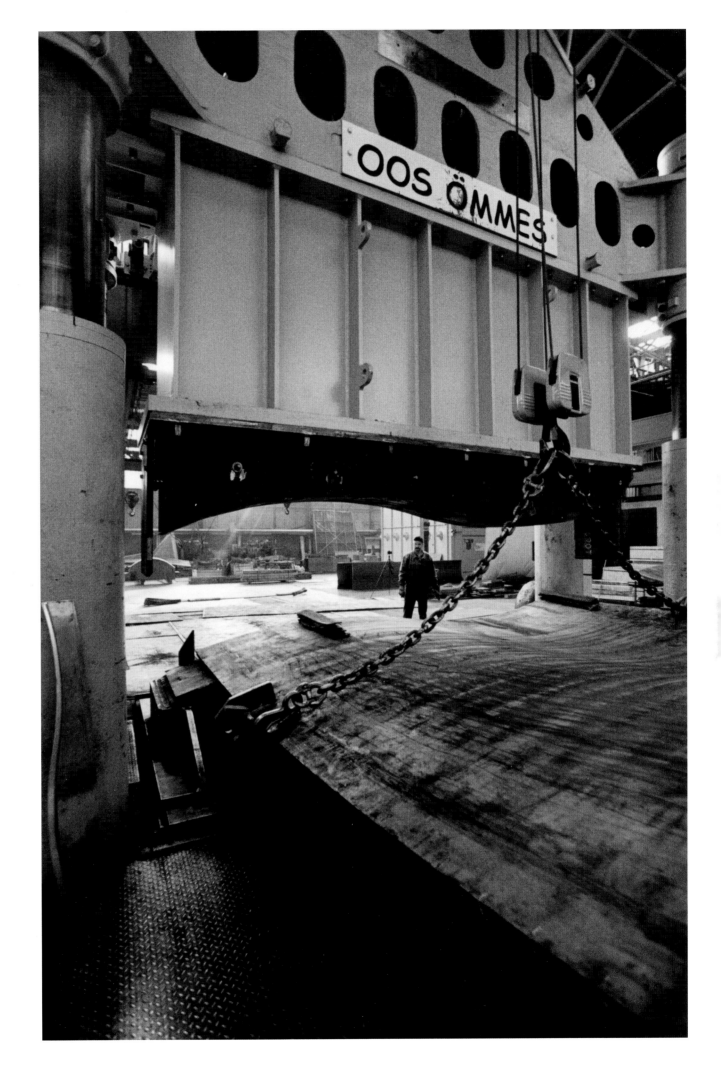

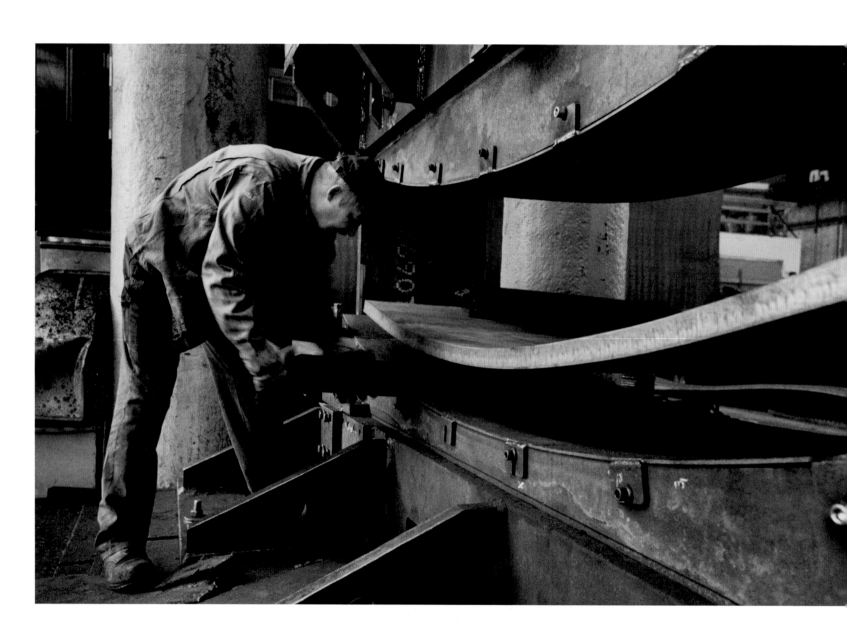

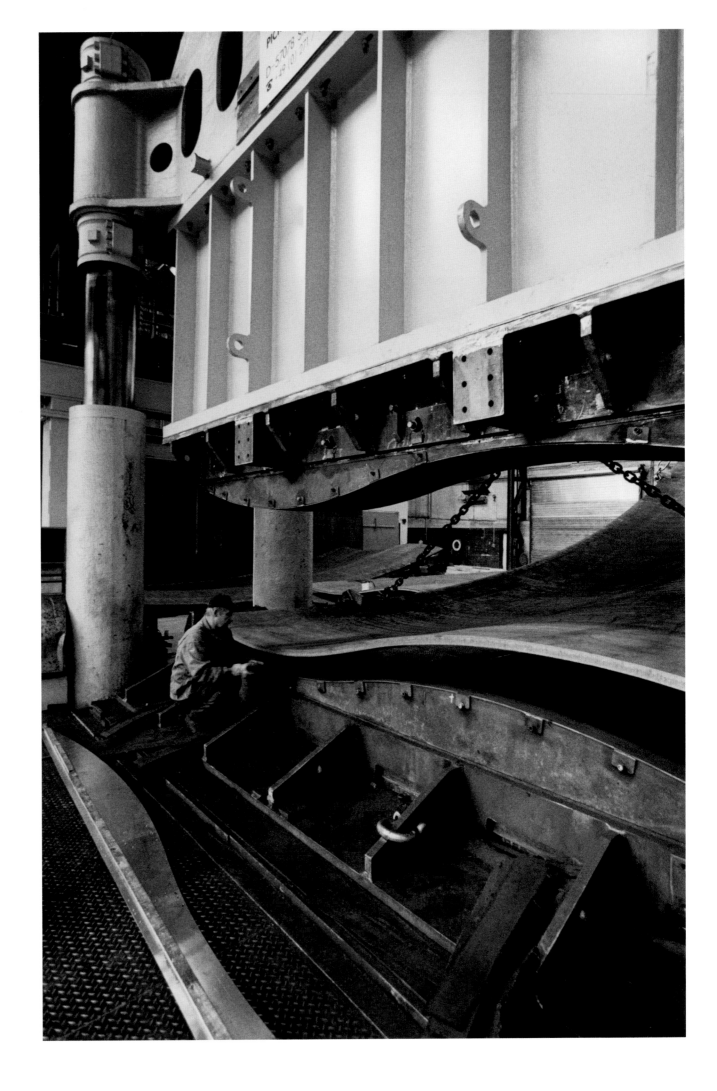

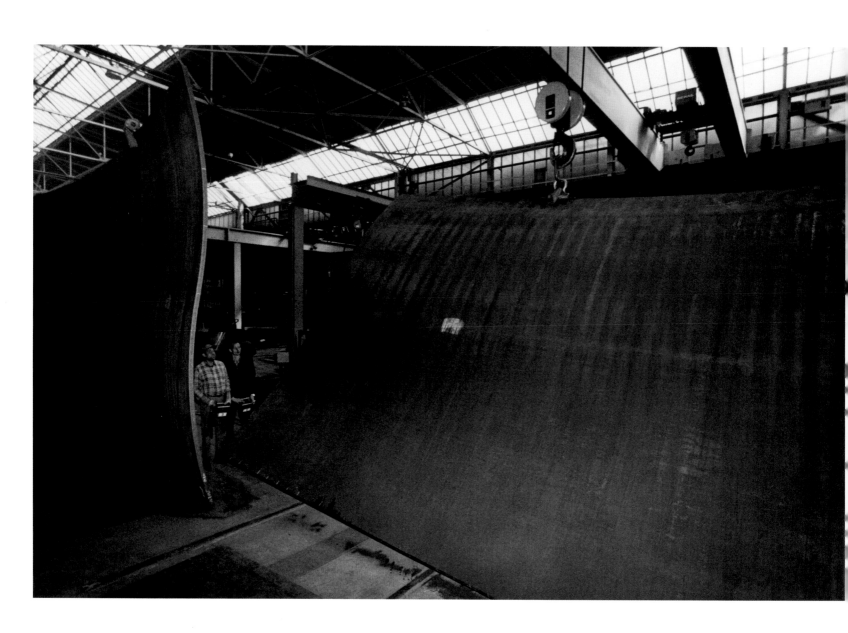

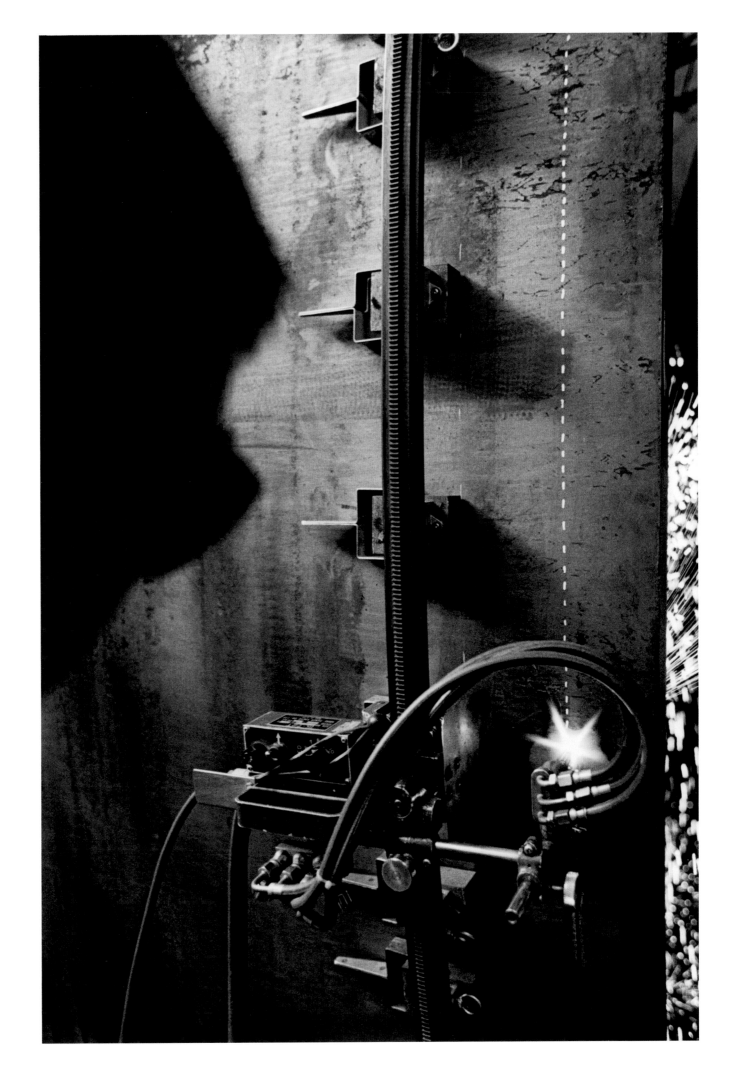

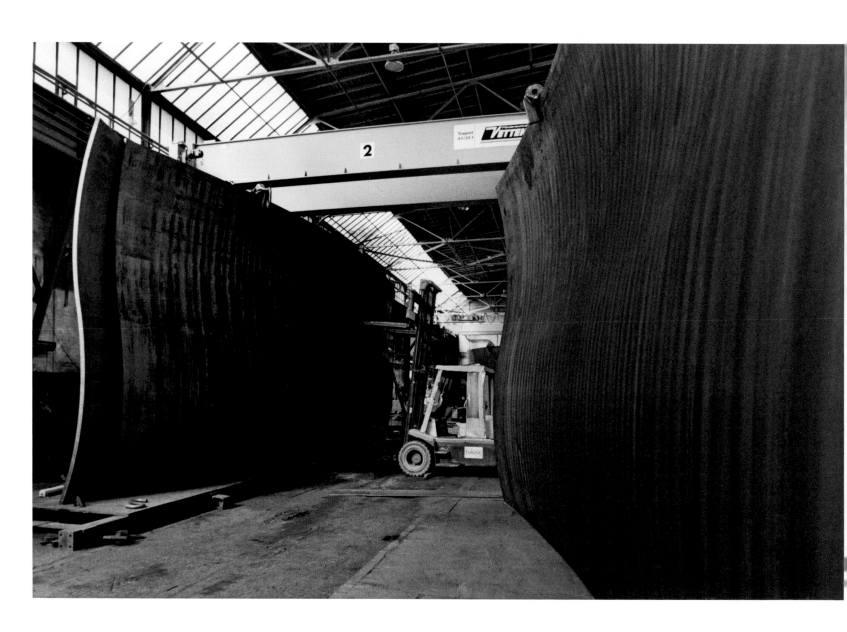

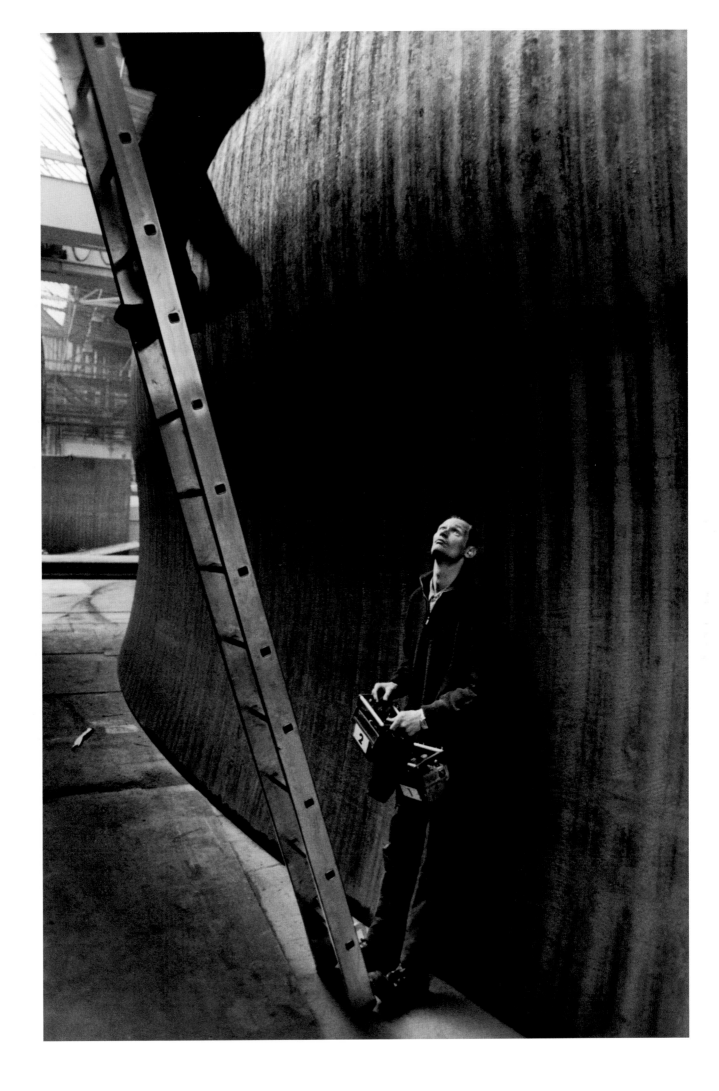

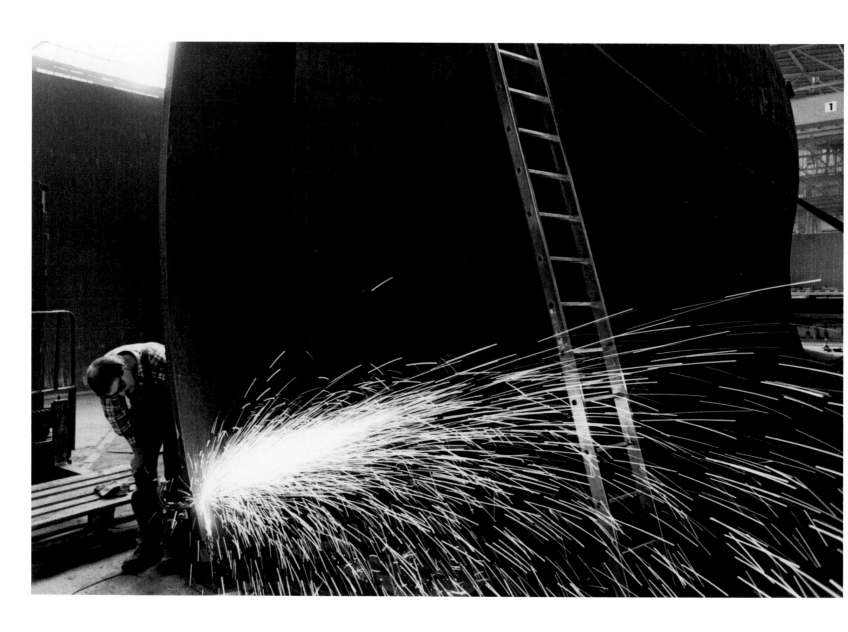

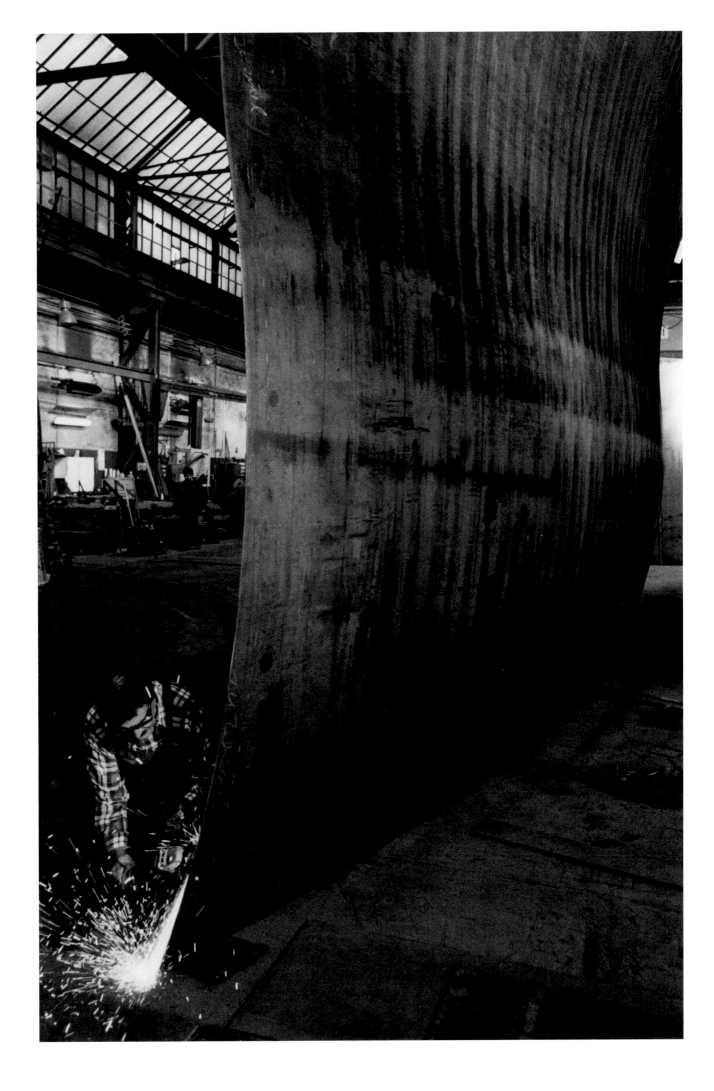

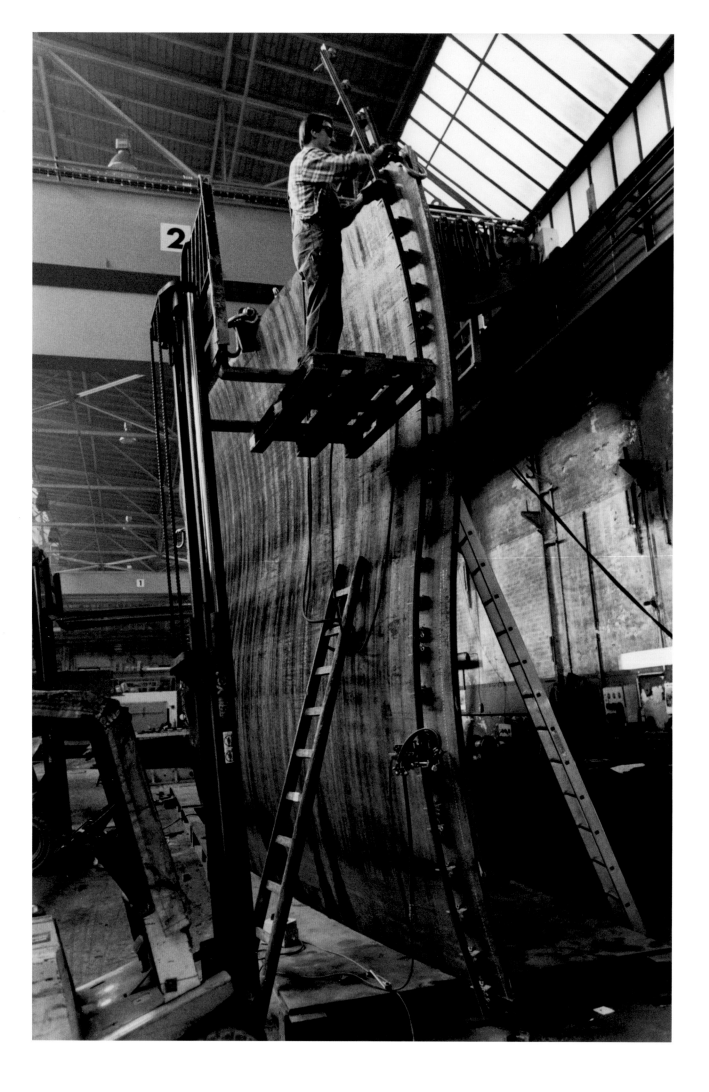

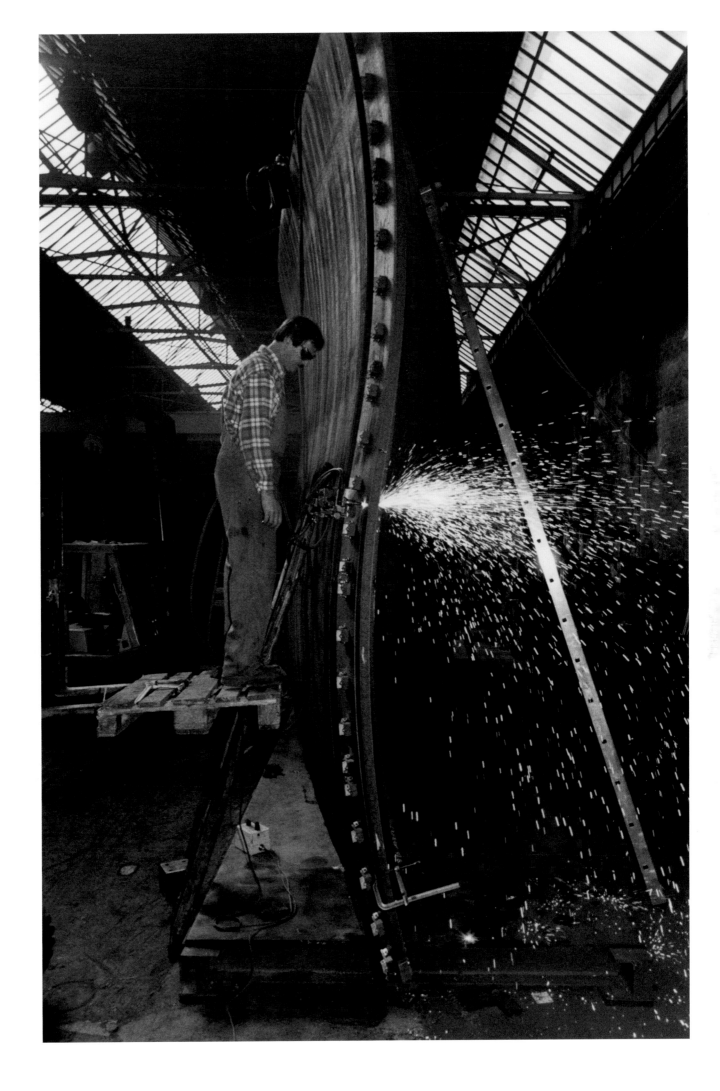

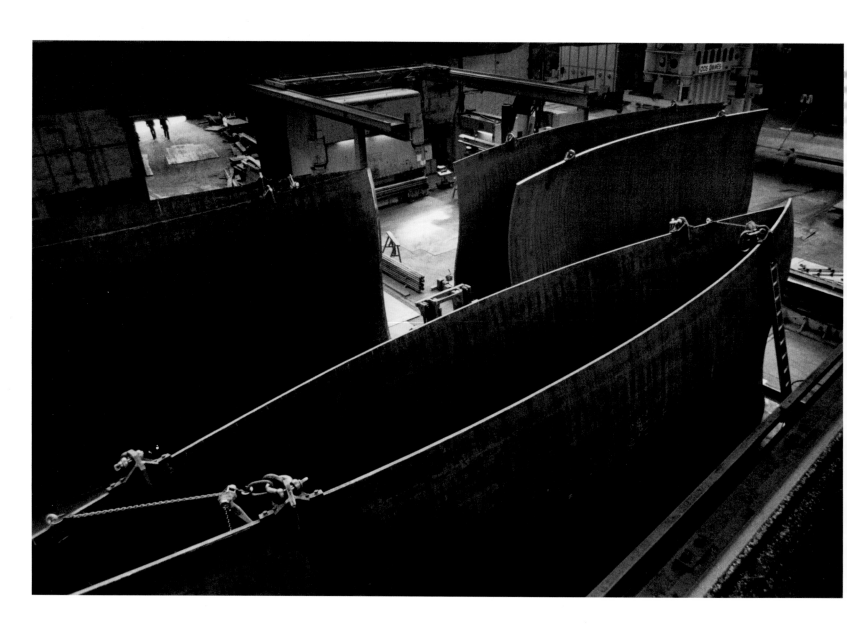

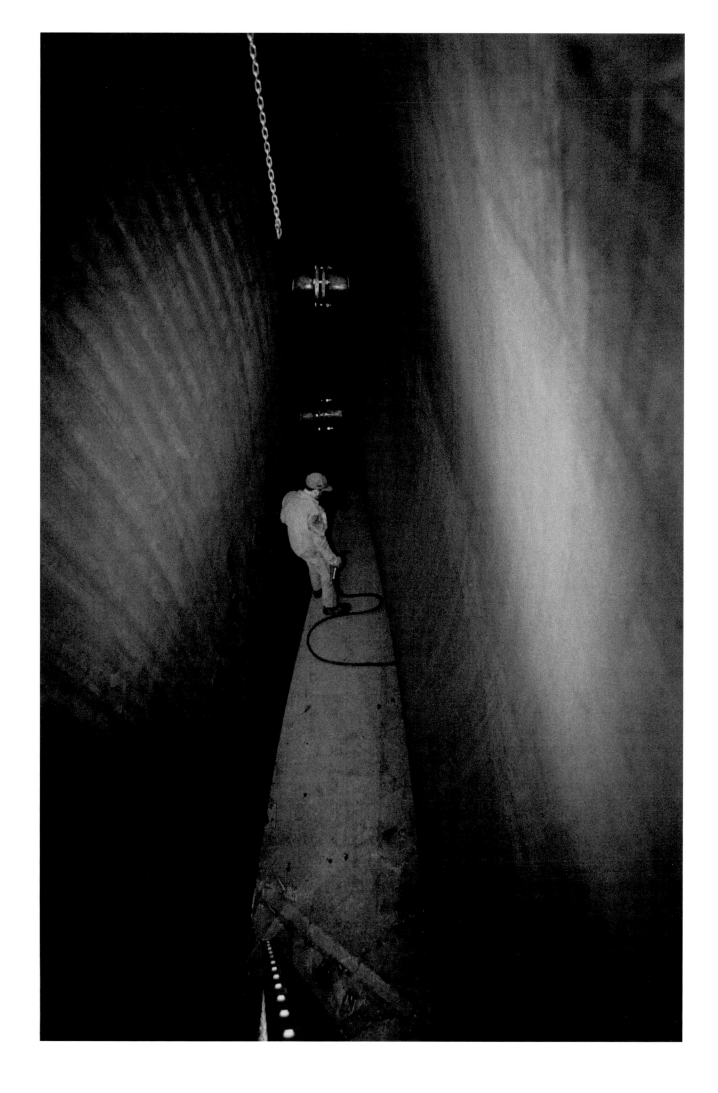

Ausgewählte Skulpturen von Richard Serra

Selected sculptures by Richard Serra

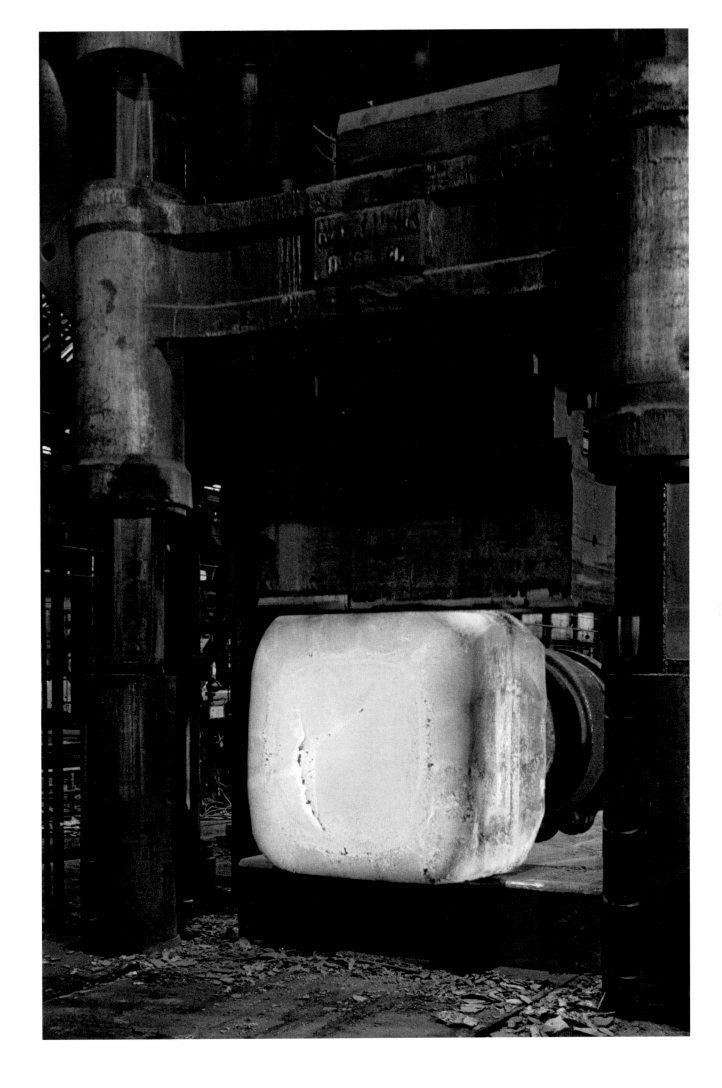

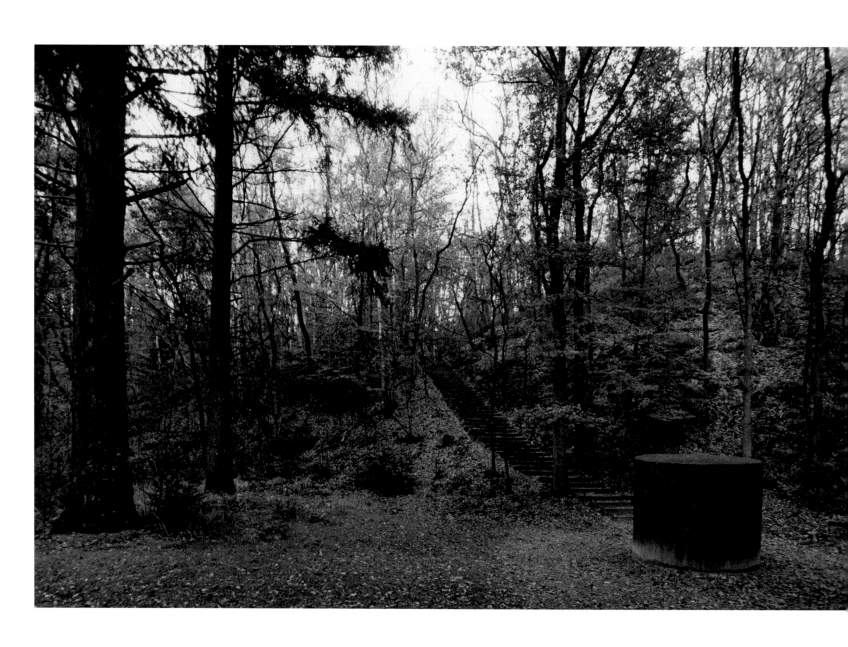

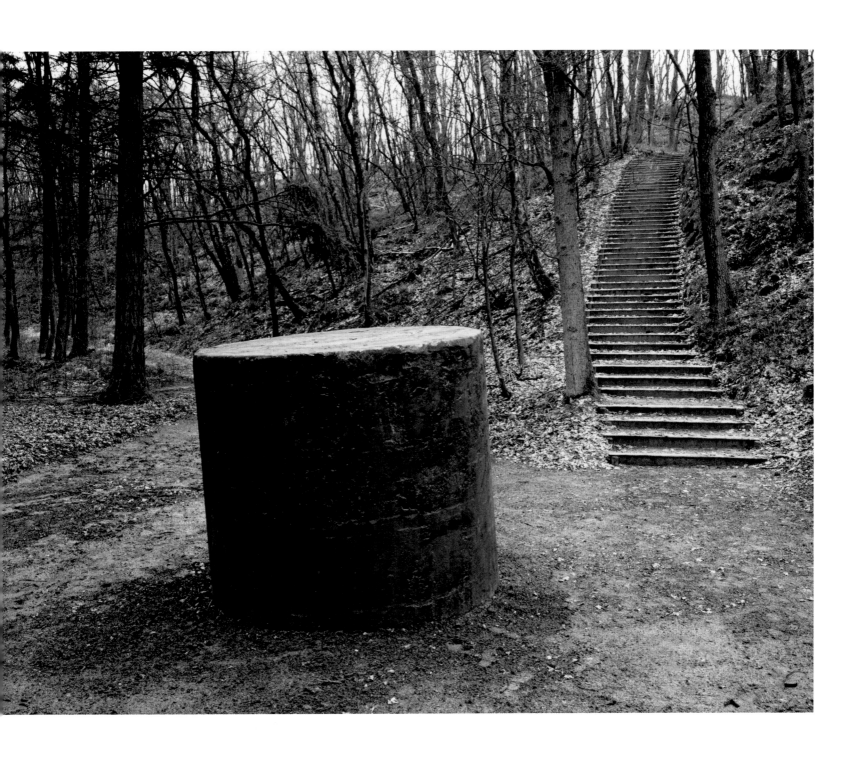

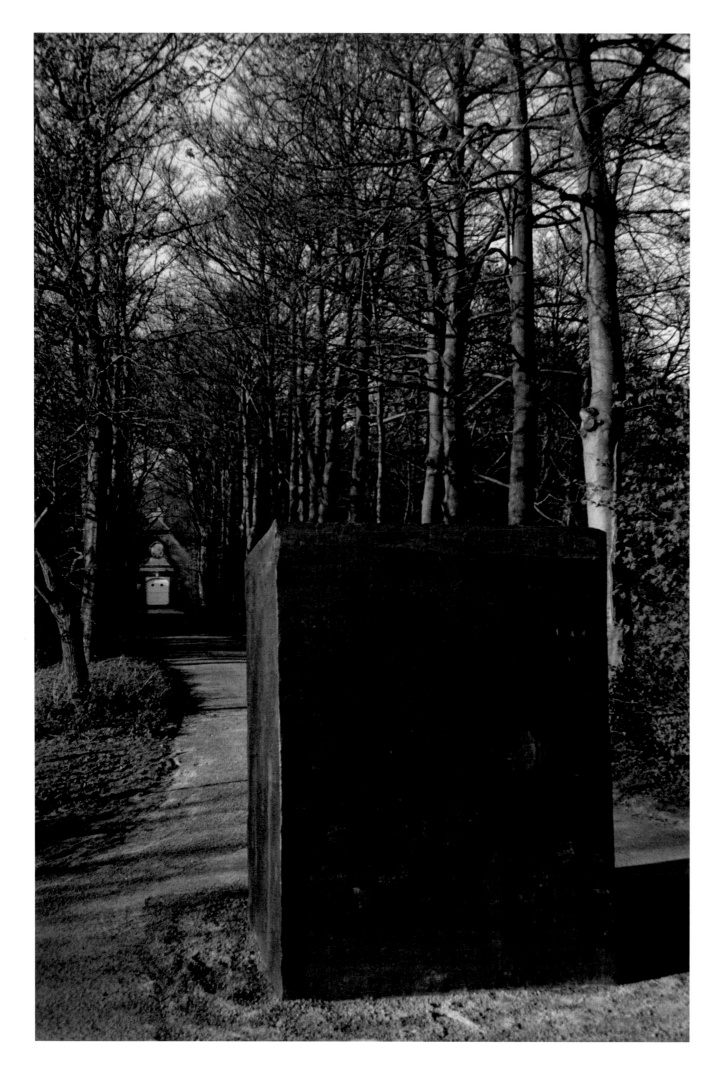

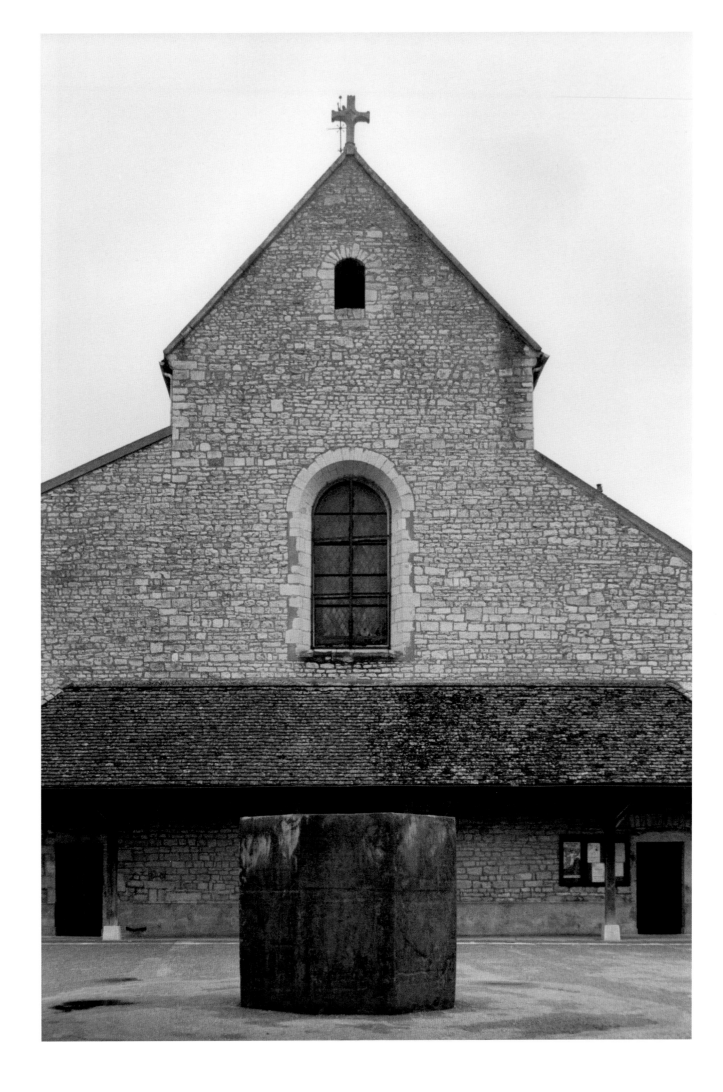

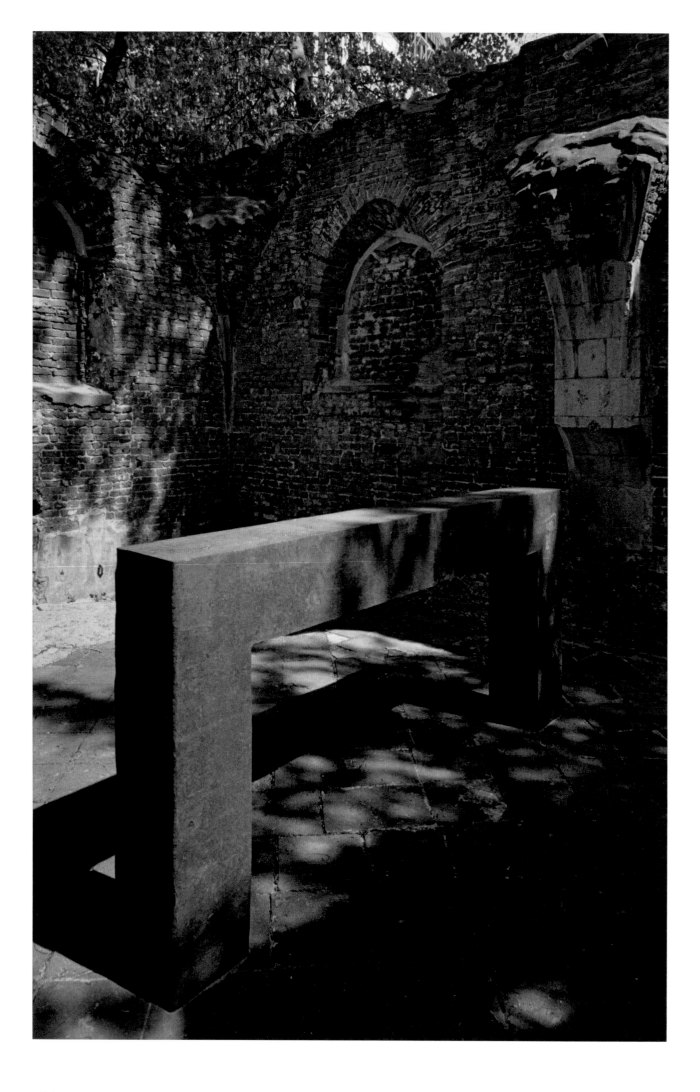

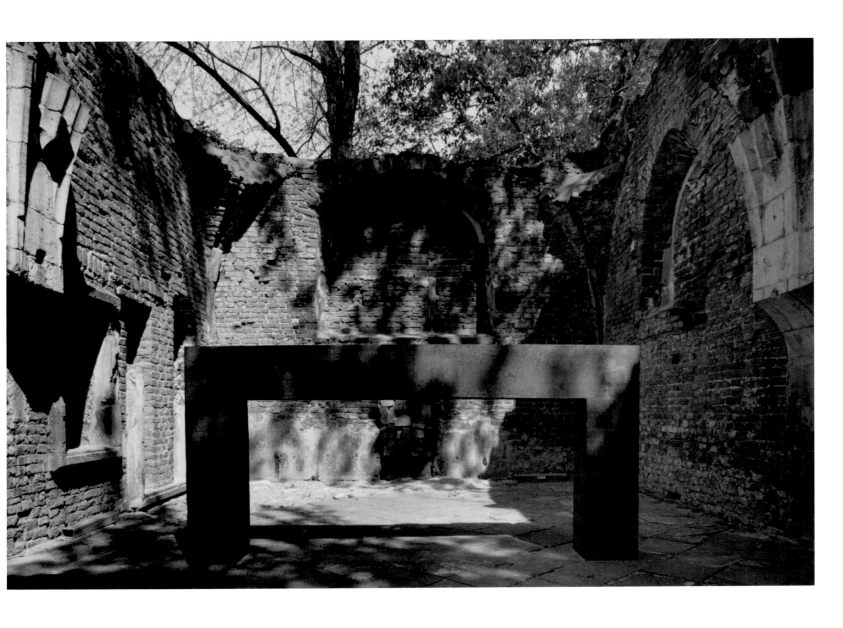

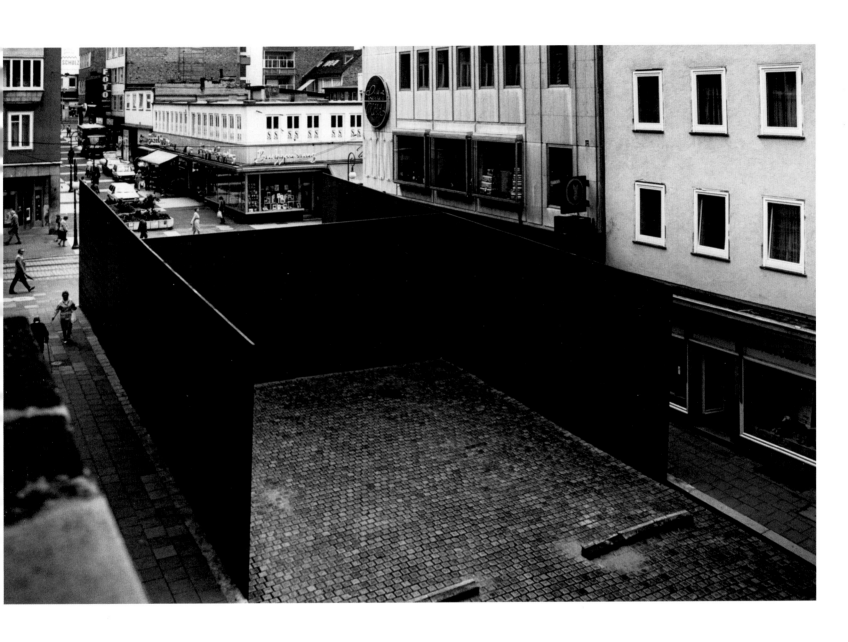

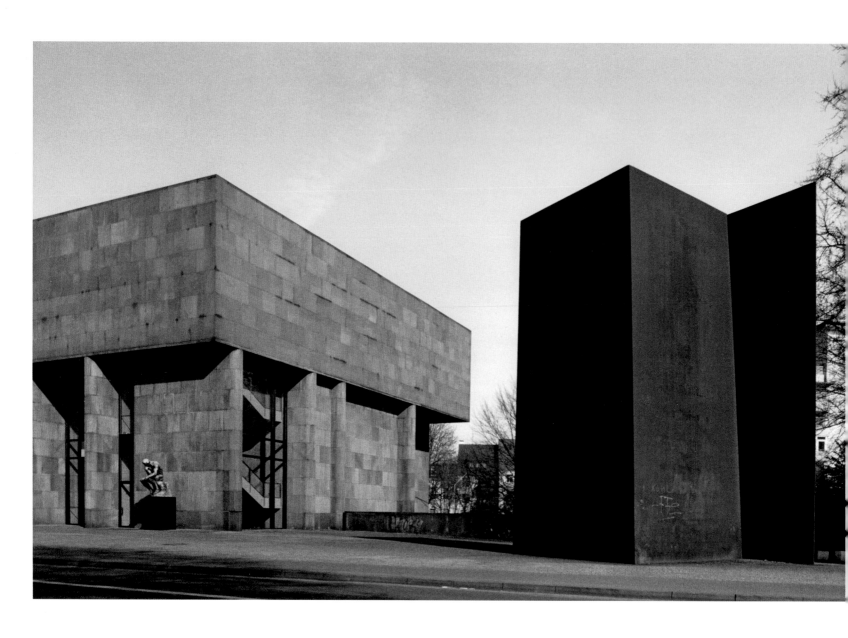

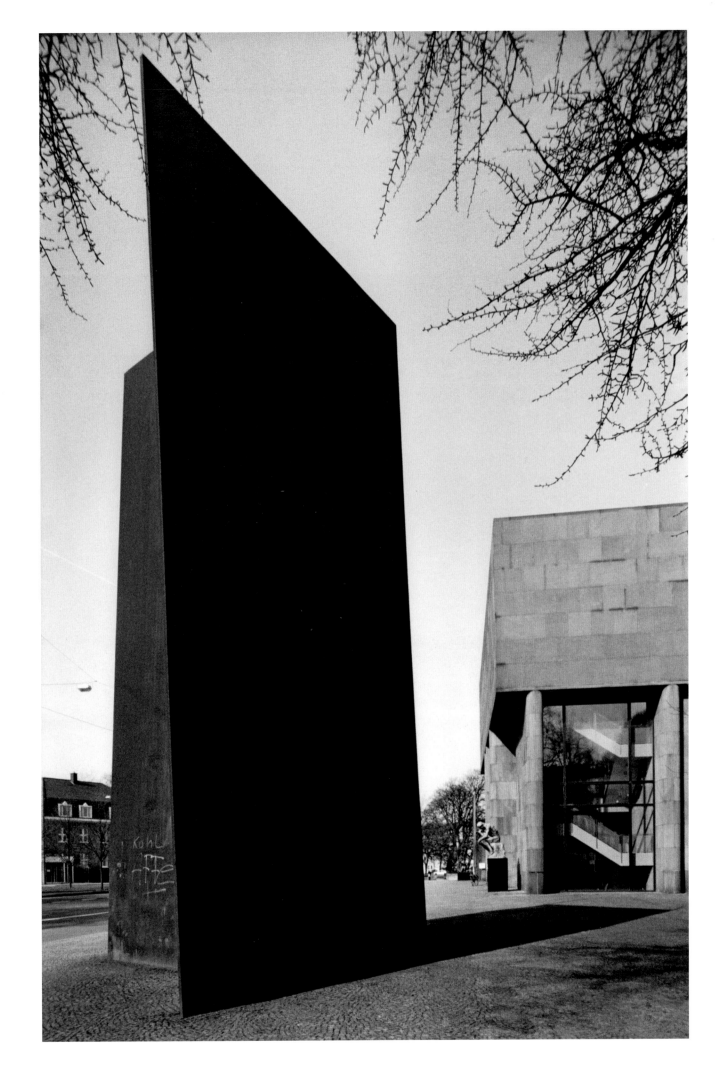

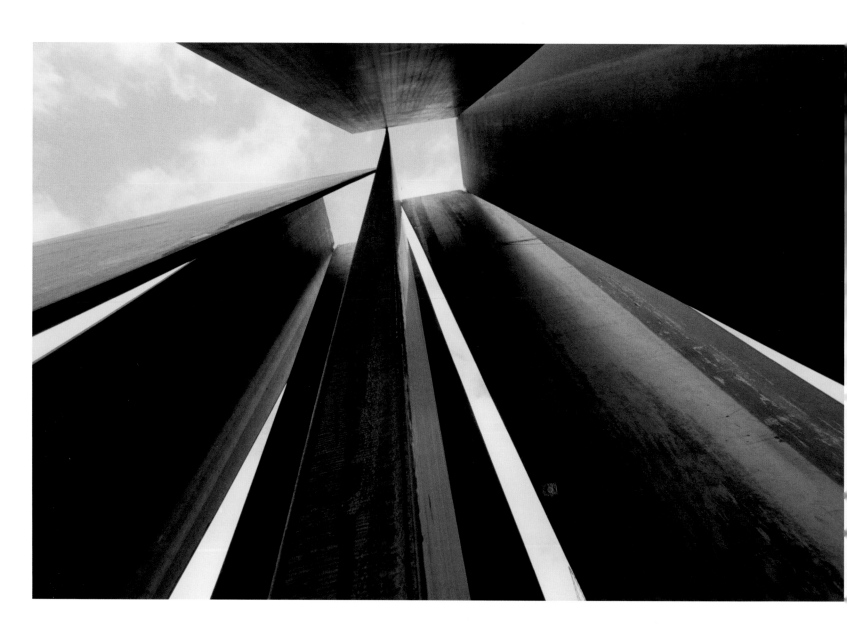

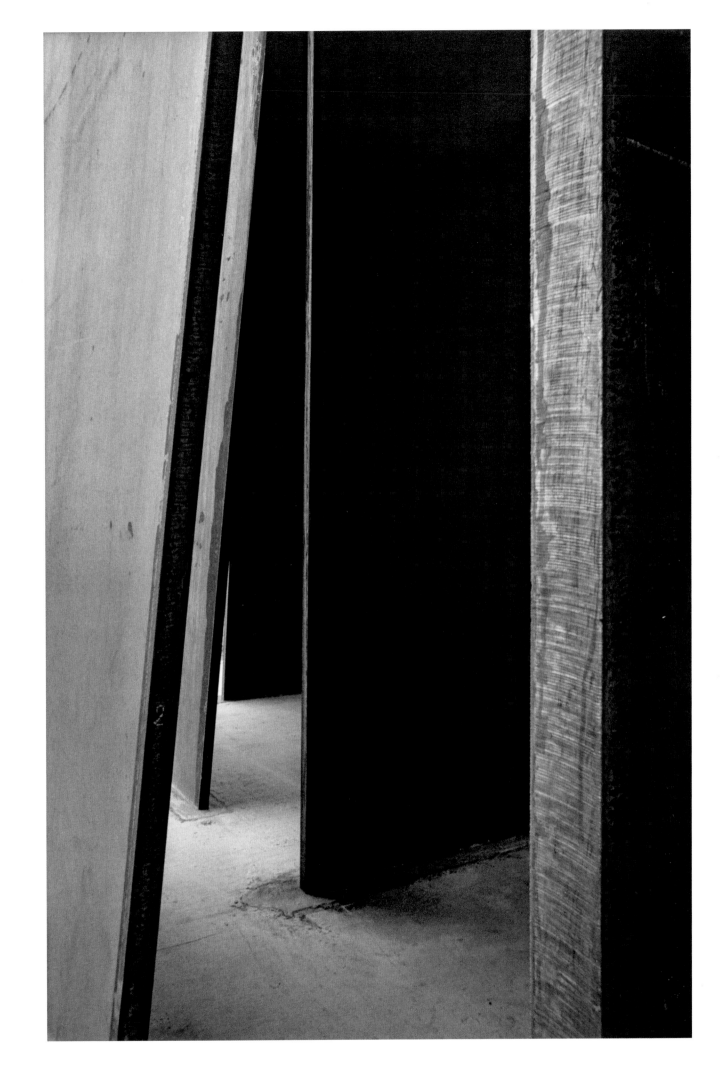

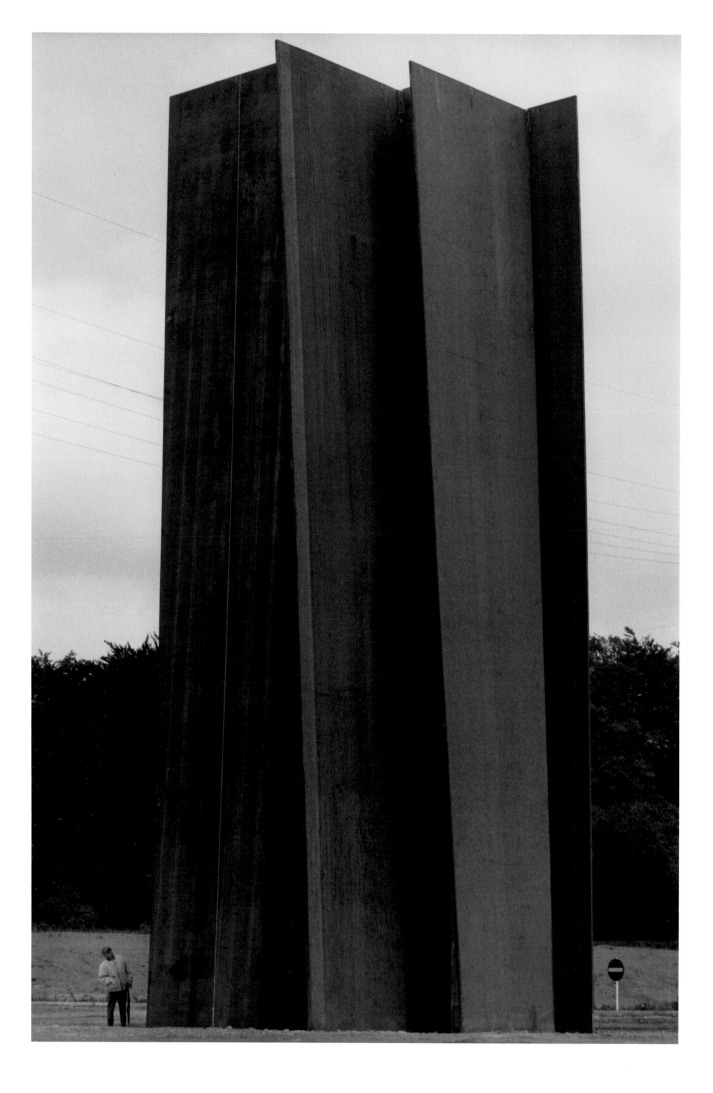

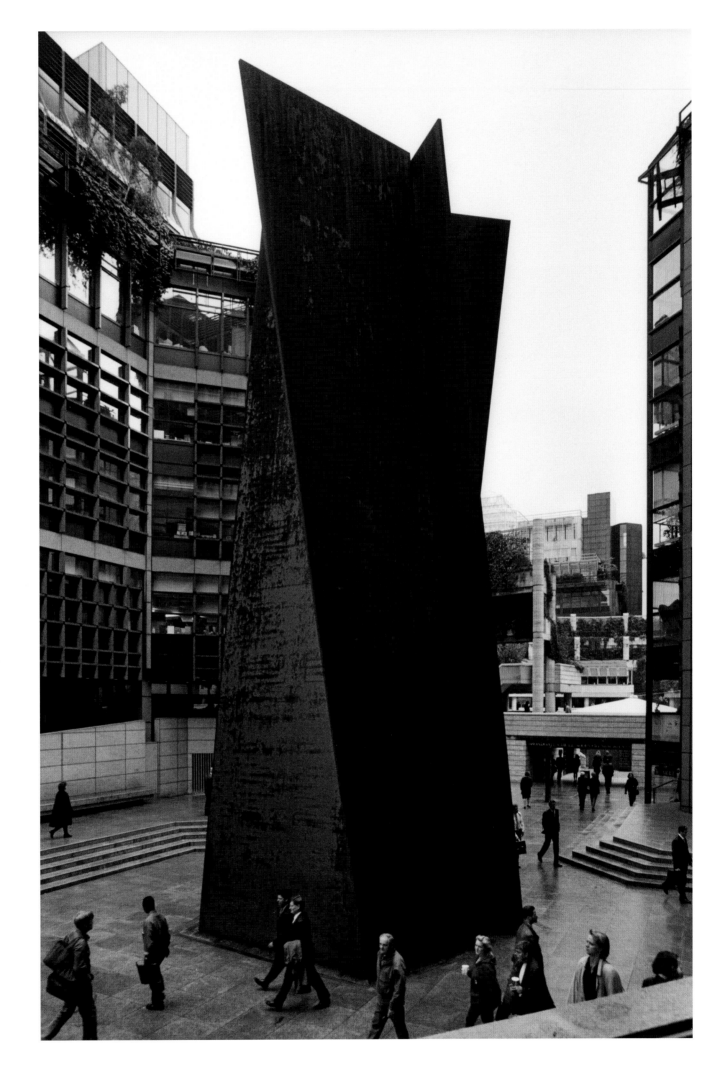

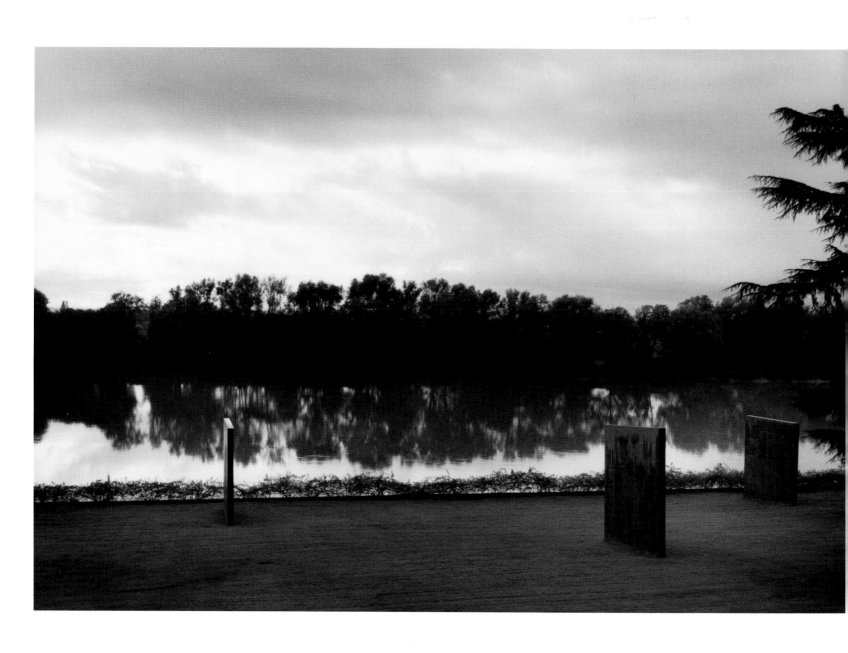

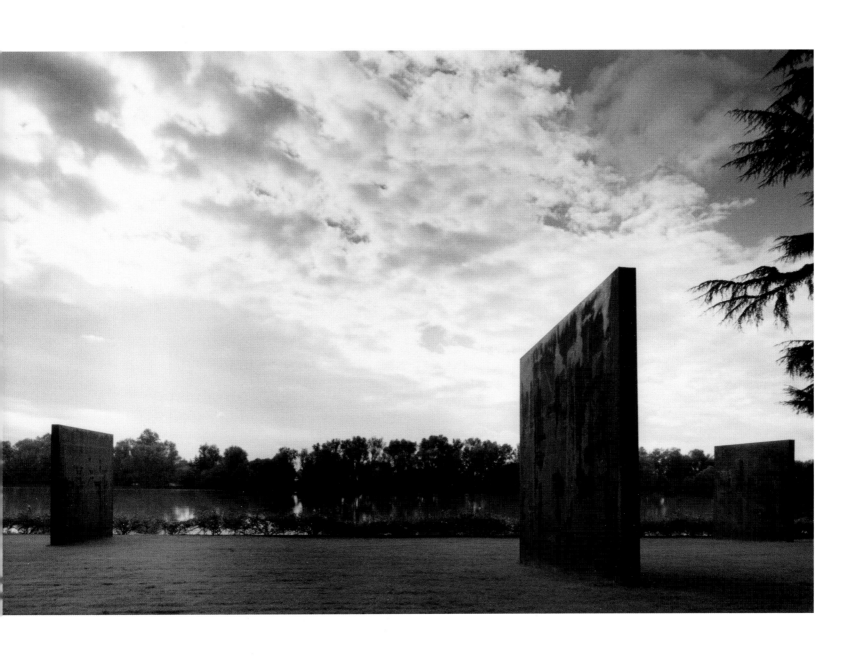

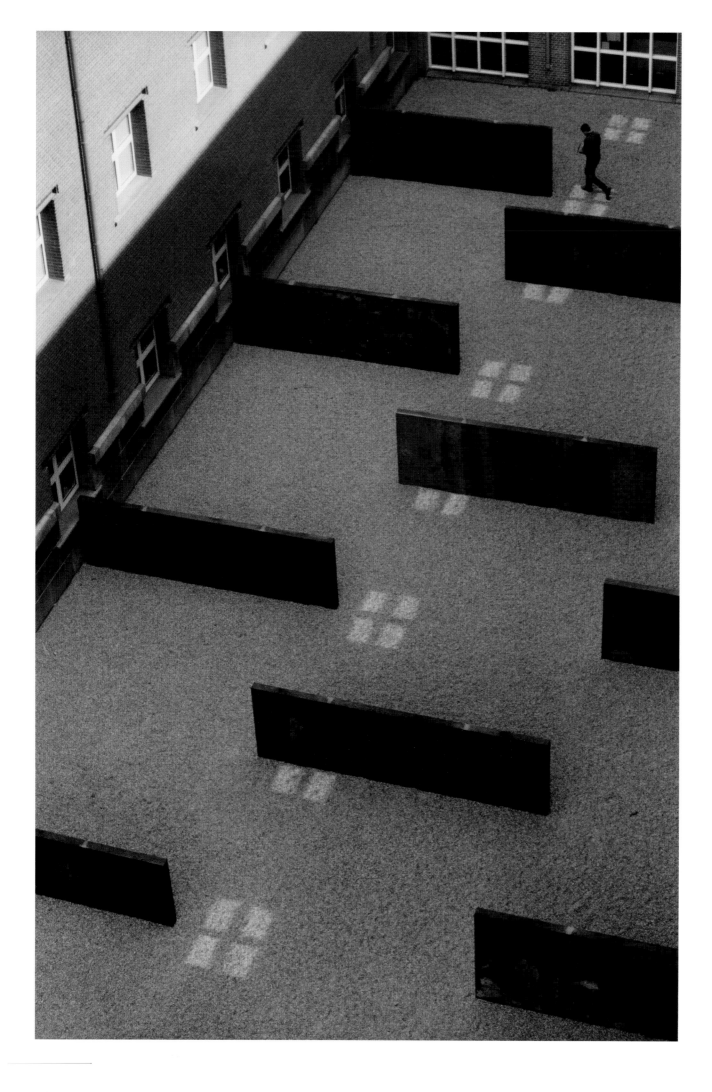

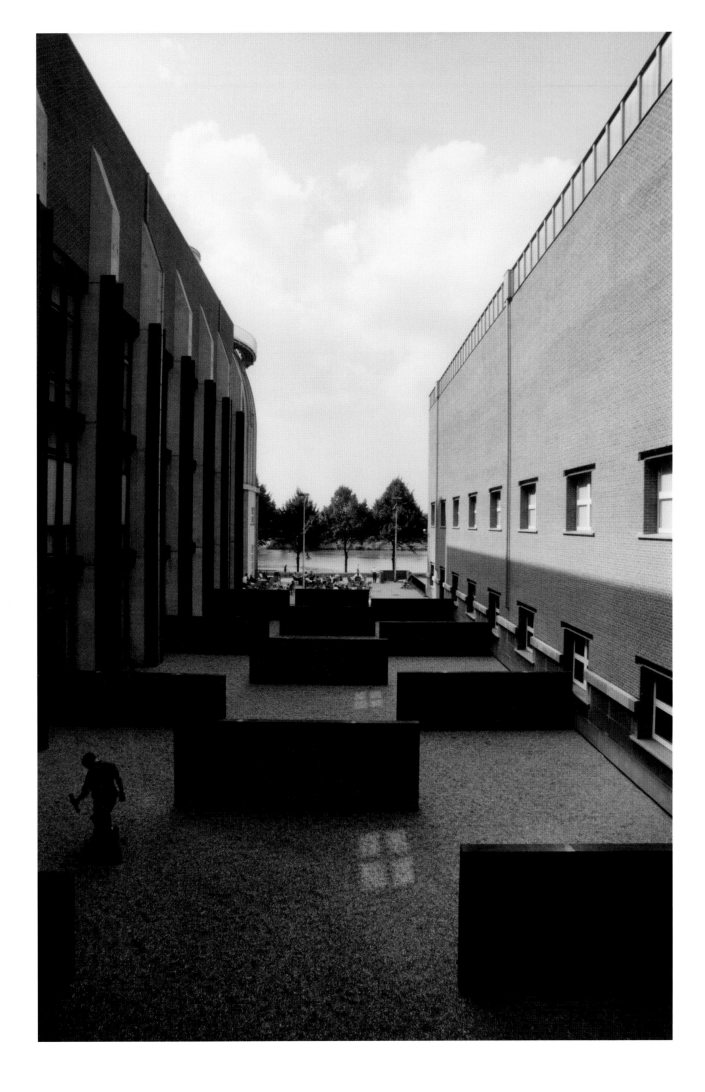

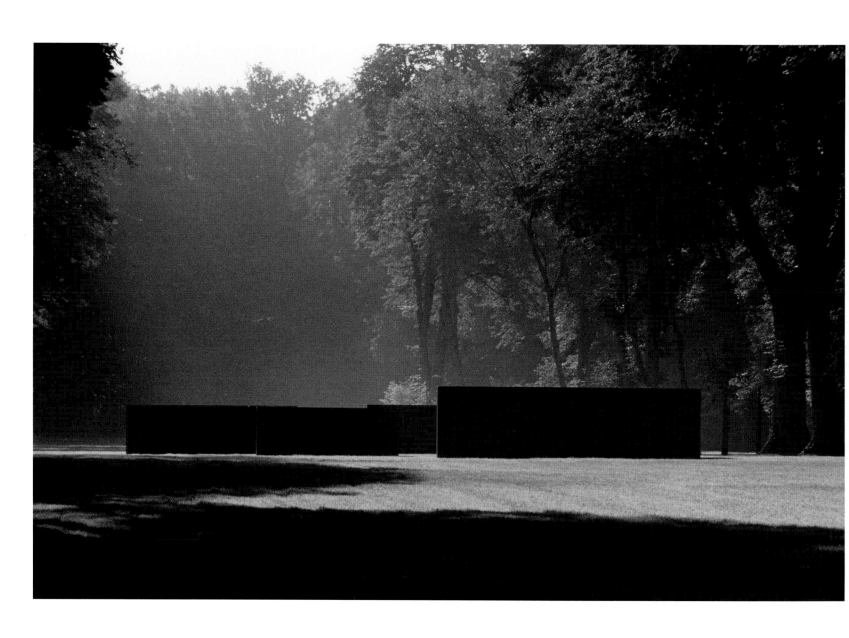

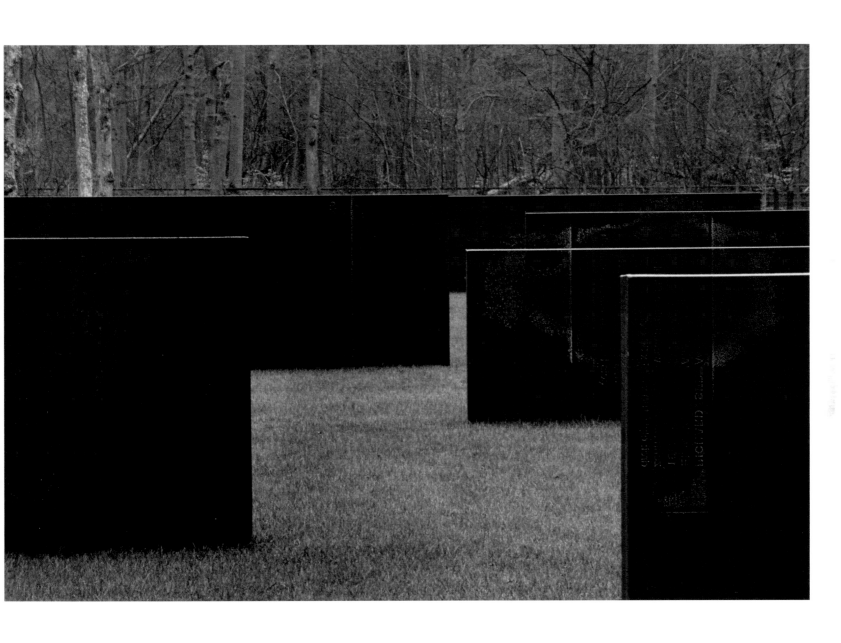

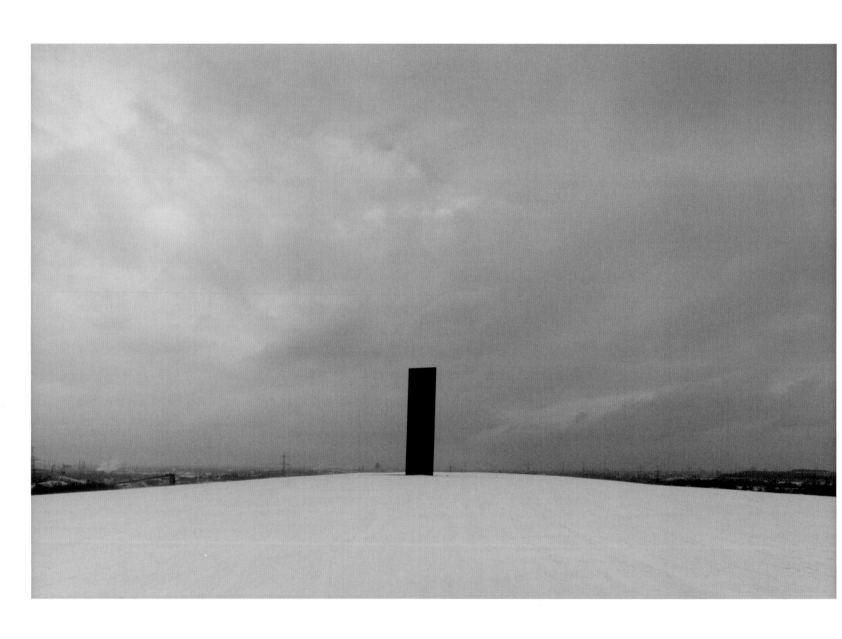

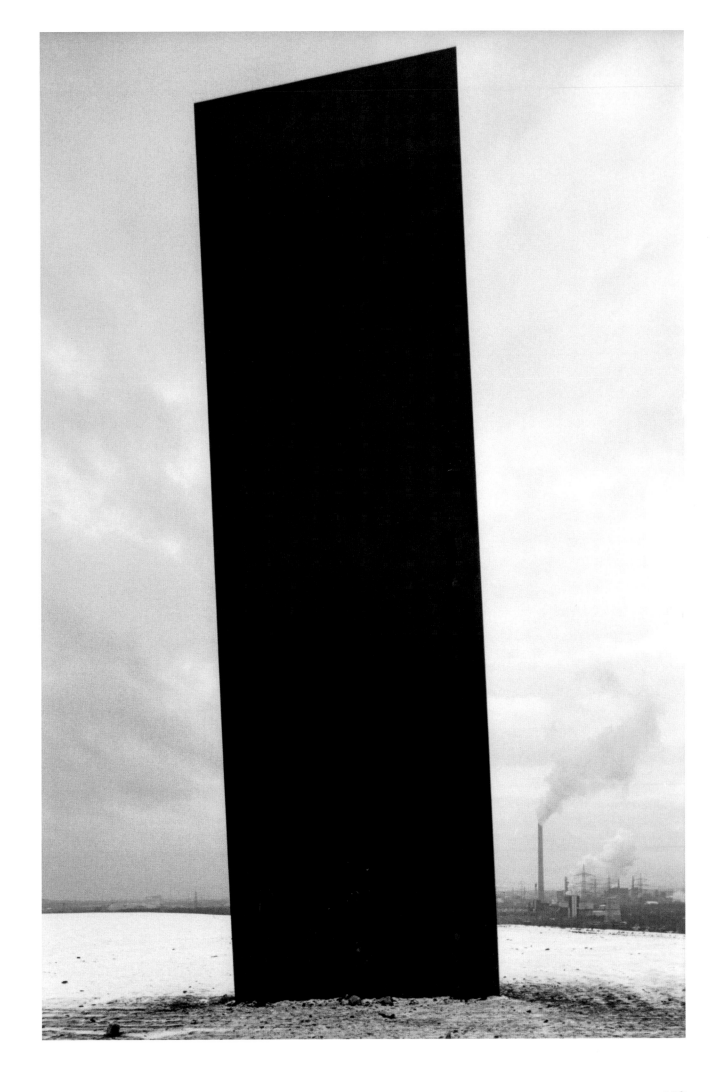

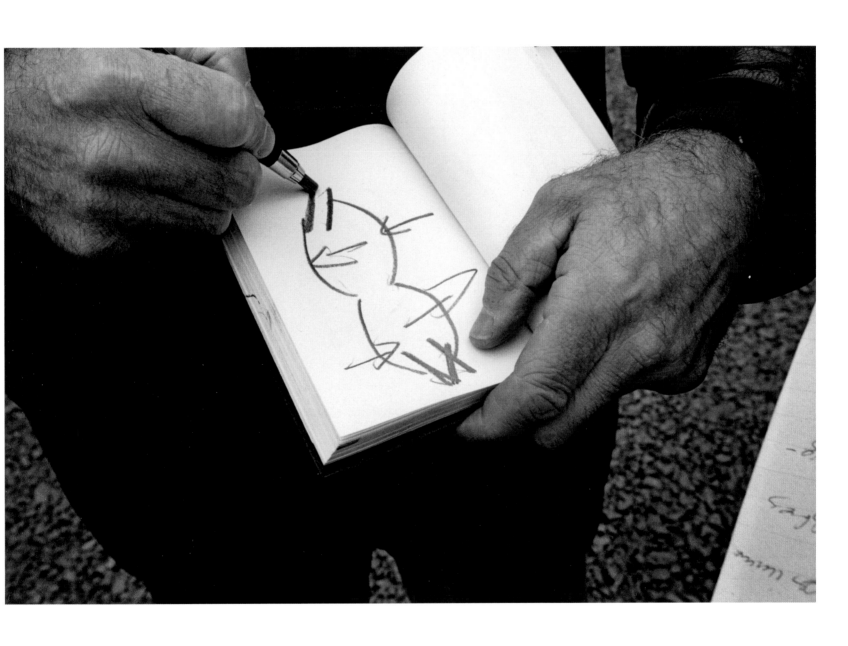

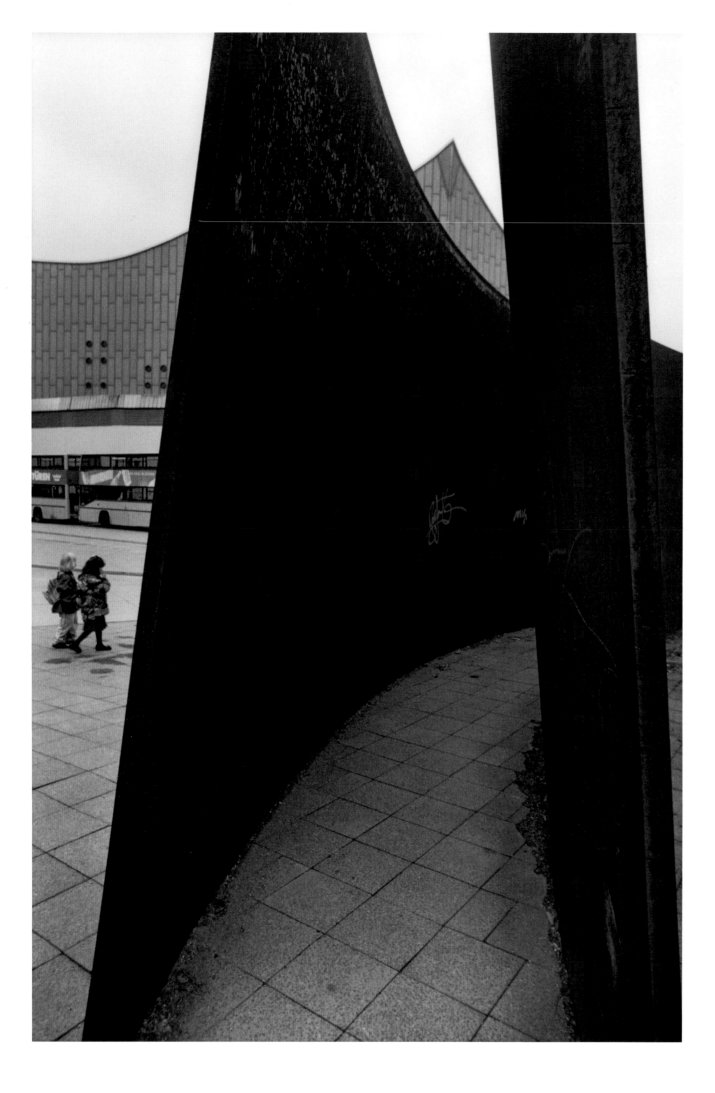

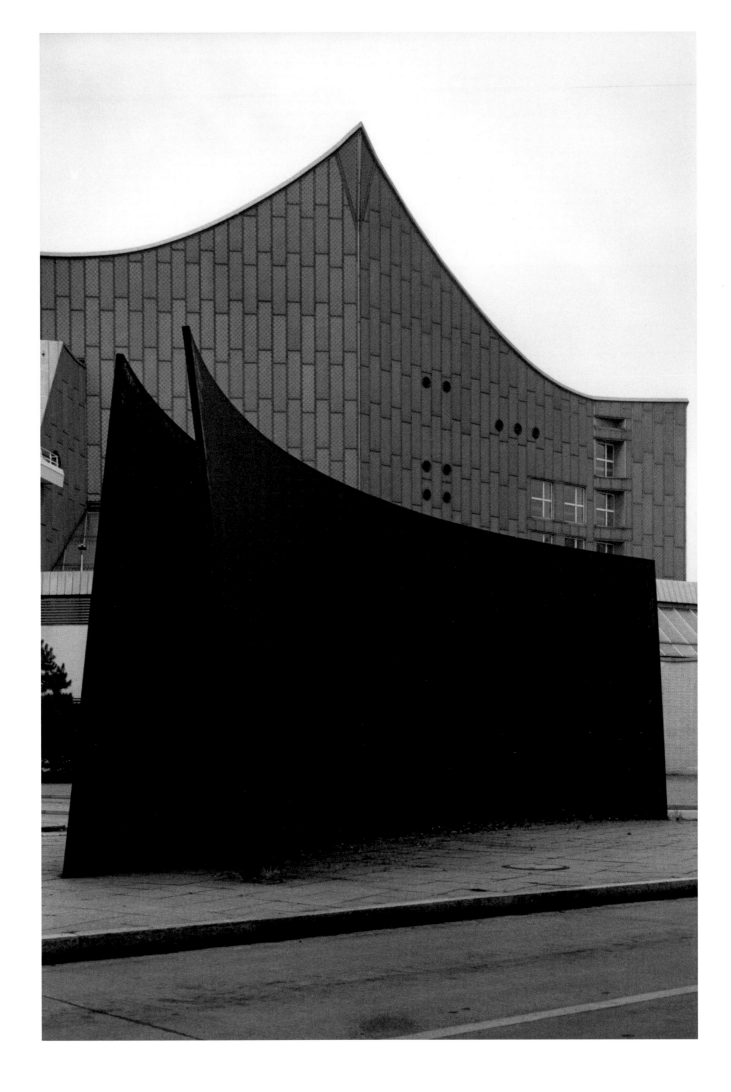

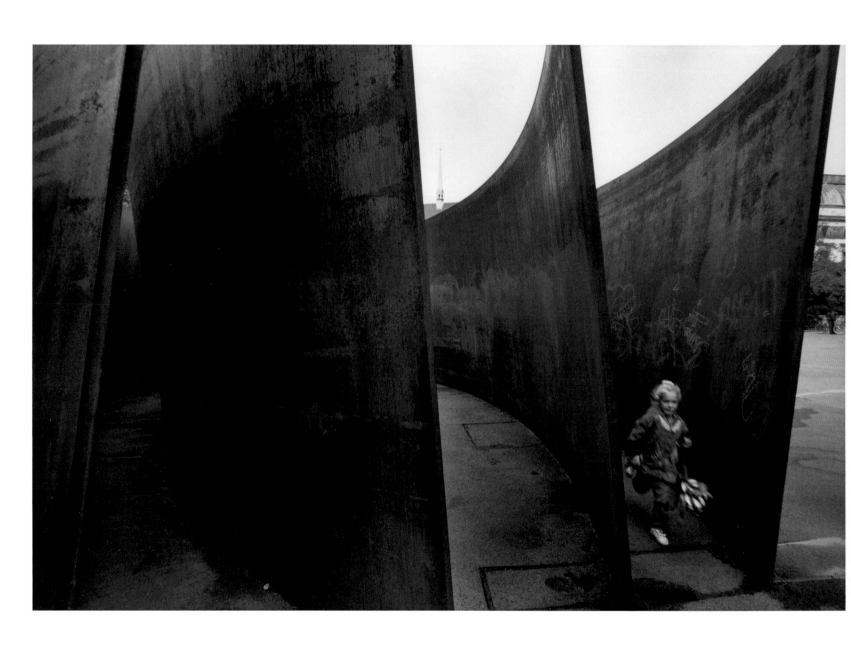

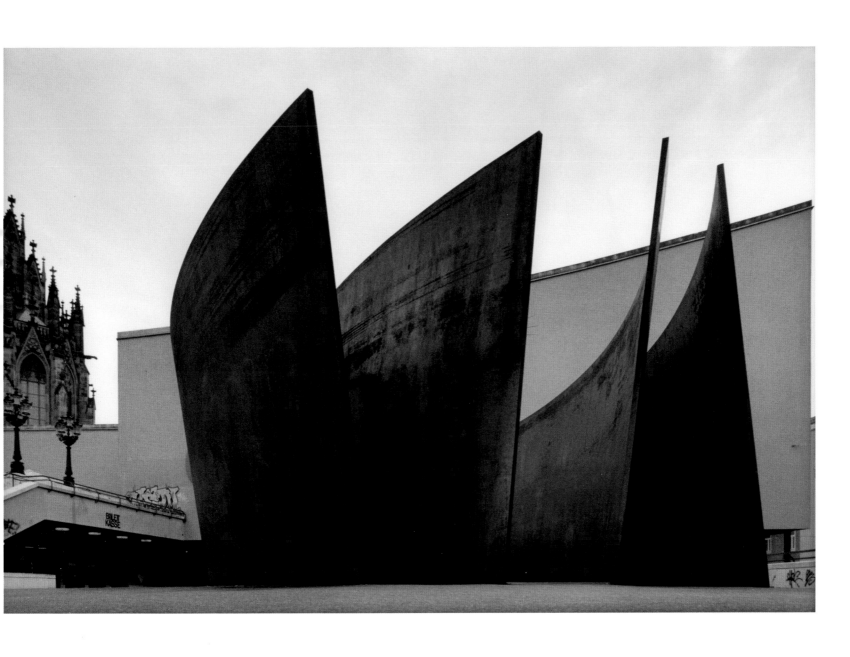

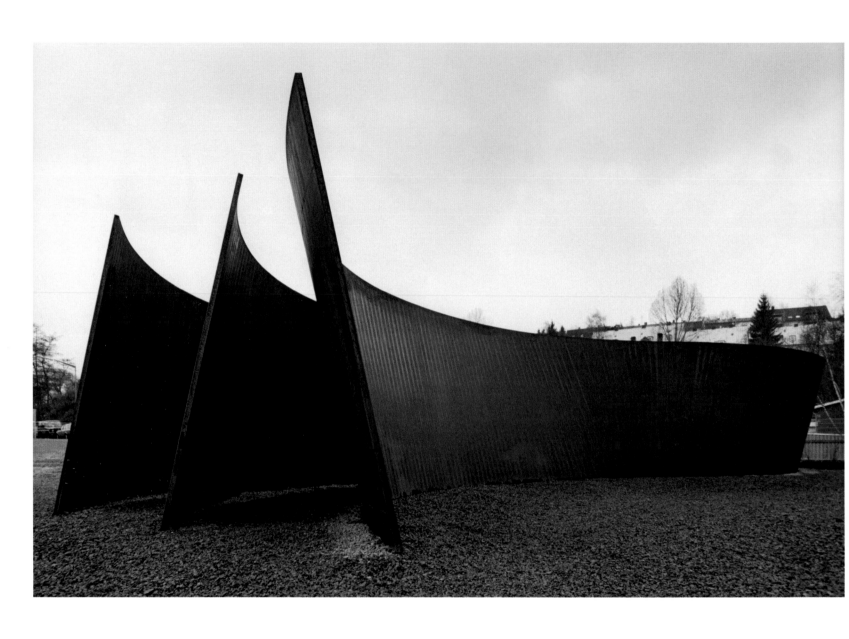

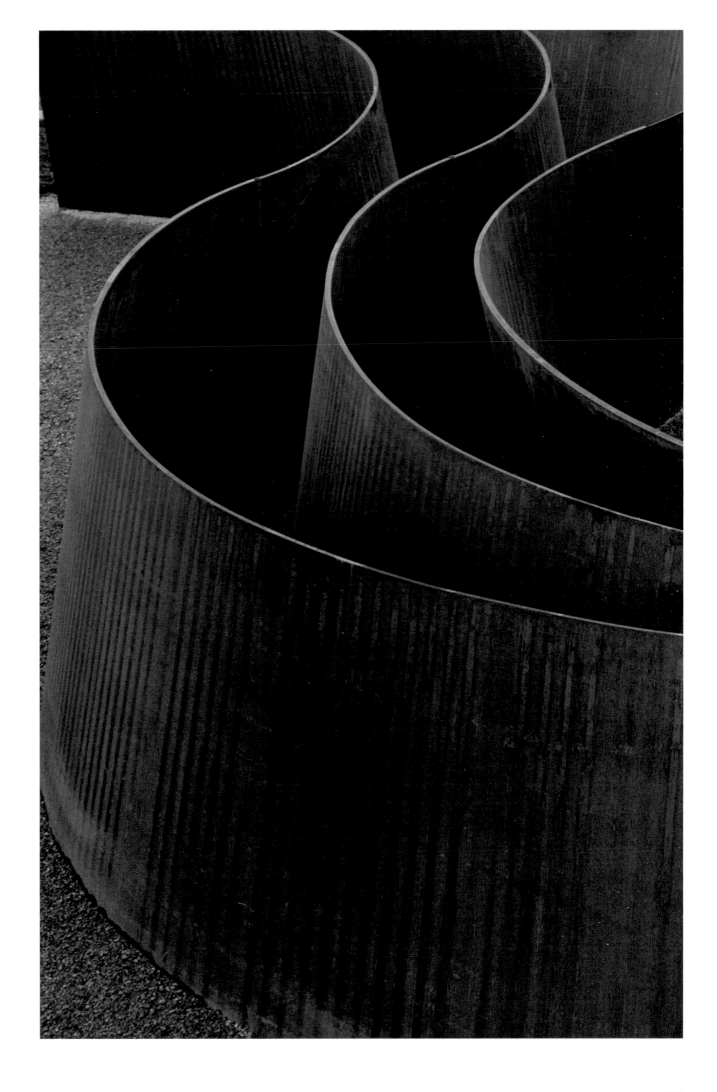

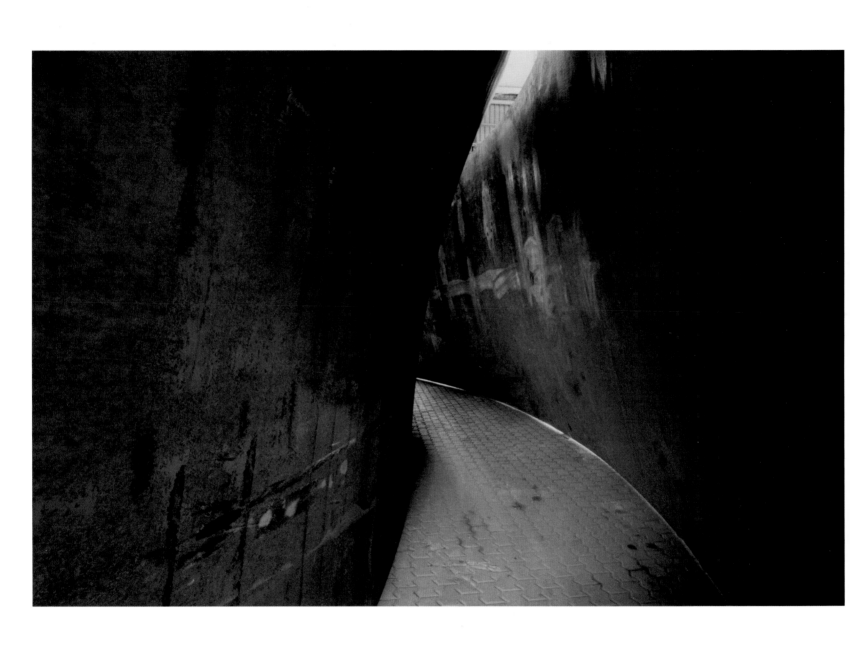

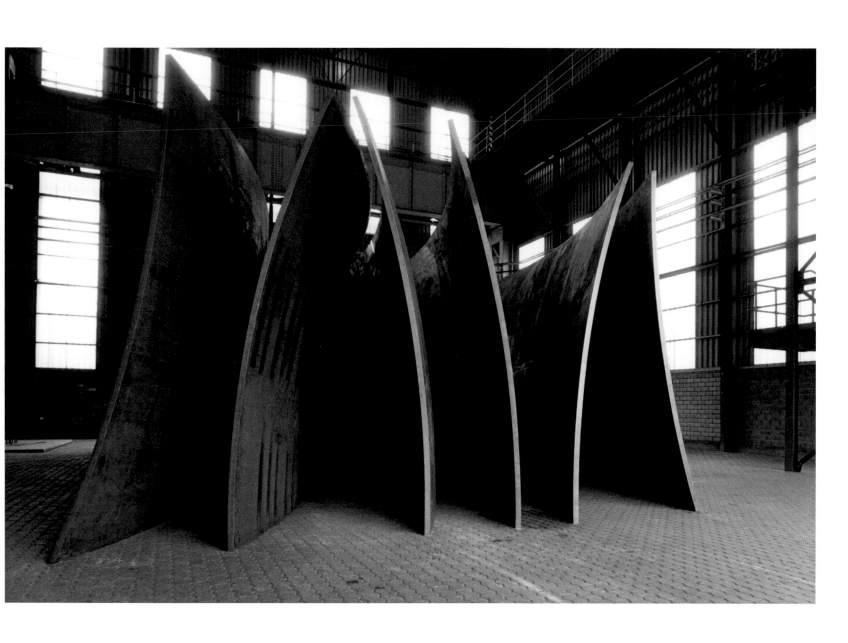

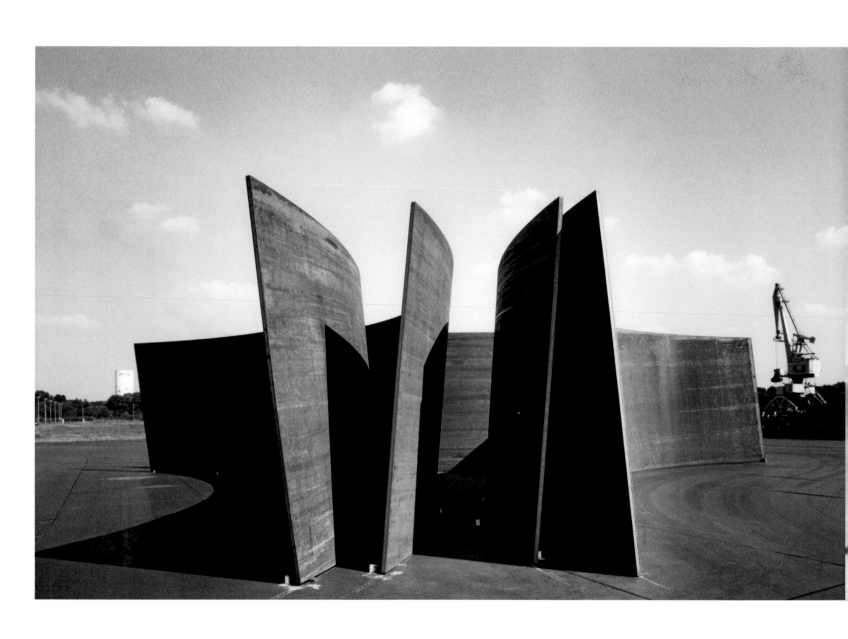

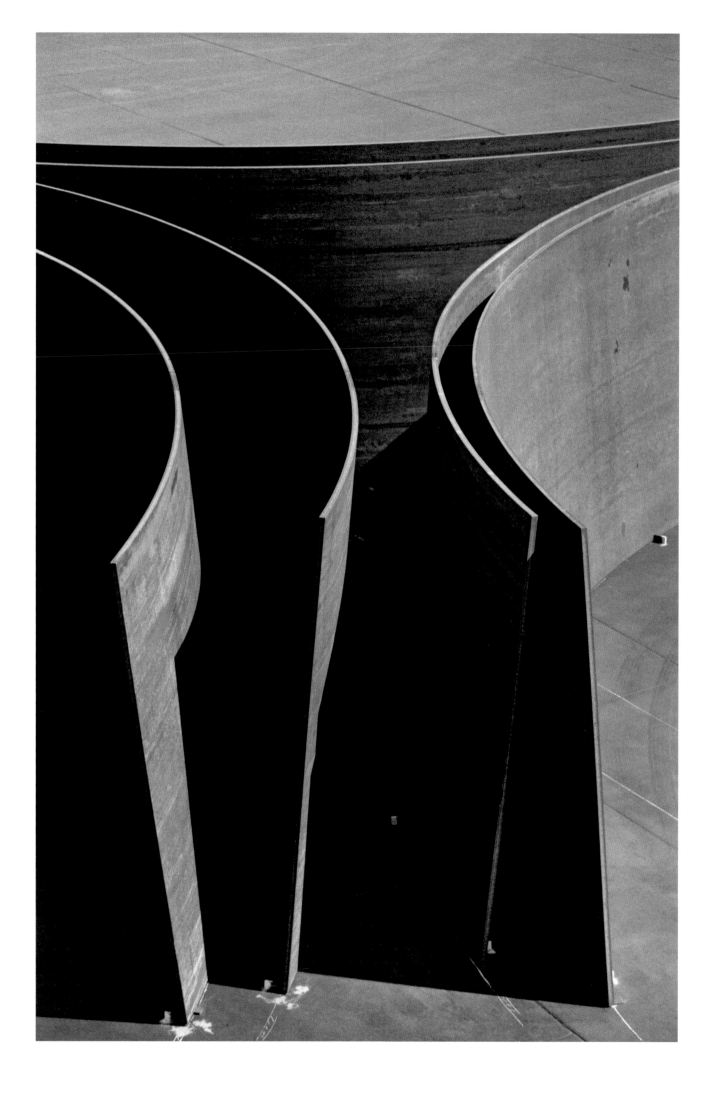

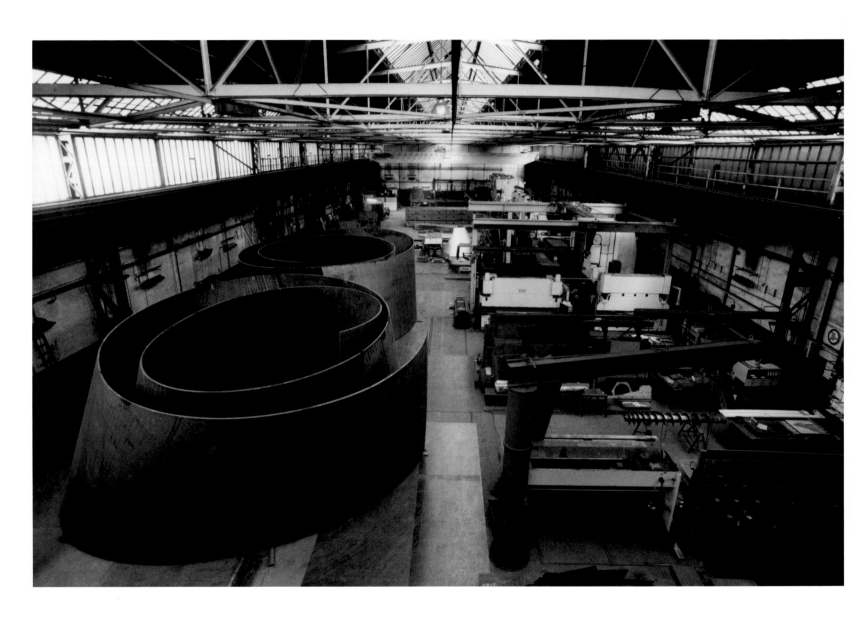

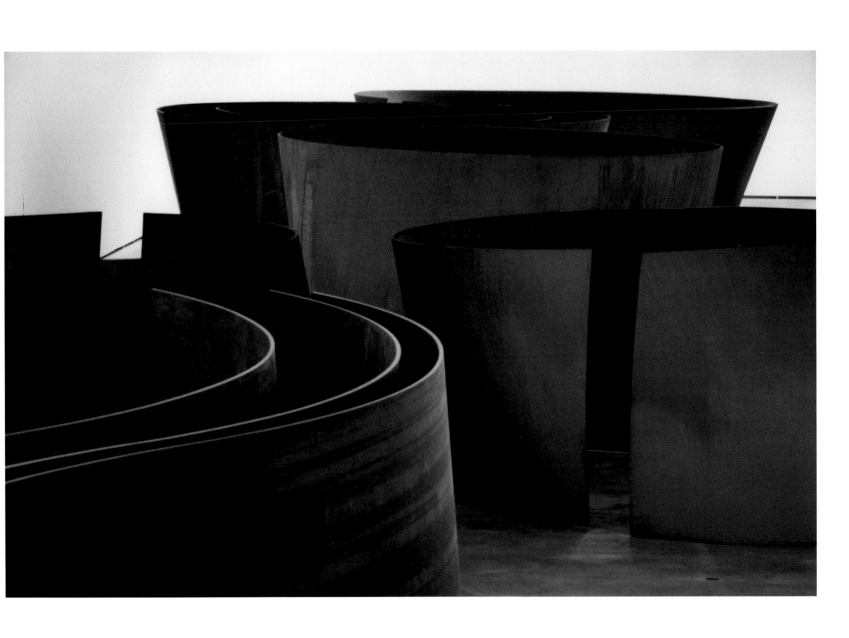

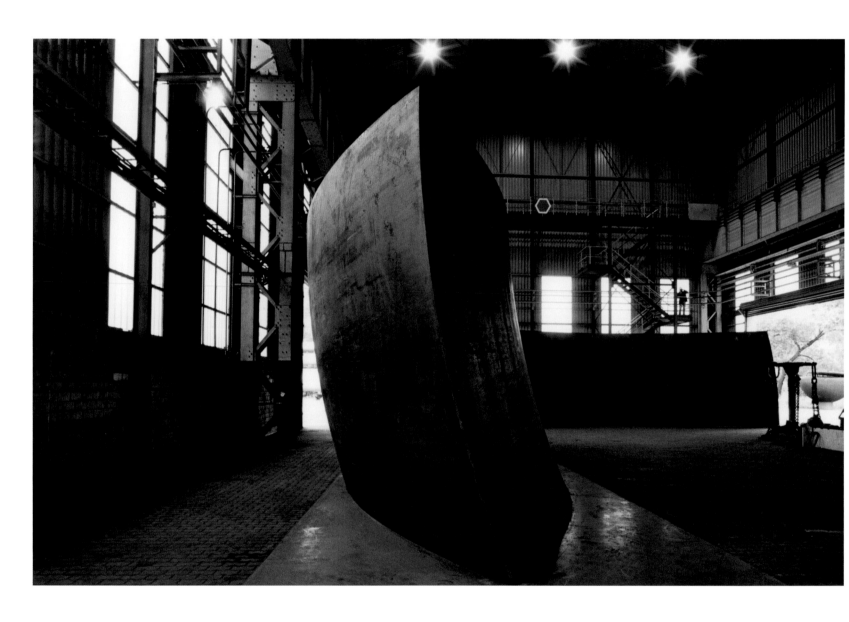

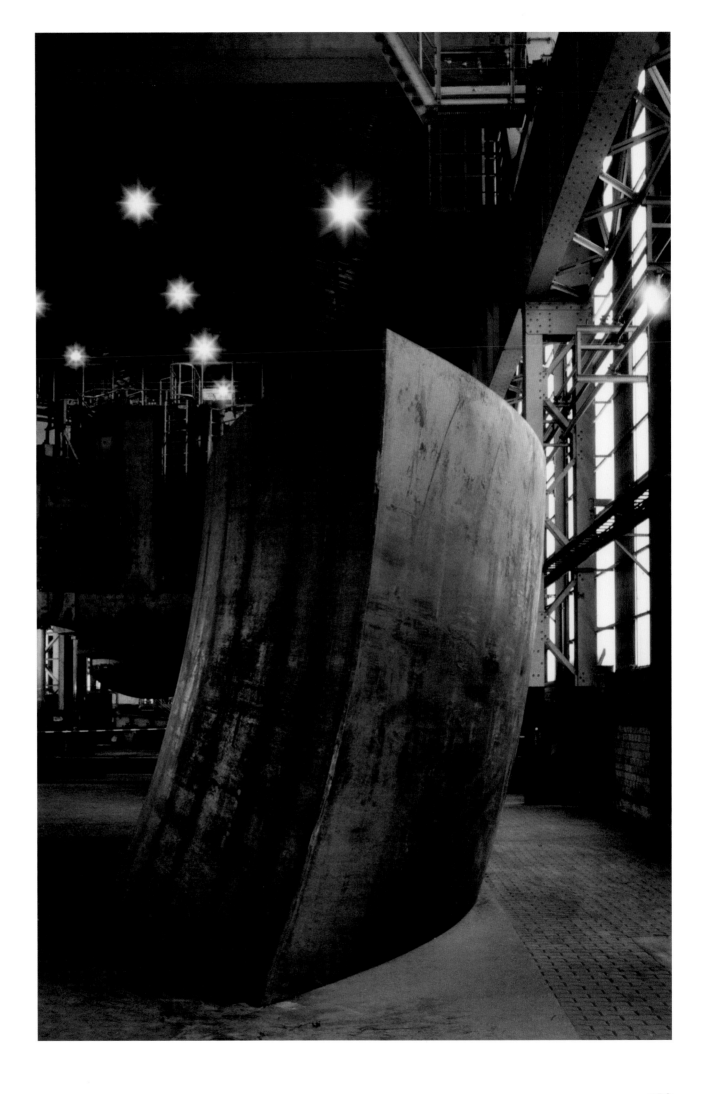

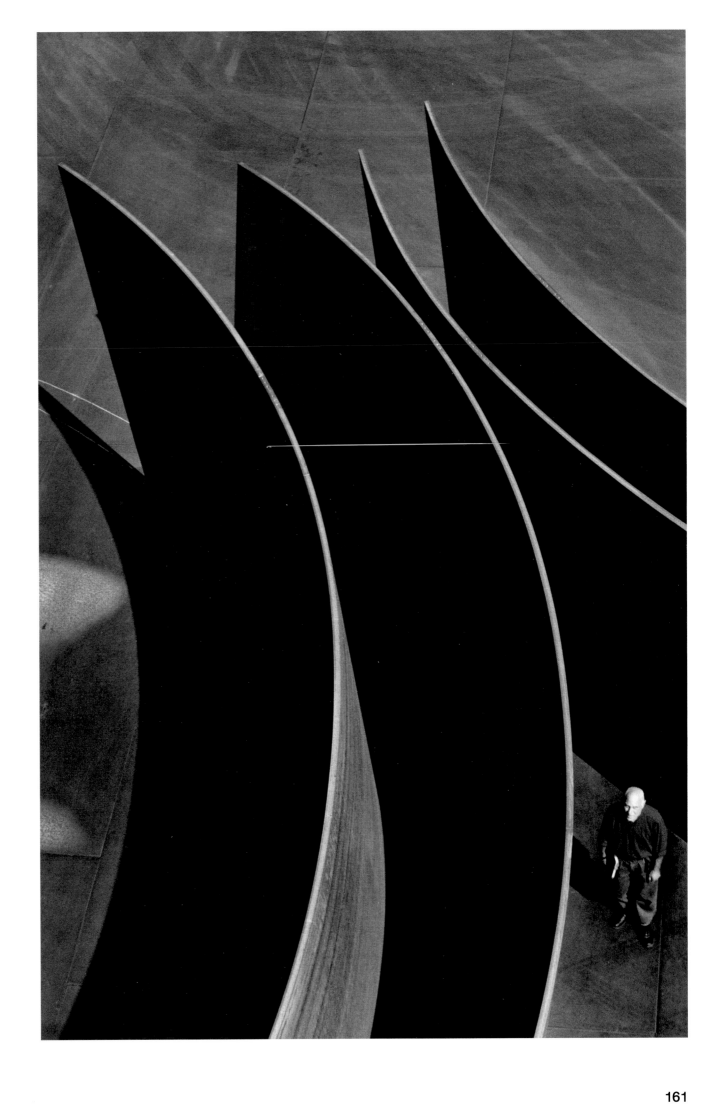

Abbildungsverzeichnis
List of illustrations

140–141
Elevations for L'Allée de la Mormaire, 1993
wetterfester Stahl, 10 Brammen /
weatherproof steel, 10 slabs:
3 Brammen, je / 3 slabs, each 180 × 625 × 30 cm
4 Brammen, je / 4 slabs, each 150 × 501 × 30 cm
3 Brammen, je / 3 slabs, each 139 × 376 × 30 cm
Sammlung / Collection François Pinault, Paris,
Frankreich / France

142–143
Bramme für das Ruhrgebiet, 1998
wetterfester Stahl / weatherproof steel
1.450 × 420 × 13.5 cm, 67 t
Schurenbachhalde, Essen, Deutschland / Germany

145
Richard Serra, Skizze im Notizbuch /
notebook sketch

146–147
Berlin Junction, 1986/87
wetterfester Stahl / weatherproof steel
2 Platten, je / 2 plates, each 395 × 1.350 × 5.5 cm
Philharmonie, Berlin, Deutschland / Germany

148–149
Intersection, 1992
wetterfester Stahl / weatherproof steel
4 konische Segmente, je / 4 conical sections,
each 370 × 1.300 × 5.5 cm
Theaterplatz, Basel, Schweiz / Switzerland

150–151
Pickhan's Progress, 1998
wetterfester Stahl / weatherproof steel
3 konische und 3 elliptische Segmente /
3 conical and 3 elliptical sections
gesamt / overall ca. 340 × 2.620 × 1.140 cm
Probeaufbau / proof installation at Pickhan
Umformtechnik, Siegen, Deutschland / Germany

152–153
Betwixt the Torus and the Sphere, 2001
wetterfester Stahl / weatherproof steel
3 Kugel- und 3 Torussegmente / 3 spherical and
3 torus sections
Gesamtmaß / overal dimensions ca.
338 × 1.146 × 813 cm
Probeaufbau / proof installation, Dillinger Hütte,
Dillingen, Deutschland / Germany

154–155
Switch, 1999
wetterfester Stahl / weatherproof steel
6 Platten, je / 6 plates, each 410 × 1.590 × 5 cm
Probeaufbau / proof installation, Dillinger Hütte,
Dillingen, Deutschland / Germany
Sammlung / Collection The Museum of Modern Art,
New York, USA

156
Probeaufbau von / proof installation of *Double
Torqued Ellipses*, Pickhan Umformtechnik, Siegen,
Deutschland / Germany

157
Ausstellung / Exhibition *Richard Serra Sculpture*,
1999, Guggenheim Bilbao, Spanien / Spain

158–159
Union of the Torus and the Sphere, 2001
wetterfester Stahl / weatherproof steel
1 Kugelsegment, 1 Torussegment /
1 spherical section, 1 torus section
gesamt / overall 360 × 1.150 × 320 cm
Dia Art Foundation, New York, USA
Probeaufbau / proof installation, Dillinger Hütte,
Dillingen, Deutschland / Germany

161
Richard Serra in der Skulptur / standing in
the sculpture *Switch*, 1999

Ausgewählte Literatur
Bücher mit Fotografien von Dirk Reinartz zu
Skulpturenprojekten von Richard Serra

Selected Publications
Books with Photographs by Dirk Reinartz on
Sculpture Projects by Richard Serra

Richard Serra, Dirk Reinartz, *Afangar*, Göttingen: Steidl und/and Zürich: Parkett/Scalo Publishers, 1991.

Text von/by Richard Serra, Fotografien von/Photographs by Dirk Reinartz. Dreisprachig in Deutsch, Englisch und Isländisch/Trilangual in German, English, and Icelandic.

Richard Serra, Dirk Reinartz. La Mormaire, Alexander von Berswordt-Wallrabe (Hrsg./Ed.), Düsseldorf: Richter, 1997.

Text von/by Stefan Germer, Fotografien von/Photographs by Dirk Reinartz. Dreisprachig in Deutsch, Englisch und Französisch/Trilingual in German, English, and French.

Richard Serra. Lemgo Vectors, Düsseldorf: Richter, 1998.

Text von/by Silke von Berswordt-Wallrabe, Fotografien von/Photographs by Dirk Reinartz. Zweisprachig in Deutsch und Englisch. Bilingual in German and English.

Richard Serra. Torqued Spirals, Toruses and Spheres, Ausst.-Kat./Exh. cat., New York: Gagosian Gallery, 2001.

Text von/by Hal Foster, Fotografien von/Photographs by Dirk Reinartz.

Richard Serra. Dirk's Pod, Silke von Berswordt-Wallrabe (Hrsg./Ed.), Göttingen: Steidl, 2004.

Texte von/Texts by Daniel Vasella, Richard Serra, Silke von Berswordt-Wallrabe, Fotografien von/Photographs by Dirk Reinartz und/and Nic Tenwiggenhorn. Zweisprachig in Deutsch und Englisch/Bilingual in German and English.

Richard Serra, Dirk Reinartz. Te Tuhirangi Contour, Göttingen: Steidl, 2005.

Text von/by Richard Serra, Fotografien von/Photographs by Dirk Reinartz.

Über Fotografien von Dirk Reinartz
On Photographs by Dirk Reinartz

Dirk Reinartz. Fotografieren, was ist, Ausst.-Kat./Exh. cat. LVR Landesmuseum Bonn, Göttingen: Steidl, 2024.

Über Skulpturen von Richard Serra
On Sculptures by Richard Serra

Richard Serra. Sculpture: Forty Years, Ausst.-Kat./Exh. cat. The Museum of Modern Art, New York: MoMA, 2008.

Dirk Reinartz wurde 1947 in Aachen geboren. Er studierte Fotografie bei Otto Steinert an der Folkwangschule in Essen. Von 1971 bis 1977 war er Fotoreporter beim „Stern". Seine zahlreichen Reisen führten ihn in viele Länder auf allen Kontinenten. 1977 schloss er sich der Fotografengruppe VISUM an, von der er sich 1982 wieder trennte, um fortan unabhängig zu arbeiten. Reinartz' Reportagen und Berichte erschienen in vielen Magazinen, unter ihnen „Life", „Fortune", „Der Spiegel", das „SZ-Magazin" und insbesondere das „Zeit-Magazin" und „Art". Seit 1985 publizierte er seine Fotografie-Projekte auch in Buchform. Dirk Reinartz' Fotografien wurden in zahlreichen Ausstellungen gezeigt. So wurde sein Projekt „totenstill" über die ehemaligen NS-Konzentrationslager etwa an 25 Orten weltweit ausgestellt, u.a. in Berlin, New York, Warschau und Santiago de Chile. Die Stiftung Situation Kunst verfügt über den kompletten Zyklus „totenstill" mit 136 Fotografien.

Seit 1998 war Reinartz Professor für Fotografie an der Muthesius Hochschule in Kiel. Er lebte in Buxtehude bei Hamburg. Dirk Reinartz starb 2004 in Berlin. Sein fotografischer Nachlass wird gemeinsam von der Stiftung F. C. Gundlach in Hamburg und der deutschen Fotothek in Dresden bearbeitet.

Dirk Reinartz was born in Aachen in 1947. He studied photography under Otto Steinert at the Folkwangschule in Essen. From 1971 to 1977, he worked as a photographic journalist for *Stern* magazine. His various travels took him to many countries and every continent in the world. In 1977, he joined the VISUM photography group, which he left in 1982 to work independently. Reinartz's reportages and bulletins appeared in many magazines, including *Life*, *Fortune*, *Der Spiegel*, *SZ-Magazin*, and, most prolifically, in *Zeit-Magazin* and *Art*. From 1985 onward, he also published his photography projects in book form. Reinartz's photographs have been shown in numerous exhibitions. For example, his project *totenstill*, featuring former Nazi concentration camps, appeared in no fewer than twenty-five exhibition locations worldwide, including Berlin, New York, Warsaw, and Santiago de Chile. The Situation Kunst Foundation holds a complete exhibition set of the *totenstill* cycle, comprising 136 photographs.

Reinartz was Professor of Photography at the Muthesius University in Kiel from 1998. He lived in Buxtehude near Hamburg. Dirk Reinartz died in Berlin in 2004. His photographic estate is currently administered by the F.C. Gundlach Foundation in Hamburg and the Deutsche Fotothek in Dresden.

Richard Serra wurde 1938 in San Francisco geboren. Studium an der University of California in Berkeley und Santa Barbara und an der Yale University (u.a. bei Josef Albers). Serra zählt zu den bedeutendsten Künstlern des 20. Jahrhunderts. Weltweit befinden sich zahlreiche seiner oft ortsspezifischen Großskulpturen im öffentlichen Raum, daneben sind seine Werke in den Sammlungen vieler wichtiger Museen vertreten. Einzelausstellungen u.a. im Museum of Modern Art und im Metropolitan Museum of Art (New York), im Centre Georges Pompidou (Paris), in der Tate Gallery (London), im Museo Reina Sofia (Madrid), im Museo Guggenheim in Bilbao. Für sein Werk erhielt Serra zahlreiche Auszeichnungen, darunter den Kaiserring der Stadt Goslar, den Praemium Imperiale, die Carnegie Medaille und den Goldenen Löwen der Biennale von Venedig; er ist Mitglied im Orden *Pour le Mérite* für Wissenschaften und Künste.

Richard Serra was born in San Francisco in 1938. He studied at the University of California (Berkeley) and Santa Barbara, as well as at Yale University (where he was invited to collaborate with Josef Albers). Serra is one of the most important artists of the twentieth century. Many of his often site-specific, large-scale sculptures can be found in public spaces around the world and his works also appear in collections of many important international museums. He has staged solo exhibitions at the Museum of Modern Art and the Metropolitan Museum of Art (New York), the Centre Georges Pompidou (Paris), the Tate Gallery (London), the Museo Reina Sofia (Madrid), and the Museo Guggenheim (Bilbao), among many others. Serra has received numerous awards for his work, including the city of Goslar's *Kaiserring*, the *Praemium Imperiale*, the Carnegie Medal, and the Venice Biennale *Golden Lion*. He is also a member of the *Pour le Mérite* of science and the arts.

Diese Publikation erscheint anlässlich der Ausstellung /
This book is to accompany the exhibition

work comes out of work
Fotografien von Dirk Reinartz zu Skulpturen von Richard Serra

Situation Kunst (für Max Imdahl)
Kunstsammlungen der Ruhr-Universität Bochum
8. November 2023 – 12. Mai 2024

Kunstverein Dillingen
16. Juni – 14. Juli 2024

Museum Wiesbaden
Hessisches Landesmuseum für Kunst und Natur
Juni – Oktober 2025

Herausgeber / Editor: Alexander von Berswordt-Wallrabe (für die Stiftung Situation Kunst)
Redaktion / Editing: Silke von Berswordt-Wallrabe
Lektorat / Proofreading: Eva Wruck, Sarah-Jane Pearson
Übersetzung / Translation: Timothy Connell

Erste Auflage 2024 /
First edition published in 2024

Book design/Buchgestaltung: Holger Feroudj / Steidl Design
Scans/Separations by Steidl image department
Gesamtherstellung und Druck/Production and printing: Steidl, Göttingen

Steidl
Düstere Str. 4 / 37073 Göttingen, Germany
Phone +49 551 49 60 60
mail@steidl.de
steidl.de

ISBN 978-3-96999-342-2
Printed in Germany by Steidl